T0326899

DUMBARTON OAKS CATALOGUES

BYZANTINE AND EARLY MEDIAEVAL

ANTIQUITIES

IN THE

DUMBARTON OAKS

COLLECTION

CATALOGUE

OF THE

BYZANTINE

AND EARLY MEDIAEVAL

ANTIQUITIES

IN THE

DUMBARTON OAKS

COLLECTION

The Dumbarton Oaks Center for Byzantine Studies
Trustees for Harvard University
Washington, D.C.

VOLUME THREE

IVORIES AND STEATITES

BY

KURT WEITZMANN

The Dumbarton Oaks Center for Byzantine Studies

Trustees for Harvard University

Washington, D.C.

1972

Distributed by
J. J. Augustin, Publisher
Locust Valley, New York

Library of Congress Catalogue Card Number 56-10351
Printed in Germany *at* J. J. Augustin, Glückstadt

FOREWORD

The Dumbarton Oaks Research Library and Collection is indeed fortunate in having been able to enlist the distinguished scholarship and unrivalled experience of Professor Kurt Weitzmann for the preparation of the Catalogue of ivories in its Collection. When I became Director in 1969, the year in which Mrs. Bliss died, one of the first projects which came to my attention was the present Catalogue, which had been started under my predecessor Mr. John S. Thacher and was already entering the final stages of completion. It is therefore a very great pleasure to me that it should now see the light of day, but it is sad that Mrs. Bliss did not live to see it too.

This volume is a welcome addition to the series of catalogues which was initiated in 1956 with the publication of Miss Gisela Richter's *Catalogue of Greek and Roman Antiquities in the Dumbarton Oaks Collection*.

It remains only for me to express to Professor Weitzmann the gratitude of Dumbarton Oaks for the time and trouble he has given to this project, which goes beyond the normal limits of a catalogue and which will be a source of the greatest interest to scholars and students in Byzantine and allied mediaeval studies thoughout the world.

William R. Tyler
Director

PREFACE

Having closely followed the growth of Dumbarton Oaks for more than thirty-five years and having often been consulted about the acquisition of ivories, I consider it a great honor to have been entrusted by Dr. John Thacher, the former Director of Dumbarton Oaks, with the writing of this ivory volume. My most sincere thanks go to him and to the staff of the museum, Mrs. Elizabeth Bland and Miss Susan Boyd, all of whom have helped in every possible way my study of the originals during my frequent visits to Washington. At a time when traveling was difficult for me, they even, on occasion, went so far as to bring a few ivories to Princeton. The strong interest of Dumbarton Oaks in the Ivory Catalogue has continued under its new Director, Mr. William Tyler, to whom I am greatly indebted for devoting to the project the same personal attention as his predecessor and for supporting it in every way.

I am particularly grateful to both directors for permitting me in a few instances to extend my discussion beyond the limits of what would normally be considered sufficient for entries in a catalogue raisonné and for letting me develop individual entries into short essays when I felt that new insights into the history of ivory carving justified such expansion.

I also profited from frequent discussions with my colleagues, the scholars in residence. While Professor Ernst Kitzinger was still in Washington, we met repeatedly in the Collection to discuss objects, and Professors Ihor Ševčenko and Cyril Mango gave me much valuable advice when I consulted them, particularly in problems of palaeography. To Miss Julia Warner and Mrs. Ellen Ash go my thanks for their final editing of the Catalogue for publication. I am most grateful to Mr. John Wilson, who carefully and patiently made the reconstruction drawings, and to Mr. Richard Amt, who is responsible for both the excellent black and white photographs and the transparencies.

My special indebtedness, however, goes to Miss Susan Boyd, who, having functioned as my assistant for the duration of the work on the Catalogue, was of invaluable help not only in every practical matter, but also in editing the manuscript in the most scrutinizing manner and often in raising questions regarding the content of the entries, occasionally forcing me to rethink a problem and to make adjustments and changes.

Finally, I should like to pay tribute to the late Mr. and Mrs. Bliss, who had introduced me to their collection before Dumbarton Oaks became a Harvard institution. It was in 1937 in Worcester, during the exhibition "The Dark Ages," that Mr. Bliss pulled out of his pocket the Thomas plaque (No. 21), making me very uneasy, for a few months earlier I had seen the plaque in the Germanic Museum at Nuremberg and I could not at first believe that such a treasure could have been sold. I also remember a day in 1939

when Mrs. Bliss came to Princeton and took from her drawstring bag the plaque with the Hodegetria between John the Baptist and St. Basil (No. 26), which she had just acquired. When I showed my enthusiasm for this entirely unknown ivory I was courteously reprimanded for having made my judgment too quickly—"It would have taken Dr. Goldschmidt a little longer to make up his mind."

PRINCETON, NEW JERSEY KURT WEITZMANN
 March 1972

CONTENTS

WESTERN MEDIAEVAL IVORIES

STEATITES

APPENDIX

LIST OF COMPARATIVE MATERIAL

ILLUSTRATIONS IN THE TEXT

ABBREVIATIONS

A.J.A.	*American Journal of Archaeology*
Art Bull.	*The Art Bulletin*
Art of the Dark Ages, Worcester Art Museum, 1937	*The Dark Ages. Loan Exhibition of Pagan and Christian Art in the Latin West and Byzantine East*, Worcester Art Museum, 1937
Athens Exhibition Catalogue, 1964	*Byzantine Art, an European Art. Ninth Exhibition Held under the Auspices of the Council of Europe. Catalogue*, 2nd edition, Athens, 1964
Banck, *Byz. Art in the U.S.S.R.*	A. Banck, *Byzantine Art in the Collections of the U.S.S.R.*, Moscow [1966]
Banck, *Corsi*	A. Banck, "Les Stéatites. Essai de classification. Méthodes des recherches," *Corsi di cultura sull'arte ravennate e bizantina*, Ravenna, 1970
Bull. Fogg	*Bulletin of the Fogg Museum of Art*
B.Z.	*Byzantinische Zeitschrift*
C.I.L.	*Corpus Inscriptionum Latinarum*
D.O.H.	*The Dumbarton Oaks Collection, Harvard University, Handbook*, Washington, D.C., 1955 and 1967
D.O.P.	*Dumbarton Oaks Papers*
Early Christian and Byzantine Art, Baltimore, 1947	*Early Christian and Byzantine Art. An Exhibition Held at the Baltimore Museum of Art*, The Walters Art Gallery, Baltimore, 1947
Exposition byz., Paris, 1931	*Exposition internationale d'art byzantin*, Musée des Arts Décoratifs, Palais du Louvre, Paris, 1931
Goldschmidt, I, II, III, IV	A. Goldschmidt, *Die Elfenbeinskulpturen aus der Zeit der karolingischen und sächsischen Kaiser*, 4 vols., Berlin, 1914–26
Goldschmidt-Weitzmann, I, II	A. Goldschmidt and K. Weitzmann, *Die byzantinischen Elfenbeinskulpturen des X–XIII Jahrhunderts*, 2 vols., Berlin, 1930 and 1934
J.A.C.	*Jahrbuch für Antike und Christentum*
Sotiriou, *Icones*	G. and M. Sotiriou, *Icones du Mont Sinaï*, 2 vols., Athens, 1956 and 1958
Volbach, *Elfenbeinarbeiten*	W. F. Volbach, *Elfenbeinarbeiten der Spätantike und des frühen Mittelalters*, Mainz, 1952

Volbach, *Mittelalterliche Bildwerke* W. F. Volbach, *Mittelalterliche Bildwerke aus Italien und Byzanz*, 2nd ed., Berlin, 1930

Westwood, *Fictile Ivories* J. O. Westwood, *A Descriptive Catalogue of the Fictile Ivories in the South Kensington Museum*, London, 1876

Wulff, *Altchristliche Bildwerke* O. Wulff, *Altchristliche und mittelalterliche byzantinische und italienische Bildwerke*, Teil I: *Altchristliche Bildwerke*, Beschreibung der Bildwerke der christliche Epochen, Königliche Museen zu Berlin, Band III, Teil I, Berlin, 1909

BYZANTINE AND EARLY MEDIAEVAL

ANTIQUITIES

IN THE

DUMBARTON OAKS

COLLECTION

Volume III

IVORIES AND STEATITES

INTRODUCTION

HISTORICALLY, the ivories of the Dumbarton Oaks Collection fall into four groups, which, however, are unevenly represented. The first group (Nos. 1–17), comprising those with pagan subject matter and dating roughly from the second to the sixth century, is the largest and includes numerically half of the material. While this group contains a few pieces of cardinal importance, it also includes a number of mass-produced carvings, so that as a whole, interesting as it is from the point of view of its considerable variety, it does not overshadow the later groups, where almost every piece has distinction and character.

The great obstacle presented by the pagan ivories is that there exists no corpus which could serve as a guide and provide points of orientation for dating and localization. Volbach's corpus (*Elfenbeinarbeiten*), which begins with the Probus diptych of A.D. 406, deals only with objects of the late classical period, and of the seventeen Dumbarton Oaks ivories of the first group, he includes only three (Nos. 9, 11, and 17). While this fifth-century date marks the earliest of the important group of ivory diptychs, it does not represent the beginning of a period of expansion for ivory carving in general, for there was in fact a rich and uninterrupted production of ivories from the time of early imperial Rome until the sixth to seventh centuries. Thus, the need is most urgent for a more comprehensive study which would reveal the continuity and extraordinary variety in ivory carvings of this period, in form as well as in subject matter. It must be admitted that the dates proposed here for the Dumbarton Oaks ivories of this group are in many instances tentative and will remain so as long as no more exhaustive study has appeared. Rodolfo Kanzler's catalogue of the very important collection of classical and late classical ivories in the Museo Profano of the Vatican Library (R. Kanzler, *Gli avori dei Musei Profano e Sacro della Biblioteca Vaticana*, Rome, 1903) is still the best point of departure for such a study. But there are other important collections, among them those of the Walters Art Gallery in Baltimore and of the Benaki Museum in Athens, which possess a considerable wealth of ivory and bone carvings as yet unpublished in catalogue form.

In any future corpus, the plaque with the scene of the Isis cult (No. 1) will provide a focal point because of its size, subject matter, quality, and incontrovertible association with Egypt. Another key piece will be the group of Orpheus as the Good Shepherd (No. 5), not so much for its artistic quality (which because of its fragmentary state cannot fully be judged), but for its association with two similar groups, which establishes it as a cult image related to but not identical with the Good Shepherd. The knife handle (No. 7) could likewise be freed from its isolation, and other luxury objects grouped around it. The statuette possibly representing Ares (No. 8), whose close stylistic relationship to the well-known medicine box with Dionysos and Tyche (No. 9) I have attempted to establish, should provide another nucleus of Egyptian ivory carving around which additional

pieces can most likely be grouped after more extensive study. The Philoxenus diptych (No. 17), although limited to a rather simple ornamental decoration, nevertheless occupies an important place in the Dumbarton Oaks Collection as a representative of the consular diptych type.

The second group, comprising the Early Christian ivories, is represented by only two pieces (Nos. 18 and 19), of which one, the pyxis from Moggio, is outstanding even within the large group of such pyxides for its lively, highly dramatic style and for some unique features in its iconography.

One of the most controversial pieces in the Collection is the Nativity plaque from the Chalandon Collection (No. 20). Goldschmidt, essentially a mediaevalist, dated it around 600 and attributed it to Alexandria, while, on the other hand, Volbach, in his corpus of Early Christian ivories, considered it mediaeval Italian, probably Sicilian, and dated it in the eleventh century. Both opinions have been championed by renowned scholars, but I myself have proposed, in an extensive study of the whole group of the so-called Grado Chair ivories (to be published in vol. 26 of the *Dumbarton Oaks Papers* and from which the present catalogue entry has been excerpted), a new date at the end of the seventh to the eighth century. I suggest that in this group of ivories the classical tradition has begun to run its course, while at the same time the first signs of a mediaeval stylization are discerned, such as a more graphic rendering of the human form, a more ornamental treatment of architectural background, and the gradual elimination of space. In contradiction to past scholarship, which assumed that there was a break in the tradition, I am of the opinion that there existed continuity and gradual transformation. In any further study of this intermediary period, the Nativity plaque, together with the group of ivories associated with it, will be a focal point.

As might be expected, the greatest strength of the Dumbarton Oaks Collection lies in its series of ivories of the Middle Byzantine period. The Goldschmidt-Weitzmann Corpus formed the basis for a systematic collection, in which each of the four major contemporary groups is represented by at least one piece of high quality. The plaque with the Incredulity of Thomas (No. 21) is among the very best examples of the "painterly" group, and was copied from a miniature of a luxury manuscript which, like the ivory itself, must have been the product of a court atelier. This group reflects more than any other the classical revival of the Macedonian Renaissance; so it is not surprising that the same atelier produced the great wealth of rosette caskets well represented in Dumbarton Oaks by the casket from the Rothschild Collection (No. 23). The special interest of this casket lies in the fact that it has on its lid, in addition to the typical putto-like warriors, a charming series of animals, most of which can be traced to an illustrated Physiologus, thus reflecting yet another popular classical source.

The most aristocratic, the so-called "Romanos" group, which in its best products marks the high point of Byzantine ivory carving, is represented by the plaque with the Hodegetria between John the Baptist and St. Basil (No. 26). This plaque belongs to the small core of the group, in which Christian spirituality and classical form have reached the most perfect harmony. Another monumental product of the Romanos group is the plaque with a *crux gemmata* enclosing a medallion with an emperor bust, perhaps that of Romanos II (No. 24). Reproduced in the Corpus after an eighteenth-century engraving because its

whereabouts was unknown at that time, its reappearance was a major discovery. Like the "painterly" group, the Romanos group must also have been produced in a court atelier, although it displays a more hieratic and restrained expression compared with the greater exuberance of the former. Different as their products are, the two ateliers must nevertheless have worked in the closest proximity, and this would explain the fact that a plaque such as the Deposition from the Cross (No. 27) reflects a mixture of the two styles, in which the most attractive aspects of each are apparent.

The third contemporary atelier produced the so-called "Nicephoros" group, represented by the plaque with the bust of the Hodegetria (No. 28). The Virgin and the Christ-child are slightly less aloof and consequently more human. Despite the somewhat fleshier faces, the products of this group also reflect the aristocratic style of the capital.

The fourth or "triptych" group, so called after the type of object which dominates it, consists chiefly of loose plaques, centers, or wings, while few triptychs have survived intact. Although the products of this group were doubtlessly made for a larger and less wealthy clientele, they still maintain a high standard of craftsmanship in spite of their lesser refinement, as seen in the Koimesis plaque (No. 29), once the center of a triptych, with its rather sketchy style, especially in the treatment of the drapery. This workshop also produced a considerable number of rosette caskets, of which the one with the Deesis and the twelve Apostles in bust form (No. 30) was reconstructed at Dumbarton Oaks from fragments which I first saw mounted on a bookcover. There is every reason to believe that the "triptych" group is also to be localized in the capital and belongs to the same period— basically the second half of the tenth century—as the other three groups. This is made clear by the plaque with St. Constantine (No. 25), who is very possibly represented with the features of Constantine VII Porphyrogenitus, the scholar and artist, who as emperor was largely responsible for the Macedonian Renaissance. The fact that this plaque reflects the styles of both the Romanos and triptych groups would indicate that the latter began as an offshoot of the former, on a level of quality which at the beginning was rather high but deteriorated as the ivories came to be mass-produced.

Omitted from the catalogue is a Crucifixion plaque in the style of the Romanos group which was published in the Corpus (II, no. 229) as being most likely a recent imitation of a Crucifixion triptych in London (II, no. 38). More careful study has turned my suspicion into conviction that it is indeed a modern forgery.

It is widely believed that during the eleventh century, when the economy of the Empire began to encounter serious difficulties, ivory carving gradually was replaced by work in less valuable steatite, and eventually came to an end. There may indeed have been a lapse, but in the Palaeologan period ivory carving—though on a limited scale—came to life again. The tiny fourteenth-century pyxis with the two imperial couples (No. 31) has long been known and often discussed because of the problem of the identification of the two couples, but it has at the same time been treated as a unique piece, stylistically as well as iconographically. In this catalogue the first attempt is made to group other pieces around it and thus to establish another focal point serving as a point of departure for future investigation of a Palaeologan school of ivory carvers.

Finally, there are three Western mediaeval ivories, all of artistic distinction, but isolated pieces since Dumbarton Oaks has never pursued a policy of systematic acquisition

in this direction. The first is an elaborate and rare Spanish chessman (No. 33), to which there exists only one parallel, in a private collection in Frankfurt, which Goldschmidt in his Corpus (IV, no. 251) dated in the thirteenth century. This attribution, however, was made before the appearance of Ferrandis' corpus of the hispano-mauresque ivories (J. Ferrandis, *Marfiles arabes de occidente*, Madrid, 1935) which permitted the more precise attachment of the two chessmen to a group of ivories executed in Cordoba at the end of the tenth or in the eleventh century.

The second piece is also Spanish, a monumental Christ Enthroned (No. 32), carved in high relief, that assuredly formed part of the famous shrine of St. Aemilianus in San Millan de la Cogolla. This shrine, made between 1060 and 1080, was destroyed in the Napoleonic war of 1809, and a certain number of pieces, in addition to the Christ Enthroned, were lost. Since volume IV of Goldschmidt's Corpus was written in 1926, one fragmentary plaque has been found and is now in the Museum of Fine Arts in Boston. Another plaque has very recently come to light in a private collection, and there is hope that the other missing plaques will still be discovered.

The third Western piece is a portable altar (No. 34), made in the Lower Rhine region in the eleventh century. It comes from the Austrian monastery of Melk where a companion piece of the same style (Goldschmidt, II, no. 104) is still preserved as part of an inventory dating back to the eleventh century. The Dumbarton Oaks piece, although of moderate quality, has raised some interesting and intricate iconographical questions.

While it is not to be expected that more Western pieces will be added to the Collection, it is to be hoped that major acquisitions of the late classical, Early Christian, and Byzantine periods may still be made.

Postscriptum

After this volume had gone to press, two acquisitions were made which unfortunately could not be integrated into the text in their proper places, but could be treated only in an Appendix. One is a plaque with a charming decorative cross (No. 41) and the other is a fragmentary plaque with the upper half of the figure of the Archangel Gabriel (No. 40), both formerly in the collection of William R. Tyler. The latter is a major acquisition, since it not only belongs to the outstanding Romanos group (and should logically, therefore, have followed No. 26, the Hodegetria plaque, in the arrangement of this Catalogue), but apparently once formed part of a rather rare object, an iconostasis beam from which four other plaques are preserved in Bamberg and two in Leningrad. Thus the hope expressed above that major acquisitions might still be made was fulfilled sooner than could have been anticipated.

CLASSICAL AND LATE CLASSICAL IVORIES

1. Plaque
 Isis Cult Scene
 Egypt, second century
 Height 20.3 cm. Width *ca.* 11.5 cm. Thickness 1.1 cm.
 Acc. no. 42.1 PLATE I

The fragmentary ivory plaque, carved in high relief, has two figures, one seated and
one standing. It has been cut down so that it now terminates in a semicircle, but originally
it must have been slightly higher and rectangular in shape, since the curved line cuts off
the top of the head of the standing figure and the colonnette on which the drapery of the
background is fastened. The recutting may have been done in the Middle Ages when the
plaque was reset. Perhaps at the same time a narrow strip at the bottom was cut away.
The most severe damage is at the upper left where the following losses occur: the drapery
with its corresponding colonnette, the cornice of the wall, and the right arm of the standing
figure with whatever attribute he may have held. Moreover, there are two breaks in the
middle of the plaque: the major loss consists of a part of the scroll and the left hand of
the seated figure who held it; above the altar a large drilled hole, connected with this
break, may have served to fasten the plaque to a wooden core. The smaller break is
below the lower arm of the standing figure, where a section of the garland is lost. In
addition, the upper right corner of the bench is cut out, causing the loss of the letter
omikron in the inscription, while other slight losses occur at the heel of the seated figure
and in the basket on the altar, along with a section of background. The ivory, which is
a light brown color, is very brittle throughout, and its surface is cracked and fissured in
many places where small splinters have fallen off. In several instances the missing parts
are filled in with a kind of gypsum, especially on the thigh of the seated man and the
elbow of the standing one.

In the left foreground a seated man, clad in tunic and mantle, reads from a scroll which
he has opened to about the width of a writing column; on his clean-shaven head he wears
a wreath of laurel or olive leaves. Because of the wreath and scroll some scholars have
called him a poet, but the whole setting speaks against this interpretation. The fact
that he sits before an altar would indicate rather that he is a priest; his general appearance,
in fact, is specifically that of a priest of Isis. He is the sacred scribe, the *hierogrammateus*,
who is depicted reciting the ritual on a Pompeian fresco in the temple of Isis, where
he is, however, standing, not seated (V. Tran Tam Tinh, *Essai sur le culte d'Isis à Pompéi*,
Paris, 1964, p. 136, no. 30 and pl. v, 2), and on a marble relief of the Hadrianic period in
the Cortile del Belvedere in the Vatican (W. Amelung, *Die Sculpturen des Vaticanischen
Museums*, II, Berlin, 1908, pp. 142–45 and pl. 7, no. 55). Furthermore, the wreath is a
common attribute of Isis priests; evidence is provided by a granite column from the

5

Iseum of Domitian in the Campus Martius in Rome, now in the Capitoline Museum (H. S. Jones, *A Catalogue of the Ancient Sculptures ... of the Museo Capitolino*, Oxford, 1912, p. 360 and pl. 92). Standing behind the seated priest is another, also clean-shaven and wearing a wreath, and clad in a garment which is tucked in under his armpits, leaving his breast bare. This costume has its closest parallels in the well-known fresco from Herculaneum depicting an Isis ceremony (Tran Tam Tinh, *op. cit.*, p. 101 and pl. XXIII). In his left hand this priest holds a garland by its looped end, as if he were about to hang it up; the missing arm must have been raised in this action. Some scholars have thought that the figure was a flute player because of a protrusion between his lips. However, it does not seem likely that a priest would be engaged simultaneously in hanging up a garland and playing a musical instrument.

In front of the reading priest there is an altar decorated with leaf garlands and on top of it, as an offering, an open basket. The tapering form of this altar is typically Egyptian. The whole scene takes place before a niche with a richly molded cornice supporting a colonnette on the right; originally a corresponding colonnette must have appeared on the left, and a *parapetasma* (now mostly missing) was fastened to both. This is the precious curtain which forms an essential part of the setting for a ritual sacrifice.

The reading priest sits on a box-like bench, on which is inscribed in huge elevated capital letters, ΑΝΔΡΟΠ(Ο) / ΛΕΙΤΗС, a word of the utmost importance for the localization and dating of the ivory. To understand this adjective the word νομός should be added to the inscription. The nomes were the administrative districts of imperial Egypt, and the ivory must be connected with the district named Andropolis. This name appears for the first time in the middle of the second century A.D. in Ptolemy's *Geography* (IV.5.18): Ἀνδροπολίτης νομὸς καὶ μητρόπολις ἀνδρῶν πόλις. In a Roman inscription of the year A.D. 204 (*C.I.L.* VI, 4, 2, 32523, b.12), the city is called Aelia Andropolis, an indication that it owed its growing importance in the second century to a grant of privileges by the Emperor Aelius Hadrianus (A.D. 117–38). A *strategos* of the Ἀνδρωνοπολείτης (*sic*) and the ἄρχοντες Ἀνδρουπολείτων are mentioned in a papyrus dating, in all probability, from A.D. 172–73 (D. Comparetti, "Epistolaire d'un commandant de l'armée romaine en Egypte," *Mélanges Nicole*, Geneva, 1905, p. 60). The form "Andropoleites" finds a striking analogy in a special group of Egyptian coins issued by the emperors Domitian, Trajan, Hadrian, and Antoninus Pius in the period A.D. 91–145, the so-called nome coins. On their reverse one finds names like Antaiopolites, Heliopoleites, and Mempheites (*sc. nomos*), and representations of divinities in Hellenistic garb. (I owe much of this information to an unpublished study of the ivory made in 1942 by a group of Junior Fellows of Dumbarton Oaks.)

The close connection between the ivory and the so-called nome coins suggests a date within the time limits of these coins, and an origin surely in the Nile delta. The ivory and coins share a pronounced Greco-Roman appearance and a lack of emphasis on Egyptian elements typical of the *interpretatio romana* prevailing in Alexandria in Roman times. It has been suggested that the nome coins originated in Alexandria, not in the capitals of the nomes, and the same may be true for our ivory. The city of Andropolis was probably located at the site of the modern village of Kherbeta, south of ancient Naukratis, i.e., not too far from Alexandria.

In its elaborate composition the ivory is unique, and this makes it most difficult to relate to other ivory carvings, although in the considerable mass of material which has come down to us there are many which must be approximately contemporary. However, none of these pieces, for the most part fragmentary, gives the slightest hint as to date or provenance, and for this reason the Dumbarton Oaks ivory, with its historical associations, should be placed in the center of a detailed study of second to third century ivories.

The type of furniture to which the ivory was originally attached is difficult to determine. Babelon (see bibliog. *infra*) suggested a luxury chest. This idea found some support when the excavations of Qustul in Nubia brought to light a huge chest, about one meter high, covered on the front with several rows of ivory plaques (W. B. Emery, *The Royal Tombs of Ballana and Qustul, Mission archéologique de Nubie, 1929–1934*, Cairo, 1938, I, pp. 383–84, no. 881 and II, pl. 109). Although crude and provincial in style and bearing plaques which are incised, not carved in relief, this fourth-century chest is an important survival of one type of furniture with ivory decoration.

Said to have been formerly in the possession of the Monastery of Zwettl, Austria.
Guilhou Collection, Paris.

E. Babelon, in *Bulletin de la Société Nationale des Antiquaires de France*, 1900, pp. 303–05. H. Graeven, *Antike Schnitzereien aus Elfenbein und Knochen*, Hannover, 1903, pp. 128 ff., no. 79. J. Strzygowski, *Koptische Kunst. Catalogue général des antiquités égyptiennes du musée du Caire*, Vienna, 1904, p. 171. *Catalogue des objets antiques et du moyen âge ... provenant des collections du Dr. B*[ignault] *et de M. C*[anessa], Paris, Hôtel Drouot, 19–21 mai 1910, p. 34 and pl. XXVI, no. 347. *D.O.H.*, 1955, no. 220. J. Beckwith, *Coptic Sculpture, 300–1300*, London, 1963, pp. 10 and 47–48 and fig. 11. *D.O.H.*, 1967, no. 264.

2. Left Corner-post of a Casket
 Maenad
 Egypt, second to third century
 Height 10.6 cm. Width 3 cm. Thickness 2 cm.
 Acc. no. 56.1 PLATE II

A vertical crack has split the ivory into two halves which are now glued together, and at the lower left side a strip of ivory has been lost. Otherwise, the condition of the ivory, especially the surface, is quite good, although the color has darkened considerably.

Various grooves cut in the back and right side of the piece indicate that it once formed the left corner-post of a casket (text fig. a). In the middle of the right side there is a groove for the insertion of the front panel, and another at the rear, close to the edge, must be for the left side wall. On the rear, at the height of the figure's feet, there are two deep, horizontal grooves into which the bottom of the casket was fitted. This means that the casket was raised from the ground and rested on four freestanding feet, each in the shape of a lion's paw. Our foot is set off on the front by a plain, narrow molding on which the figure stands. An indentation cut into the top on both the front and left sides was made

for a high lid similar to that on the well-known casket in Brescia (cf. J. Kollwitz, *Die Lipsanothek von Brescia*, Berlin, 1933, Plate Vol., pls. 2–5). While no casket such as we have described has survived intact from classical antiquity, its shape survived in

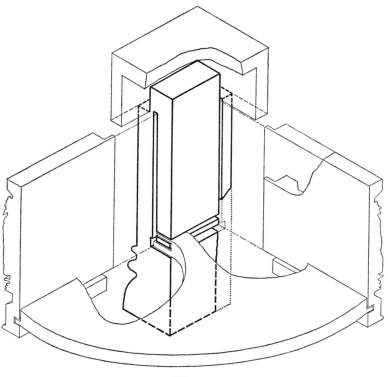

Fig. a

Ilsamic art. An ivory casket of about the eleventh century in the Metropolitan Museum of New York (M. S. Dimand, *Handbook of Muhammadan Decorative Arts*, 2nd ed., Metropolitan Museum of Art, New York, 1947, p. 128 and fig. 73), which belongs to a group traditionally termed Fatimid but now believed to be South Italian, probably from Amalfi (cf. E. Kühnel, "Die Sarazenischen Olifanthörner," *Jahrbuch der Berliner Museen*, I, 1959, pp. 33 ff.), has similar corner-posts decorated with turbaned men standing frontally on similar socles (PL. LXIX, fig. 40). Ivory caskets raised from the ground by solid corner-posts are preserved from as early as the late fourth century in Early Christian art, the best known example of which is the Brescia casket mentioned above, although it has symbolic motifs rather than human figures carved on the posts. A photograph of the inner side of this object, made when it was reassembled as a casket, shows precisely the same kind of grooves on the side walls and the raised bottom as does our ivory (Kollwitz, *op. cit.*, Text Vol., pl. I, b).

Fitted very tightly into the width of the post is the figure of a maenad, standing frontally in a slightly contrapposto pose as she leans to her right and looks up to her

left, presumably toward something represented on the lid. With her right hand she touches her flowing hair, and in her left she holds a thyrsus. A fluttering mantle covers her legs and left arm and, without clear demarcation, forms a veil billowing out behind her head and shoulder. One might expect the corresponding post at the right to have had either another maenad moving in the opposite direction or perhaps a satyr. In addition, it would seem quite likely that the front side, if not the other three as well, was decorated with figured ivory reliefs. In the Antiquarium in Berlin (Inv. Berlin TC 4963–66; F. Fremersdorf, *Das Römergrab in Weiden bei Köln*, Cologne, 1957, pl. 61), there are four related ivory plaques with figures of almost the same size as our maenad, and these may well have belonged to a casket of the type I have tried to reconstruct. The best preserved of these represents Aphrodite looking into a mirror, which she holds in her left hand, while with the other she grasps her hair (PL. II, fig. 1). The carving of the nude body with its emphasis on swinging curves and softly modelled surfaces, the treatment of the clinging drapery, and other details of the high relief are similar enough to the Dumbarton Oaks piece to suggest that the Berlin plaques, though apparently not belonging to the same casket, are not only approximately contemporary, but presumably the product of the same or a locally related workshop. Though it cannot be proved, Alexandria seems to be the likely place of origin.

There is no sure basis for accurately dating the great mass of ivory and bone carvings of the Greco-Roman period. Yet, among the mythological and especially the Bacchic sarcophagi of the Hadrianic period, one finds a similar treatment of female figures, in which fluttering, wind-swept garments are pressed against the torsos, exposing well-proportioned, fleshy bodies in imitation of models of the high classical period (cf. J. M. C. Toynbee, *The Hadrianic School*, Cambridge, 1934, pls. XXXVIII–XLII). These figural types were adapted by ivory craftsmen and were especially suitable for the decoration of what probably were toilet caskets. Although it is impossible to say how long the types survived, it seems likely that our ivory belongs to the second century, but a third-century date should not be excluded.

D.O.H., 1967, no. 265 and pl.

3. Statuette. Bone
 Criophore
 About third century
 Height 6.8 cm. Width 3 cm. Thickness 1.3 cm.
 Acc. no. 63.24 PLATE III

The small, convex object with the figure of a criophore is carved in openwork from a cylindrical piece of bone. The concave back of the object is also carved, though only sketchily, indicating that it, too, was meant to be seen. Thus, it is unlikely that this piece was intended as an appliqué for furniture, as were so many of this period. The subject of a shepherd carrying a lamb is common and occurs in two other bone carvings of ap-

proximately the same size, one in the Landesmuseum, Bonn, and the other in the Museum of the Canton, Zug (Th. Klauser, "Studien zur Entstehungsgeschichte der christlichen Kunst," *J.A.C.*, I, 1958, p. 34 and pl. 2e–f). Both of these served as knife handles; however, because our piece is carved in rather delicate openwork, it is not very likely that it served the same purpose, even though it is approximately the same size and is decorated with the same motif.

The feet of the shepherd, together with the supporting base and the lower half of the right tree, are missing, and there is some damage to the wrist of the figure's left arm.

The youthful shepherd, who has curly hair and a short beard, is clad in a knee-length tunic girdled at the waist and carries on his shoulders a ram, whose legs he holds firmly with his left hand. Standing between two trees whose branches close over his head, he leans on a club-like staff which he holds in his right hand. Traditionally, such lamb-bearers, or criophores, have been interpreted as Christ as the Good Shepherd, based on the well-known parable of the Lost Sheep. But recently, in the article cited above and its continuations (*J.A.C.*, 3, 1960, pp. 112ff.; 5, 1962, pp. 113ff.; 7, 1964, pp. 67ff.; 8–9, 1965–66, pp. 126ff.; 10, 1967, pp. 82ff.), Klauser has brought forth evidence that many figures of the lamb- and ram-bearers on sarcophagi and other objects are not necessarily Christian. He demonstrates that during the Greco-Roman period, in addition to being a popular composition derived from bucolic genre scenes in which it had no underlying meaning, the type was in certain instances interpreted as the personification of Philanthropia. The deeper significance of this interpretation obviously appealed to the Christians and explains the ease with which the criophore was adapted as an illustration of the New Testament parable. Since the change was in meaning only and not in form, the question of whether a criophore is pagan or Christian can be determined only by the context of the piece, which is not clear in our case.

Openwork bone reliefs are rather rare in the late classical and Early Christian period, but other examples do exist. There is a group of Artemis and Hermes of approximately the same size as our criophore in the Museo Profano of the Vatican (R. Kanzler, *Gli avori dei Musei Profano e Sacro della Biblioteca Vaticana*, Rome, 1903, pl. VII, no. 8, there dated third to fourth century), in which the foliage of a tree behind Hermes' head is quite similar in design to that of our piece. Another example of openwork shows Aphrodite standing with a male figure, probably Ares, whose head and right arm are broken off (Kofler-Truniger Collection, Lucerne, unpublished, Inv. K 477T; height 7.3 cm. width 6.8 cm.). Significantly, this group is also flanked by two trees, the left one being almost entirely preserved and showing its lower foliate branches, that at the right broken off at the height of the god's elbow (PL. III, fig. 3). A fourth, rather late, small-scale openwork figure (Baltimore, Walters Art Gallery, unpublished, Inv. 71.478; height 8.8 cm.) represents Aphrodite flanked on one side by a tree whose foliage frames her head, and on the other by a support (PL. III, fig. 2). The narrow round base suggests that we are dealing with the handle of a knife, as in the case of the two shepherds published by Klauser.

Among the numerous marble criophores, the one closest in style to ours, as William Wixom has shown, is the newly discovered statue in the Cleveland Museum which, from its context, may be identified as the Good Shepherd (see bibliog. *infra*, cover and figs. 23–24). The third-century date assigned to this marble on the basis of the style of

the portrait busts with which it was discovered is completely justified. Our bone figure shares with it the easy stance, the free movement, and the sketchily yet surely designed drapery. The slender proportions of our criophore and his quite elegant bearing show an even better understanding of the classical mode. Thus we see no reason to date it later than the third century.

Said to have been found in Istanbul.

D.O.H., 1967, no. 272 and pl. W. D. Wixom, "Early Christian Sculptures at Cleveland," *Bulletin of the Cleveland Museum of Art*, March 1967, p. 88 c, fig. 54.

4. Fragment of a Frieze. Bone
 Mounted Hunter
 East Mediterranean (?), third to fourth century
 Height 5.3 cm. Width 2.7 cm. Thickness 0.5–0.8 cm.
 Acc. no. 63.23 PLATE III

This convex fragment of bone carved in openwork with a hunting scene has been broken on all sides because of its fragile technique. Both arms of the rider, the neck, head, forelegs, and lower hindlegs of the horse, and the legs of the dog are missing; of the attacking wild animal only the head is left. Because the hindquarters of the horse are curved slightly inward and the horse's neck is turned around sharply at a right angle, the group seems to be part of a frieze which was laid around an object of irregular shape. This object, most likely a vessel of some sort, provided the background against which the openwork was effectively silhouetted. A gold or gilded background would seem, at first thought, most appropriate, and there are a number of examples of mediaeval openwork ivories mounted in such a fashion. But the fact that the back of the Dumbarton Oaks piece is also carved, if only sketchily, argues against such a metal ground, since the back would then not be seen. This raises the question of whether it might possibly have been laid around an object made of glass. Although we must admit that we do not know of any other instance of ivory openwork used in this manner, one can point to examples in other materials, such as metal and glass, which were.

In the Hermitage in Leningrad, there is a kantharos, found near Tiflis, whose upper part consists of a frieze with hunters, both mounted and on foot, executed in pierced silver and set against a glass of dark violet color (L. Stephani, in *Compte-rendu de la Commission impériale archéologique pour l'année 1872*, St. Petersburg, 1875, pp. 143 f. and *Atlas*, pl. II, 1–2; A. Kisa, *Das Glas im Altertume*, II, Leipzig, 1908, p. 602 and figs. 208 a–b). Another pertinent parallel is a glass in the Treasure of St. Mark's in Venice, which in later times was turned into a situla (*ibid.*, p. 609 and figs. 226–27; F. Neuberg, *Ancient Glass*, Toronto, 1962, pp. 82–83 and fig. 87). It belongs to the category of cut glass known as the *diatreta*, or "cage-cups," and has around its rim a hunting frieze, consisting of two riders and dogs pursuing a panther, executed in *à jour* work, which gives the same silhouette effect as the silver frieze set against glass. It seems more than a coincidence

that both parallels (1) have the same subject matter; (2) have been dated to the same period, that is, within the third century A.D.; and (3) point to the eastern Mediterranean as their place of origin, the kantharos because of its provenance and the glass situla on the basis of its style and technique (Kisa, *op. cit.*, p. 630). Thus it may be suggested that our bone carving is a fragment of a similar luxury object of a kind which was produced during a rather short phase of the late classical period in the eastern Mediterranean.

All that is left of what probably was a frieze of some length is a youthful hunter, dressed in a tunic, chlamys, and boots, who rides a galloping horse and spears an attacking wild beast. The remaining part of the animal's head is not large enough to determine its species, though, judging from the snout, a boar seems more likely than a lion or bear. The motif of a dog attacking a wild beast is a common feature in hunting scenes, especially on the numerous hunting sarcophagi which attained great popularity in the third century A.D. (cf. G. Rodenwaldt, "Zur Kunstgeschichte der Jahre 220 bis 270," *Jahrbuch des Deutschen Archäologischen Instituts*, 51, 1936, pp. 82 ff. and pls. 3–4). While iconographically close to the hunting sarcophagi, the slightly chunky style of the rider and horse of the Dumbarton Oaks piece suggests a slightly later date, probably in the fourth century. Its alleged provenance from Istanbul strengthens the likelihood of an east Mediterranean origin.

Said to have been found in Istanbul.

D.O.H., 1967, no. 269.

5. Sculptural Group
 Criophore (Orpheus as Good Shepherd)
 Egypt (?), third to fourth century
 Criophore: Height 7.8 cm. Width 6 cm. Thickness 3 cm.
 Lamb: Height 4.8 cm. Width 4 cm. Thickness 1.6 cm.
 Acc. no. 45.3 PLATE IV

This group of a shepherd carrying a ram on his shoulders, originally flanked by two lambs at his feet, is both fragmentary and in extremely poor condition. The lower legs of the shepherd are lost, as is the broad plinth on which the shepherd and the two lambs stood (cf. a similar criophore group in the Liverpool Museum [PL. V, figs. 5, 6, 7], *Burlington Fine Arts Club. Catalogue of an Exhibition of Carvings in Ivory*, London, 1923, p. 38, no. 3, and pl. I; A. Legner, *Der gute Hirte*, Düsseldorf, 1959, p. 15 and fig. 6). The lamb on the lower left has been lost, while that on the right is detached; the shepherd's left arm and the front legs of the ram which he held with his left hand have broken away. In addition, most of the tree against which he was leaning has been lost, although traces of the trunk remain along his back. The piece is split in many different parts which have been carefully glued together; the forepart and hindpart of the ram were each consolidated from three broken pieces. Brown rust stains in the shepherd's left thigh indicate that a repair was once attempted with iron nails.

The surviving lamb, which has ram's horns, has been just as badly damaged and is today glued together from at least three different parts. Evidently only the left side of the animal was intended to be seen, since it alone was carved with the design of the fleece. The lamb must have been placed at the lower right of the composition, with its smooth, slightly concave right side attached to the standing shepherd. In the hindquarters part of an iron nail remains, apparently corresponding to the repair in the shepherd's thigh mentioned above. This fastening, however, stems from a repair and, in my opinion, places the figures in an incorrect relationship. In the present mounting (not shown here), the lamb is placed too low—in the Liverpool piece its head reaches the hip of the shepherd— and it must also have stood more to the side, thus flanking the shepherd, rather than in front of him.

The entire surface of both parts is corroded, splintered, and rubbed to such an extent that a discussion of the style is possible only by comparison with the better preserved group in Liverpool. Two large holes are drilled through the body of the shepherd, apparently for its fastening with ivory pegs to a wooden ground. A hole of lesser diameter is drilled in the forepart of the lamb and may have been destined for a peg which attached it to the shepherd, while smaller holes in the hindquarters seem to be associated with the later mounting using iron nails.

The lamb-bearer or criophore had a long tradition in ancient art as a motif in bucolic genre subjects, but in the Greco-Roman period it assumed a symbolic meaning as a personification of Philanthropia (Th. Klauser, "Studien zur Entstehungsgeschichte der christlichen Kunst," *J.A.C.*, 3, 1960, pp. 112 ff.; 5, 1962, pp. 113 ff.; 7, 1964, pp. 67 ff.; 8-9, 1965-66, pp. 126 ff.; 10, 1967, pp. 82 ff.). This interpretation prepared the way for its adaptation as an illustration of the parable of the Good Shepherd (John X:14). Yet what immediately distinguishes our shepherd from all others in marble or in catacomb frescoes is the fact that he wears a Phrygian cap, which of course is the most characteristic attribute of Orpheus. More important, this is not an isolated case—we have mentioned above the group in the Liverpool Museum, and there is another such group in the Abegg Stiftung, Riggisberg (PL. V, figs. 8, 9, 10, published here with the kind permission of the Abegg Stiftung). In all three of them, he wears, in addition to the Phrygian cap, a sleeved tunic, not the *exomis* which occurs more frequently, though not exclusively, in the marble groups. Moreover, in both the Dumbarton Oaks and the Liverpool ivories the tunic is carefully pleated and embroidered along the hem, thereby giving the figure a higher status than that of an ordinary shepherd. Across his chest is slung a pouch, a familiar attribute in several of the marble figures.

The fusion of Orpheus and Christ has long been known in Roman catacomb painting. J. Wilpert quoted five examples (*Le pitture delle catacombe romane*, Rome, 1905, pp. 36 and 222 and pls. 37, 55 [lost], 98 [not reproduced], and 229), and well-known passages of Clement of Alexandria have often been cited to explain the parallelism between Orpheus and Christ, the *tertium comparationis* being the soothing of wild passions. But in all these instances, it was the classical image of the lyre-playing, seated Orpheus which had been chosen as a model for the Christians. Yet, the association of Orpheus with the Good Shepherd is not entirely without parallel. There is a mosaic in a Christian cult room at Aquileia which represents the lamb-bearer, and although he does not wear a Phrygian

cap as in our ivories, his association with wild animals in addition to the lamb suggests the fusion of Orphic and Christian cult images (R. Eisler, "Orphisch-Dionysische Mysterien-gedanken in der christlichen Antike," *Vorträge der Bibliothek Warburg*, 1922–23, Pt. II, Leipzig, 1925, p. 15 and fig. 10). Even before the Christians, the Jews had adapted the lyre-playing Orpheus as the model for King David as a shepherd and continued it for several centuries. Among the examples are a fresco in the Jewish catacomb of the Vigna Randanini in Rome (*ibid.*, pp. 33 ff. and figs. 2–3), a fresco in the synagogue of Dura (C. Kraeling, *The Synagogue. The Excavations of Dura-Europas*, Final Report, VIII, Pt. I, New Haven, 1956, pp. 220 ff. and fig. 59), and a mosaic recently discovered at Gaza (H. Stern, "Un nouvel Orphée-David dans une mosaïque du IIe siècle," *Comptes rendus de l'Académie des Inscriptions et Belles Lettres*, July 1970, pp. 63 ff.). Yet, outside the context of a cult room, a church, or a catacomb, one cannot always be certain whether the lamb-bearer has a pagan or a Christian connotation. In the case of another ivory criophore at Dumbarton Oaks (No. 3), I left the question undecided, but in the present instance I feel more confident that the figure is a Good Shepherd: in the first place, he is fused with Orpheus, i.e., another cult image; and secondly, he appears no fewer than three times as a fixed iconographical type.

Stylistically the three ivories vary considerably. The Dumbarton Oaks figure and the one in the Abegg Collection share an unusually high degree of three-dimensionality which is most pronounced in the shepherd's head, thrust forward in such a way that the full weight of the heavy lamb is convincingly supported by the neck and shoulders of the bearer. Although in each case the lower legs are missing, the position of the upper thighs indicates that both figures showed a clear distinction between the free and the weight-bearing leg. Moreover, each was a composite group in which two separately carved lambs, standing on the ground, flanked the shepherd on either side. Yet, in spite of all this, the groups were not intended to be truly three-dimensional, that is, to be seen from all sides. The back of the Dumbarton Oaks figure clearly shows traces of a tree against which the figure was leaning and which provided a foliated background. In the case of the Abegg figure, it is not clear whether there was a tree, and so it is possible that this figure was without a background feature. In contrast, the Liverpool figure is standing quite erect with the head projecting very little; there is scarcely any distinction between the weight-bearing and the free leg, and the whole composition with two flanking lambs is carved in one piece and seemingly pressed between two parallel planes. The figure leans against a tree whose branches spread above the shepherd's shoulder and cover the rear of the lamb. This group gives the effect of *à jour* work, though not as delicate as that of the smaller shepherd in this Collection (No. 3).

Within this group of three ivories, we meet the same distinction between freestanding and tree-supported shepherds which is characteristic of the numerous marble figures (Klauser, *op. cit.*, and W. D. Wixom, "Early Christian Sculptures at Cleveland," *Bulletin of the Cleveland Museum of Art*, 54, 1967, pp. 75 ff. and figs. 22–24). In addition, they reflect the same development from a sculptural, three-dimensional figure standing in a relaxed stance to one which becomes more rigid in pose and is forced into the narrow confines of a two-dimensional space. The early phase covers principally the third century, and the marble shepherd of the Cleveland Museum (Wixom, *loc. cit.*) belongs to this

period; the later phase, characterized by the loss of movement and the frequent use of the drill in the treatment of the tunic, includes most of the fourth century. I propose to date our three ivories within these two centuries: the Dumbarton Oaks and the Abegg shepherds probably belong to the third century, while the Liverpool shepherd fits better into the fourth.

The problem of the localization of these three ivory shepherd figures is just as difficult as it is for the comparable marble figures. The latter have been found in practically every eastern Mediterranean country as well as in Rome and Spain (J. Kollwitz, "Die Statue des Guten Hirten im Seminar für christliche Archäologie," *Kunstwerke aus dem Besitz der Albert Ludwig Universität, Freiburg i. Br.*, Berlin, 1957, pp. 7 ff.), and where no provenance is known it is difficult to localize them on the basis of style alone. The Dumbarton Oaks and Abegg ivories present an additional difficulty in their bad state of preservation, which has destroyed the criteria necessary for stylistic analysis, and, in the case of the Dumbarton Oaks figure, has even led to a misjudgment of the style. The facial expression of this figure has a strange affinity to ancient oriental, chiefly Mesopotamian, sculpture, but, contrary to some suggestions, it could not have been carved in the ancient Near East. Our figure is said to have been acquired in Egypt, as was the Liverpool group, reportedly found on the banks of the Nile. Nothing seems to contradict an Egyptian origin for our group of Orpheus-Good Shepherds. In fact, one may find support for an Egyptian origin in a strange parallel. A sixth-century Egyptian ivory pyxis in London (PL. IV, fig. 4), showing Daniel in the lion's den (O. M. Dalton, *Catalogue of the Ivory Carvings of the Christian Era*, London, 1909, p. 11, no. 13 and pl. VIII), has a lamb placed between an angel and Habakkuk. This lamb is completely out of context, although its proximity to a tree suggests that ultimately it was derived from a scene of the Sacrifice of Isaac. However, its scale is much too large for any scenic connection with the pyxis, and it has a three-dimensional quality completely different in style from the carving on the rest of the pyxis. I should like to suggest that it was copied from a freestanding lamb such as one of those which flank the Good Shepherd. The strength of this possibility would indicate that at the time the pyxis was made Good Shepherd groups like ours were well known in Egypt.

D.O.H., 1955, no. 228. *D.O.H.*, 1967, no. 271.

6. Incised Plaque from a Casket. Bone
Hermaphrodite
Egypt, about fourth century
Height 7.9 cm. Width 5.6 cm.
Acc. no. 45.5 PLATE VII

Both of the lower corners of the plaque have been broken away and there is some damage to the figure of the hermaphrodite around the navel, but otherwise, except for the loss of most of the colored wax, the plaque is well-preserved. Incised plaques such as

this were used in combination with those carved in relief as the decoration of wooden caskets. One in the Walters Art Gallery in Baltimore is preserved almost intact (*Early Christian and Byzantine Art*, no. 181 and pl. XVIII). It is decorated with plaques carved both in intaglio and in relief with figures drawn from Dionysiac sources. The tapering shape of our plaque suggests that it was located on a truncated lid, and, since it has no holes, one must assume that it was inserted in a sunken field.

Incised in the plaque is the nude figure of a hermaphrodite, leaning on a columnar pedestal and holding his right arm over his head. His mantle, which is held between his knees and covers one leg, is taken up by his right arm and billows out like a veil. In his left hand he holds what appears to be a flowering branch. Appearing from behind him is a panther, an element drawn from the Dionysiac realm which allows one to suggest that the lost plaques of this casket depicted maenads and satyrs, and perhaps Dionysos himself, and that the casket resembled both in form and iconography the one in Baltimore.

The fluent lines of the figure, incised with clarity and assurance, were once filled with black wax, while the broad areas of drapery were filled solidly with red wax, faint traces of which are still recognizable. The ground of the drapery has been roughened so that these large areas of colored wax would adhere securely; nevertheless, most of it has flaked off. The Baltimore casket provides a rare example in which the colors are still well preserved; here the predominant colors are red and green—red for most of the drapery and green for the patches of grass which are used as spacefillers. We may assume the same color scheme for our plaque, with green used for the branch as well as for the grass.

These incised plaques were fashionable in Egypt for a rather limited period, and every major museum has some examples, usually dated in the third and fourth centuries. While Bacchic figures are common, the hermaphrodite is somewhat rare. There is, however, a fragment of a hermaphrodite in a similar pose and the same incised technique, and with the mantle originally filled with colored wax, in the museum in Berlin (Wulff, *Altchristliche Bildwerke*, no. 341 and pl. XIV).

Gift of John S. Newberry, Jr.

D.O.H., 1955, no. 222. *D.O.H.*, 1967, no. 267.

7. Ivory and Bronze Knife Handle
 Dionysos (?)
 Fourth century
 Knife: Height 10.7 cm. Width (including blade) 7.8 cm.
 Ivory Handle: Height 9.5 cm. Width 4.5 cm. Thickness 0.9 cm.
 Acc. no. 69.11 PLATE VI

The knife consists of an ivory handle carved in relief, to which a bronze panther is attached by his feet and underbelly at the upper left side, and an iron blade, which is

now broken off. The ivory has been cut for the insertion of the blade, which penetrates to about two-thirds the depth of the handle. The rust of the iron and the corrosion of the bronze have adversely affected the color of the ivory so that it is now stained green from the copper oxide and light brown from the rust. In addition, the whole surface of the ivory is cracked and fissured, making it very brittle.

The ivory part of the handle has the shape of a recessed half-arch, on which is carved a naked youth standing frontally in a relaxed pose, his weight on the left foot. His right arm rests on a knobby tree trunk, while in his left hand he holds a bunch of grapes. He is clad in a short chlamys, fastened on the left shoulder and falling over the top of the tree trunk. At the top of the ivory are the foreparts of a rampant panther whose head is sculptured in the round, repeating the motif of the panther in bronze.

The presence of panther and grapes characterizes the youth as a member of the retinue of Dionysos. The carver may even have had in mind Dionysos himself, although the figure lacks some of the characteristic attributes, like the fillet or vine wreath on his head or the thyrsus, with which he is usually, though not always, represented. The rather heavyset proportions and the slightly fleshy treatment of the figure bring to mind the Dionysos of the large medicine box (No. 9), although the carving lacks the smoothness of the latter. Thus a date in the fourth century would seem likely.

There are three more knife handles in ivory or bone which show a similar decorative design and belong to more or less the same period. The one in the Walters Art Gallery, Baltimore (PL. VII, fig. 11), represents a standing Heracles holding a lion skin over his left arm and leaning on his club. Above him is a very large full-length lion, forming the ridge of the handle. The second, in the Metropolitan Museum, New York (PL. VII, fig. 12), shows a naked Heracles, seated on a rock and holding an enormous club. A basket beside him refers to the Labor of the Augean Stables. On the indented half-arch above, in a position identical to that of the bronze panther in the Dumbarton Oaks piece, is a rearing lioness carved in the round. The third piece, in the collection of George Eumorfopoulos (*Burlington Fine Arts Club. Catalogue of an Exhibition of Carvings in Ivory*, London, 1923, no. 19 and pl. I, there considered to be a product of Hither Asia [?]), represents a lioness devouring a goat, with a panther, smaller in scale, placed along the indented half-arch as on the New York and Dumbarton Oaks handles.

Knives of this type with more modest bone carvings are not uncommon. One with the statuette of a pugilist was found at Mandeure (Doubs) (E. Michon, in *Bulletin archéologique*, 1925, pp. XXVI–XXVII and pl. I), and another one with a simple tree was found at Soissons (M. J. Valois, in *Bulletin de la Société des Antiquaires de France*, 1914, pp. 122–23 with fig.); these indicate that such knives were made in many parts of the Roman Empire.

N. Landau Collection, Paris.
Bliss Collection, 1947 (on loan to Dumbarton Oaks since 1947).
Gift of John S. Thacher, 1969.

D.O.H., 1955, no. 221 and pl. (incorrectly listed as Gift of Mr. and Mrs. Bliss). R. J. Gettens, "The Corrosion Products of Metal Antiquities," *Smithsonian Report for 1963*, Washington, D.C., 1964, pl. 8. *D.O.H.*, 1967, no. 266 and pl.

8. Statuette
Ares (?)
Second half of fourth to fifth century
Height 8.5 cm. Width 4.7 cm. Thickness 1.6 cm.
Acc. no. 38.63 PLATE XI

Although carved on all sides, the figure is rather flat, its movement confined within the limits of two narrow planes; indeed, it is intended to be seen primarily from the front. Both legs have broken off below the knee, and there are small chips off the left shoulder, the left knee, and the crest of the helmet. Except for these losses and slight traces of rubbing, the ivory is in good condition.

The youth is standing in a relaxed pose in which, originally, his raised left leg must have rested on a rock or some similar support. He leans forward with his crossed arms resting casually on his left thigh. The figure is nude except for a short mantle wrapped around his left arm and a plain helmet which was originally crested. Beneath its circular rim, a row of curly locks is visible.

The pose is not unlike that of a marble statue in the Lateran (H. S. Jones, *A Catalogue of the Ancient Sculptures ... of the Museo Capitolino*, Oxford, 1912, p. 288, no. 21 and pl. 70) representing a youth who also has a mantle slung around the left arm, although this figure differs in other respects: the mantle covers his loins, he wears no helmet, and his right arm is raised. According to Jones, this marble statue was once called an athlete, but he calls it an ephebus and mentions Furtwängler's suggestion that it was a Hermes Agoraeus. The same uncertainty prevails in the case of our statuette, which, because of the exaggerated muscular treatment of the body, has also been called an athlete. However, in late classical works from the second half of the fourth through the fifth century, this muscular treatment is used for many male figures and does not necessarily denote an athlete. Incised metal objects typical of this style include a plaque in the British Museum and two situlae, one in the Palazzo Doria Pamphili in Rome and the other in the Archaeological Museum in Madrid (A. Carandini, *La secchia Doria*, Studi miscellanei, Seminario di Archeologia e Storia dell'Arte Greca e Romana dell'Università di Roma, 9, 1963–64, Rome, 1965, pls. V and VII–XXVIII). In order to achieve a vivid, undulating outline, the muscles in these figures are exaggerated. Especially characteristic is the swollen muscle in the hip, so strongly marked in the ivory (cf. the situla in Madrid, *ibid.*, pl. XXVIII). The ivory also shares the fleshy and somewhat brutish face with the figures on the situlae, and, therefore, this feature cannot be considered as evidence that the figure is an athlete. Neither the style nor the iconography would contradict an identification of our figure as a god or hero, and the helmet, in fact, suggests that the figure may represent Ares.

The proximity in style to the incised metal objects mentioned above dates our ivory in the same period, i.e., the second half of the fourth or the fifth century, and justifies its localization in Egypt where, as Carandini has shown, the situlae seem to have originated.

Bliss Collection.

H. Peirce and R. Tyler, *L'Art byzantin*, I, 1932, p. 61 and pl. 76, A and C. M. C. Ross, *Bull. Fogg*, 9, 1941, p. 70. *D.O.H.*, 1955, no. 223 and pl. J. Beckwith, *Coptic Sculpture 300–1300*, London, 1963, p. 11 and fig. 17. *D.O.H.*, 1967, no. 270.

9. Medicine Box
Sides: Dionysos between a Maenad and a Satyr
Lid: Tyche
Egypt, second half of fourth to fifth century

Box: Height 15.2 cm. Width at top 8.9 cm., at bottom 8.1 cm.
 Thickness at top 4.6 cm., at bottom 3.5 cm.
Lid: Height 13.7 cm. Width 6.2 cm. Thickness at top 0.8 cm.
Acc. no. 47.8 PLATES VIII–X
 COLOR PLATE I

The trough-shaped box was originally divided into six compartments by ivory partitions, cut separately and inserted into grooves. These partitions, similar to those in the medicine box with Hygieia (No. 10), are lost today, but their original position is indicated by the grooves (PL. IX, B). The box is closed by a tapered sliding lid with thin projecting ledges on three sides (PL. X, B), which fit into grooves cut in the frame of the box, thus holding the lid in place. Because of their thinness the ledges are extremely fragile, and the one on the right has been broken in two places—at the top, where a piece of the lid proper broke off with it, and close to the bottom. These two breaks were repaired by means of square metal patches set into recesses in the back of the lid. However, the ledges apparently continued to break, and they have been replaced by full-length metal strips, fastened with nails. At the top (PL. IX, A) the lid has a thick, profiled molding with a double volute, typical of most medicine boxes (cf. No. 10), which makes it more easy to slide. Protruding beneath the molding is the tip of a broad metal pin which has been inserted from the back through a conical hole. The purpose of this pin is unclear, since when the lid is closed it is largely hidden by the ivory of the box proper and therefore could not be part of the lock structure. Perhaps at some later time, when the object was no longer used as a box, the lid was mounted separately or suspended from a hook. At the top of the box (PL. X, A) a square sunken field was cut for a lock, now missing, which was attached with nails all around. This area has been severely damaged, with the thin bottom, the side toward the lid, and one lateral side all badly broken. Apparently the lock was fastened by pushing two metal pins into two corresponding holes on the inner side of the lid, which are slightly off center. Two iron loops at the left and right of the lock are for the attachment of a strap (cf. No. 10, where holes for such loops also exist).

The figures on the rounded surface are badly rubbed, with the result that the face of the central figure has been quite disfigured; the faces of the lateral figures are also worn, as are their feet and the tips of the acanthus leaves on which they stand. In addition, a vertical crack extends along the entire length of the left-hand figure. The lid is in a much better state of preservation, a fact which can be explained by the protection provided it by the high relief of the molding at the top. Only the head of the putto, being more exposed, suffered from rubbing. Whereas the ivory of the box proper is a warm, creamy hue, that of the lid has a darker, brownish color, due to the fact that it was less exposed to light (COLOR PLATE I).

The curving side of the box is occupied by three figures who stand on a kind of socle formed by a row of acanthus leaves. In the center stands Dionysos, clothed in a mantle

falling from his left shoulder, slung around his right arm, and enveloping his legs, leaving the upper part of his body exposed. On his head are traces of a wreath of vine leaves which was tied at the back by ribbons, the ends of which appear over his shoulders. He leans on a thyrsus with a pine cone at each end, and with the other hand he holds a kantharos. A panther steps forward from behind Dionysos, eagerly raising its head to lick the wine which spills from the vessel. At his right stands a maenad, holding a thyrsus and dressed in a long, girdled chiton, with a vine wreath in her hair. Behind her head is a tympanon which she holds in her raised left arm, but because of the narrowness of the space, this arm does not appear organically connected with the body. It is quite conceivable, as some scholars have suggested, that this figure is meant to represent Ariadne. At the other side of Dionysos stands a satyr, who wears what seems to be a panther skin knotted around his neck and falling down his back, leaving the upper part of his body exposed. Around his hips he wears what appears to be a fawn skin in the shape of a loincloth. Corresponding to the tympanon of the maenad is the wineskin he carries over his left shoulder, while with his right hand he holds a pedum. Several scholars have proposed that this figure represents Heracles, but the attributes and the soft, fleshy face speak more convincingly in favor of a satyr.

The lid is filled with a female figure who wears a long undergarment covering most of the feet, a slightly shorter girdled tunic over it, and a mantle which falls over the left shoulder and envelops the lower part of the body. With her right hand she holds a rudder and with her left a cornucopia filled with fruit. Her hair falls in curly strands over her shoulders, and she wears the typical crown of Isis, consisting of two feathers rising from a tiny sun disk and flanked by the horns of a cow. In the upper left corner of the lid is a flying Eros, who points with one hand at the rudder and in the other holds a folding mirror. The two figures are placed in front of a *parapetasma*, which is suspended from the upper corners.

This combination of attributes gives the figure a triple connotation. Rudder and cornucopia are the property of Tyche, the Goddess of Good Fortune, who in this case must be the personification of a maritime city; the headgear characterizes her as Isis, while the mirror held by Eros alludes to Aphrodite. The combination of Isis and Aphrodite was particularly popular in Egypt and therefore the Tyche is almost certainly that of the city of Alexandria, as both Beckwith and Wessel have suggested (see bibliog. *infra*).

On the similar medicine boxes in Chur, Sitten (Volbach, *Elfenbeinarbeiten*, nos. 84–85) and Dumbarton Oaks (No. 10), the lid is occupied by the figures of Asclepius, Hygieia, or both; there is no other medicine box with a representation of Fortuna-Tyche. However, this figure does occur, appropriately enough, on a terracotta money box formerly in the collection of Count Caylus and now at the Cabinet des Médailles in Paris (Graeven, see bibliog. *infra*, p. 184 and fig. 29), and here its significance is obvious. This parallel induced Graeven to consider our ivory box also a container for money, and he accordingly interpreted what clearly is a folding mirror as a money bag. Although this interpretation cannot be maintained, the parallel does suggest that the Fortuna-Tyche might be understood as the bringer of "good fortune," be it material aggrandizement or good health. In this context Dionysos would have to be understood as playing a role similar to that of Asclepius.

Stylistically the bodies are well modelled, and the limbs as well as the draperies are convincingly articulated; but what distinguishes the style from either that of contemporary works from other centers or that of earlier classical periods is the tendency to a softness of the forms and a fleshy, sensual treatment of the bodies and faces, with their full, round cheeks and chins. Volbach (*Frühmittelalterliche Elfenbeinarbeiten*, p. 100) quoted as a parallel the diptych with two pairs of lovers in Brescia (*idem, Elfenbeinarbeiten*, no. 66 and pl. 21), but in this case the figures are more slender and muscular, and they do not have the peculiar fleshiness which characterizes the figures of the medicine box. As for the heavyset proportions, Volbach compares the figures on our box with those on the plaque in the Arsenal Library, Paris, showing a Muse between two poets (*ibid.*, no. 71 and pl. 27), but the manner in which the drapery is pressed against the bodies is quite different from the flowing folds of the garments on our box. Volbach assumed for these three ivories an origin in Italy, preferably northern Italy. This is indeed quite likely for the two parallels but, in our opinion, not for the Dumbarton Oaks box. A closer connection is to be found with the figures on the diptych with Helios and Selene in the Cathedral Treasure of Sens (*ibid.*, no. 61 and pl. 17). The face of the reclining Thetis in the Selene plaque and that of the female centaur in the Helios plaque exhibit features such as the full chin, sensuous mouth, and dreamy eyes, which are quite similar to those on our box, and the nude bodies reveal a similar tendency toward undulating, soft forms. In discussing the Sens diptych, Volbach pointed correctly to Egyptian bone carvings as the closest parallels. In my opinion an Egyptian origin is also more than likely for our medicine box. Perhaps the closest stylistic parallel is the statuette of Ares in this Collection (No. 8), with regard both to the fleshy body treatment and to the face with its rounded chin and dreamy upward look, caused by drilling the pupil directly under the upper lid. Therefore, for both iconographic and stylistic reasons, Egypt in general, and Alexandria in particular, is the most likely place of origin.

Attenborough Collection, London.
W. Francis Cook Collection, Richmond Hill, England.

Westwood, *Fictile Ivories*, pp. 10–11, nos. 34–35. A. Michaelis, *Ancient Marbles in Great Britain*, Cambridge, 1882, p. 620, no. 1. H. Graeven, "Die thönerne Sparbüchse im Altertum," *Jahrbuch des Deutschen Archäologischen Instituts*, 16, 1901, pp. 187–88 and fig. 33. Cecil H. Smith and C. Amy Hutton, *Catalogue of the Antiquities ... in the Collection of the Late Wyndham Francis Cook*, London, 1908, pp. 97–98, no. 1 and pl. XXII. *Bull. Fogg*, 10, 1947, figs. 228–29. *Early Christian and Byzantine Art*, Baltimore, 1947, no. 104, pl. XV. K. Weitzmann, "Byzantine Art and Archaeology in America," *A.J.A.*, 51, 1947, p. 403 and pl. CI–CII. Volbach, *Elfenbeinarbeiten*, no. 83 and pl. 27. *Idem*, "Frühmittelalterliche Elfenbeinarbeiten in der Schweiz," *Actes du III Congrès international pour l'étude du haut moyen âge, Lausanne, 1951*, Lausanne, 1954, p. 100 and figs. 42–43. *D.O.H.*, 1955, no. 224 and pl. J. Beckwith, *Coptic Sculpture 300–1300*, London, 1963, pp. 11 and 48 and figs. 19–21. K. Wessel, *Koptische Kunst*, Recklinghausen, 1963, pp. 125–26 and fig. 88. *D.O.H.*, 1967, no. 273 and pl.

10. Medicine Box
 Hygieia
 Egypt, sixth century
 Box: Height 7.5 cm. Width 5.9 cm. Thickness 3.3 cm.
 Lid: Height 6.6 cm. Width 4.5 cm. Thickness (at top) 1 cm.
 Acc. no. 48.15 PLATE X

The box is in the shape of a trough, within which are six compartments meant to contain various medicines. It is closed by a sliding lid which widens slightly at the top, where a thick profiled molding serves as a kind of handle with which the lid is more easily moved. A hole has been cut in the molding to hold the hasp, a hinged metal band which originally connected with a lock at the top of the box proper. The lock is now lost, but a sunken field and four nail holes indicate its placement (PL. X, C). Two larger holes to the left and right of the lock indicate the position of metal loops, now lost, for the attachment of a strap to carry the box (cf. also No. 9). All the holes show traces of green, the stain of oxidized metal. The surface of the lid, especially the face of the figure, is slightly rubbed.

Carved in relief on the sliding lid is a figure of Hygieia, the daughter of Asclepius and the Goddess of Healing. Seated in a frontal position on a throne with a draped back, she holds in her right hand the sacred serpent and in her left a bowl from which the serpent drinks. Medicine boxes of this type with similar subjects on the lid are not uncommon among Egyptian ivory carvings of the late classical period. In the museum of Sitten (Sion), there is a somewhat larger box whose lid is decorated with the standing figures of Hygieia, holding the serpent and bowl, and Asclepius (Volbach, *Elfenbeinarbeiten*, no. 84 and pl. 27). There is a second box, of intermediate size, in the treasure of the cathedral of Chur, the lid of which is decorated with the standing figure of Asclepius. This box was found in a marble casket under the high altar of the cathedral and had apparently been reused as a reliquary (*ibid.*, no. 85 and pl. 27). There is also a large box at Dumbarton Oaks (No. 9) which seems to have served as a container for medicines, although the figural decoration of Dionysos with a maenad and a satyr is iconographically related only indirectly, if at all, to such a function.

In the late classical period, when these boxes were made, pagan subjects began to be replaced by Christian ones, and, significantly, a healing scene was chosen as the decoration appropriate to their function. One such example is the lid of a medicine box in the Museo Sacro of the Vatican, which has as its subject Christ Healing the Blind Man (*ibid.*, no. 138 and pl. 46).

The broad, thickset proportions of the figure, combined with the sure and yet summary treatment of the folds, has its closest parallel in a series of Egyptian pyxides, of which the one in the Berlin Museum (*ibid.*, no. 187 and pl. 57) is the most closely related. These pyxides are dated by Volbach, correctly I believe, in the sixth century, and thus I assume the same date for our box.

D.O.H., 1955, no. 226. J. Beckwith, *Coptic Sculpture 300–1300*, London, 1963, pp. 12 and 49 and fig. 24. *D.O.H.*, 1967, no. 276.

11. Plaque
 Scribe (*notarius*)
 Egypt, second half of fifth century
 Height 9.7 cm. Width 4.9 cm.
 Acc. no. 47.4 PLATE XII

The plaque has a most unusual shape. Although both the upper and lower right corners are broken off, as is a small fragment on the left side with the figure's raised right hand, the remaining sides of the plaque appear to be original. Hence, what at first glance might appear to be breaks, such as the diagonal line which cuts off the edge of the head, the line below the figure's raised arm (most of which is chipped away), and the uneven left side, are, in my opinion, intentional and original cuts. These edges have been slightly roughened just like the reverse, apparently to give the plaque a firmer hold when glued into the sunken field of what was probably a wooden core. Two holes, to the left and right of the neck, and a fragment of a third in the lower right corner point to additional fastening by means of ivory pins. When reconstructed, the shape of the plaque, with a sharp angle containing the figure's lost right hand and another sharp angle where the diagonal meets the right edge, looks quite unbalanced. It is therefore tempting, although still only a hypothesis, to assume a companion plaque of the same shape but in mirror reversal. Since the figure of our plaque leans to the right, that of the postulated companion piece probably leaned to the left. The symmetrical composition created by such a pair of plaques would be broader at the top than at the bottom because of the extended arms and thus would fit a box of triangular shape. This projected shape suggests that the object was a box for writing implements of more or less the same shape as that in the hand of the figure on our ivory. As will be shown below, this figure represents a scribe, a subject as appropriate for a writing box as the figure of Asclepius is for a medicine box.

The youthful person is a court official, wearing a short tunic, a chlamys, decorated with a tablion and fastened with a large fibula over the right shoulder, and the high boots, or *calcei mullei*, worn by the higher civil dignitaries. His office is indicated by the object he holds in his left hand (PL. XII,C), suspended by a strap similar to those which must have been on the large medicine box (No. 9) which, as we have seen, preserved the original metal loops for their attachment. This object is a triangular box for writing implements, quite similar in shape to the one in the left hand of the Evangelist Mark in the Rossano Gospels (PL. LXIX, fig. 41) (A. Muñoz, *Il codice purpureo di Rossano*, Rome, 1907, pl. XV). In this miniature, three pens stick halfway out of the utensil, so the vertical cuts in our ivory should be understood as the spaces separating pens, while the square boss in the lower part of the triangle would be the inkpot. On top of the box are incised the letters NOTA. Since the Greek and Latin alphabets have all four letters in common, it is not clear whether we are dealing with a Greek or Latin inscription, i.e., "notarios" or "notarius." In any case, it does identify the bearer of this object as a court scribe. In the scene of Christ before Pilate in the Rossano Gospels (*ibid.*, pl. XIV), there is a scribe writing on a diptych dressed just like the figure on our ivory in a short tunic, a chlamys with a tablion, and high boots.

As suggested above, there may have been a companion piece, which could have represented another scribe. Pairs of scribes occur in late classical art, like those on the Probianus diptych in Berlin (Volbach, *Elfenbeinarbeiten*, no. 62 and pl. 18), where they flank Probianus, the vicar of the city of Rome, and turn slightly toward him. On the other hand, since our scribe is depicted in the act not of writing, but, as the raised arm indicates, of hailing or acclaiming someone, the other plaque, if indeed there was one, may have represented a high official in whose service the scribe or *notarius* was employed.

The flatness of the relief, the thickset proportions of the figure, and the straight outlines speak for an Egyptian origin, since these stylistic features predominate in a group of sixth-century ivory pyxides which can be ascribed with certainty to Egyptian workshops (Volbach, *op. cit.*, nos. 190–97). But the handling of the drapery is softer in our ivory than in these pyxides, and thus we are inclined to date our piece somewhat earlier, probably in the second half of the fifth century.

Bull. Fogg, 10, 1947, fig. p. 227. Volbach, *Elfenbeinarbeiten*, no. 260 and pl. 68. *D.O.H.*, 1955, no. 225. *D.O.H.*, 1967, no. 275.

12. Furniture Appliqué. Bone
Dancing Maenad (fragment)
Egypt or Syria, fourth to fifth century
Height 13.5 cm. Width 3.3 cm.
Acc. no. 38.82 PLATE XII

The tall, narrow plaque is sketchily carved in low relief with the slender figure of a maenad. The upper part, including her head, shoulders, and raised right arm, is broken away, as is a small piece at the left side at the height of the knee. The sharp-edged cutting of the body's contour and the sketchiness of the lines of the garment, coupled with the fact that the ground has not been uniformly cut away, suggest that the piece is unfinished.

The dancing maenad is shown turning to our right, her right leg crossing in front of her left. A veil-like mantle falls behind her and seems to have been caught between her legs. The narrowness of the plaque did not leave much space for the arms; the left one may have been pressed against the thigh, a common gesture in such carvings (cf. the plaque in the Berlin Museum, Wulff, *Altchristliche Bildwerke*, pl. XVI, no. 382), while the missing right arm was probably raised over the head, holding the end of the mantle (*ibid.*, pl. XVI, no. 373).

The proportions of the figure, in contrast to the majority of carvings of this kind, are unusually slender and may have been determined by the piece of furniture to which the plaque was attached. There do exist, however, a few narrow strips of bone carved with figures of similar proportions, such as that with two youths in the Berlin Museum (*ibid.*, pl. XVII, no. 389), and another in Cairo (J. Strzygowski, *Koptische Kunst. Catalogue général des antiquités égyptiennes du musée du Caire*, Vienna, 1904, p. 183, no. 7089 and fig. 237). Strzygowski dated the Cairo piece second to third century, while Wulff dated

the Berlin piece third to fourth century. Lack of stylistic distinction makes it difficult to be more precise, but a date as late as the fifth century should not be excluded as a possibility for our piece.

The Dumbarton Oaks carving was found during the excavations of 1938 at Antioch in a burned stratum of a Roman building (section 14-R), together with sherds and lamps ranging in date from the second through the fifth or sixth centuries. This provenance does not, however, prove that the piece was made in Syria. It could have been an import from Egypt, where undoubtedly the great majority of such bone carvings were made, although its unfinished state would indeed favor a Syrian origin.

Found in the excavation of Antioch, Syria in 1938 (b-53-B225).
Bliss Collection, 1938.

D.O.H., 1955, no. 246. *D.O.H.*, 1967, no. 274 (where the accession number is incorrectly given as 39.20).

13. Pin Head. Bone
 Woman's head
 Egypt, about fourth century
 Height 4 cm. Width 1.7 cm.
 Acc. no. 39.30 PLATE XIII

This crowned female head, carved in bone, once formed the terminal of a hairpin, but the pin proper has been broken off. In addition, the left horn of the crown is lost and the head has split vertically, the two parts now being glued together.

The slender face is topped by a high coiffure with the hair rendered in a reticulate pattern which has parallels among the Greco-Roman terracottas of Egypt (E. Breccia, *Terrecotte figurate greche e greco-egizie del museo di Alessandria*, II, Bergamo, 1934, p. 46, no. 271 and pl. LXII, 316). At the back, the hair is tied in a low chignon, then swept upward so that it provides support for the headgear. Seen from the front, this headgear consists of a huge diadem-like disk surmounted by two feathers and flanked by the horns of a cow. This is the typical crown of Isis, which in the Greco-Roman art of Egypt is also often worn by Aphrodite, as may be seen in a number of Egyptian terracottas of this period (cf. Breccia, *op. cit.*, I, 1930, p. 52, no. 235 and pl. XXIV, nos. 1, 2, and 4). This suggests that the hairpin belonged either to a priestess of Isis or to an adherent of the Isis cult.

Gift of Marvin C. Ross.
Bliss Collection, 1939.

D.O.H., 1955, no. 247.

14. Pin Head. Bone
Woman's Head
Egypt, about fourth century
Height 2 cm. Width 1.5 cm.
Acc. no. 47.1 PLATE XIII

This female head, carved in bone, is the terminal of a hairpin, but the pin proper has been lost.

Like the pin head No. 13, the head has a very high, wig-like coiffure whose stylized design consists of concentric lines crossed by radiating lines. Parallels for the coiffure may be found among the Greco-Roman terracottas of Egypt (cf. E. Breccia, *Terrecotte figurate greche e greco-egizie del museo di Alessandria*, II, Bergamo, 1934, p. 45, nos. 262 and 268, pls. LXI, no. 306 and LXII, no. 313). At the back of the head, the hair, which is parted in the center, is swept up from a chignon at the nape of the neck and thus supports the high coiffure of the front.

Similar pin heads in bone in the form of stylized heads are in the museum in Berlin, dated by Wulff in the fourth century (Wulff, *Altchristliche Bildwerke*, pl. XXI, nos. 454–57).

Said to have been found at Tipasa, Algeria.
Gift of Madame Henri Bonnet.

D.O.H., 1955, no. 248.

15. Hairpin. Bone
Aphrodite
Egypt, fourth century or later
Height 7.5 cm. Width 0.6 cm.
Acc. no. 48.4 PLATE XIII

This well-preserved hairpin terminates in the standing figure of Aphrodite. The Aphrodite Pudica, in which the goddess is shown covering her nakedness with both hands, is a type widely known in classical antiquity. But deviating from the Praxitelean type, the goddess on our pin covers her legs with a garment—a variant frequent in the Greco-Roman period. Other types of Aphrodite were used as the decoration of hairpins, such as the Aphrodite Anadyomene on a pin in the Berlin museum who takes up her hair with both hands (Wulff, *Altchristliche Bildwerke*, pl. XXI, no. 453). In both instances the style is extremely rough and sketchy, thus precluding a precise date. For the Berlin pin Wulff proposed a date in the third to fourth century, and it is likely that ours is slightly later.

D.O.H., 1955, no. 249.

16. Plaque from a Casket or Chest (?). Bone
Hunting Scene
Egypt, fifth to sixth century
Height 5.7 cm. Width 10.3 cm.
Acc. no. 58.5

PLATE XIII

The semicircular bone plaque is incised with the figure of a hunter in pursuit of a stag. It has three breaks: horizontally across the hunter's chest, vertically along the neck of the stag, and diagonally from the hunter's left elbow to the back of the stag. An area below the antlers of the stag, including its left front leg, has been lost and replaced by plaster.

This plaque was shown in the Baltimore exhibition in 1947 along with another semicircular plaque depicting a lion hunt, which is carved in the same technique (*Early Christian and Byzantine Art*, nos. 196 and 197 and pl. XIX). The sizes differ and the styles, though contemporary, reveal different hands; yet the parallels between them suggest that such hunting scenes on semicircular plaques were quite common. Other sets of the same form and technique represent the Seasons. A fragmentary plaque with a bust of Spring was exhibited in Baltimore with the two hunting plaques (*ibid.*, pl. XIX, no. 193), while a well-preserved example with the same motif is in the Benaki Museum in Athens (unpublished). Such plaques must have decorated the lunettes of an arcade whose intercolumnar spaces were filled with rectangular plaques. A toilet box, also in the Baltimore exhibition (*ibid.*, pl. XVIII, no. 181), illustrates this type of decoration, although it uses triangular pediments instead of lunettes. However, there is a huge chest in the Cairo Museum, found in a Nubian royal tomb (W. B. Emery, *The Royal Tombs of Ballana and Qustul, Missions archéologiques de Nubie, 1929-1934*, Cairo, 1938, I, pp. 383-84, no. 881 and II, pl. 109), which has three rows of incised bone plaques under separate aediculae, and in two rows the aediculae are crowned by lunettes as well as pediments. Although in this case the gables and lunettes do not enclose bone carvings, in less provincial and more ambitious chests of this type these areas probably were filled with incised plaques such as ours. The chest from Qustul is important because it is the only one with an exceedingly rich decoration of incised bone carvings to have survived.

The bareheaded hunter is dressed in a short tunic with long sleeves, decorated with the circular patches, or *segmenta*, which are typical in late classical art from about the fourth to the sixth century. He wears boots and holds an oval shield with a double strap in his outstretched left arm. While normally a shield would have only one such strap, our plaque is not the only example with two. On a bronze situla with incised decoration in the Archaeological Museum in Madrid, dated in the fifth century, there is a lion hunter protecting himself with a shield very much like this one (A. Carandini, *La secchia Doria*, Studi miscellanei, Seminario di Archeologia e Storia dell'Arte Greca e Romana dell'Università di Roma, 9, 1963-64, Rome, 1965, pp. 26 ff., fig. B, and pl. XXVI, fig. 35). With his lance lowered, our hunter strides to the right in pursuit of the fleeing stag.

Both hunter and hunted are designed in a sketchy, vivid manner, and their slender proportions add to the impression of great agility. The indication of a spatial setting is remarkable; a few lines suggest undulating ground and sparse bushes. Such reflections

of a painted model are rather rare in these incised bone carvings, at least in this naturalistic form. It is more usual to find the background filled with flowers and tufts of grass as, for example, in the toilet box mentioned above.

All areas with a rough striation were originally filled with colored wax, i.e., the flesh areas, the boots, the ornaments on the tunic, and the inside of the shield. From the evidence of other incised plaques, the colors were more or less limited to red, green, and gold. Moreover, they were applied not only to the roughened areas but were used also in the incised outlines.

A precise chronology for this kind of incised plaque has not yet been established.

Early Christian and Byzantine Art, Baltimore, 1947, p. 56, no. 197 and pl. XIX.
 D.O.H., 1967, no. 268.

17. Consular Diptych of Philoxenus
 Inscriptions and Ornament
 Constantinople (?), A.D. 525
 Each leaf, Height 33.3 cm. Width 12.5 cm. Thickness 0.9 cm.
 Acc. no. 35.4 PLATES XIV, XV

Originally the two leaves of the diptych were held together by a hinge, consisting of a metal pin, now lost, which was in turn held in place by six metal loops, three on either plaque. A groove for the pin is cut along the inner edges for more than half their length, and there are deep cuts in the ivory for the loops, which were fastened with nails. On one plaque of the diptych these bronze nails are still preserved, but on the other they are lost. Graeven (see bibliog. *infra*) believes they are antique, while Delbrueck (see bibliog. *infra*) considers them mediaeval. The cut for the lower loop on the reverse may be responsible for the loss of the lower right corner, where half of an inscription roundel is missing. Above and below this roundel there are holes for nails used to fasten horizontal metal bands which held the broken corner in place. A slight indentation in the middle of each outer edge was made for some device, either in metal (similar to lashes in a manuscript) or a simple cord, to hold the diptych closed. The obverse has a crack through the upper right inscription roundel. Both plaques have holes at regular intervals all around the profiled frame which point to a different use at a later period, when the diptych was probably mounted on a wooden core; some smaller holes in the trilobed endings of the lozenges may have served the same purpose. Since the diptych was a writing tablet, there is in the back of each leaf a sunken field to be filled with wax. It is known that diptych plaques were often used in the Middle Ages as covers for books, with parchment sheets cut to fit the oblong format of the ivories. Contrary to Delbrueck's statement (see bibliography), there are no traces of color visible, but the plaques have a pleasing creamy hue, and on the whole are in good condition.

The decoration of the two leaves is identical and is carved with simplicity and clarity. A frame with a simple molding between thin staffs encloses a lozenge, bordered by a

grooved profile. At the top and bottom the lozenge ends in a palmette lotus, its stem encircled by a laurel wreath with an incised oval in the center. The acute angles of the lozenge enclose vine leaves whose forked stems connect with its border. The centers are occupied by octagonal tablets framed by borders of lotus palmettes and containing a Latin inscription in incised majuscule letters. On the obverse (PL. XIV, B) of the diptych it reads: FL(avius) THEODO(rus) / FILOXENVS / SOTERICVS / FILOXENVS / VIR ILL(ustris); it continues on the reverse (PL. XIV, A): COM(es) DOM(esticorum) / EX MAGISTR(o) (Militum) / PER THRACIA(m) / ET CONSVL / ORDIN(arius) (Flavius Theodorus Filoxenus, son of Sotericus Filoxenus, with the rank of *illustris*, domestic count, formerly master in Thrace, and ordinary consul). Four circles in the spandrels, marked by a simple molding, bear a dedicatory inscription, also written in incised majuscules, but this time in Greek. Composed in trimeters, it begins on the obverse: TⲰ CⲈ/MNV/NONTI / TOIC // TPO/ΠOIC / THN A/ΞIAN and continues on the reverse: VΠA/TOC / VΠAP/XⲰN // ΠPOC/ΦⲈPⲰ / ΦI(λο)/ΞⲈN(ος) (While holding office as consul, I, Philoxenus, offer this gift to one who takes pride in his way of life).

Philoxenus, whose name is given with all his titles, was consul of East Rome in the year A.D. 525. Diptychs of this kind were presented by newly appointed consuls as gifts to senators, high-ranking officials, or friends. There is another diptych of Philoxenus in the Cabinet des Médailles in Paris with precisely the same decoration (Delbrueck, no. 31), except that name and title in the octagonal tablet were written in color, of which traces are left, while the roundels with the dedicatory inscription are lacking altogether. This proves the serial manufacture of such diptychs. A third diptych of Philoxenus, also in the Cabinet des Médailles (Delbrueck, no. 29), is more sumptuously decorated with the bust of the consul and the bust of a female personification, perhaps that of the city of Constantinople (so Delbrueck, p. 145). Whereas this diptych, as the inscription indicates, was made for a member of the Senate, the other two, which are less elaborate, were probably made for lower officials or friends.

Trivulzio Collection, Milan.
Bliss Collection, 1935.

Corpus Inscriptionum Latinarum, V, no. 8120, 4. H. Dessau, *Inscriptiones Latinae Selectae*, I, no. 1308. Westwood, *Fictile Ivories*, pp. 364–65. W. Meyer, *Zwei antike Elfenbeintafeln der K. Staats-Bibliothek in München, Festgabe zum fünfzigjährigen Jubiläum des Deutschen Arch. Inst. in Rom*, Munich, 1879, p. 71, no. 27. H. Graeven, "Entstellte Consular-diptychen," *Römische Mitteilungen*, 7, 1892, pp. 206–8 and fig. E. Molinier, *Histoire générale des arts appliqués à l'industrie*, I, *Ivoires*, Paris, 1896, pp. 30–31, no. 30. L. von Sybel, *Christliche Antike*, II, Marburg, 1909, p. 234. Goldschmidt, I, pp. 78–79 and fig. 35. O. M. Dalton, *East Christian Art*, Oxford, 1925, p. 211. R. Delbrueck, *Die Consular-diptychen und verwandte Denkmäler*, Berlin-Leipzig, 1929, I, pp. 146–47, no. 30 and II, pl. 30. *Art of the Dark Ages*, Worcester Art Museum, 1937, no. 58 and fig. 58. C. R. Morey, in *The Art News*, Feb. 20, 1937, p. 15 and fig. p. 14. *Bull. Fogg*, 10, 1945, p. 108 and fig. p. 111. D.O.H., 1955, no. 229. *The History of Bookbinding. An Exhibition Held at the Baltimore Museum of Art*, Baltimore, 1957, pp. 1–2, pl. 1. D.O.H., 1967, no. 278.

EARLY CHRISTIAN IVORIES

18. Pyxis
 Moses Receiving the Law and Daniel in the Lions' Den
 Syro-Palestinian (?), end of fifth to sixth century
 Height (without lid) 8.4 cm. Diameter 11.5 cm.
 Acc. no. 36.22

PLATES XVI, XVII
COLOR PLATE 2

The condition of the pyxis is generally good, except that it is split cleanly in two almost equal halves. The breaks are quite old and were undoubtedly caused by the ill-fitting wooden bottom, which is surely a replacement of the original ivory one. Several holes around the base indicate that the bottom was at one time reinforced by metal bands. When the pyxis was restored in 1937, the wooden bottom was trimmed and fastened with wax to prevent further expansion of the cracks. Earlier repairs were removed, and the small holes made in a former restoration in order to tie the ivory together (visible in the photographs first published by Venturi) were closed with wax.

The present wooden lid (PL. XVII, B) is also a replacement, added in the Middle Ages, to judge from the metal hinges. The original lid was certainly made of ivory and must have had a rim around its edge which rested on the narrow ledge around the top of the pyxis, like those on the pyxides retaining their original lids (cf. Volbach, *Elfenbeinarbeiten*, nos. 164, 166, and 178). When it was replaced, the lid was turned around and the back hinge nailed to the square panel which originally held the lock. On what is now the front, two sets of holes, in the left wing and right shoulder of the angel on Daniel's left, mark the original placement of the metal bands of the back hinges (cf., *ibid.*, those on nos. 166 and 176).

Traces of polychromy remain on the lid, blue on top and red on the side. Since the same colors are used on the pyxis proper—blue for the garment of the angel on the right and red for the background (COLOR PLATE 2), the polychromy probably dates only from the Middle Ages when the wooden lid was added. There is no evidence that Early Christian pyxides were painted at the time of their manufacture, and, if I am not mistaken, this pyxis is the only one with such traces of color.

Two Old Testament scenes decorate the surface: Moses Receiving the Law and Daniel in the Lions' Den. The scene of Moses on Sinai is depicted in a compact and highly dramatic composition (PL. XVI, A, B). Moses energetically strides forward, his arms outstretched to receive the Law, in a pose skillfully suggesting his steep ascent of the mountain. The artist has sucessfully compressed his model, which must have had a taller format allowing a fuller development of the ascending movement, into the rather limited height of the pyxis. With his raised hands veiled by his mantle, Moses receives the Law

31

from the Hand of God issuing from a small segment of the sky. Contrary to the biblical text, the Law is shown not in the shape of a pair of tablets but in that of a scroll. Though not a common representation in Early Christian iconography, it is not unique, and among other examples where the scroll was used in place of the tablet is the sixth-century mosaic of this subject in the monastery of St. Catherine at Sinai (cf. K. Weitzmann, "The Mosaic in St. Catherine's Monastery on Mount Sinai," *Proceedings of the American Philosophical Society*, 110, 1966, p. 400 and fig. 14; H. Schlunk, "Sarkophage aus christlichen Nekropolen in Karthago und Tarragona," *Madrider Mitteilungen*, 8, 1967, pp. 244 ff., who cites five other examples).

As mentioned above, the use of the scroll contradicts the biblical text, which specifically speaks of two tablets. The explanation for this change may be sought in the influence of a Jewish literary—and perhaps even pictorial—tradition, in which the Laws of Moses are associated with the Torah scroll. According to some Jewish writings, Moses received on Sinai not only the Decalogue but the entire Pentateuch, i.e., the whole body of scripture contained in the Torah scroll, the latter being written in tiny script between the text of the Ten Commandments. Equally pertinent is the text of a Jewish legend which resolves the contradiction between tablet and scroll by the following statement: "It is another of the attributes of the tablets that although they are fashioned out of the hardest stone, they can still be rolled up like a scroll" (L. Ginzberg, *The Legends of the Jews*, 1947, III, p. 119 and VI, p. 49, note 259).

Watching the awe-inspiring spectacle are three youthful Israelites (PL. XVI, B). Two stand quietly in the background, each holding a staff in his veiled left hand, his right hand raised in the classical gesture of astonishment. In contrast to their calm poses, the third has dramatically thrown himself to the ground and, in a theatrical gesture, flings his right arm over his head. It is likely that his gesture was intended as a shield against the brilliant light emanating from the Godhead, which is described as a "devouring fire on the top of the mount in the eyes of the children of Israel" (Exod. XXIV:17).

Whereas catacomb frescoes and sarcophagi usually depict Moses on Sinai with few if any onlookers, our pyxis and a contemporary one in the Hermitage in Leningrad (PL. XVII, fig. 13) (Volbach, *op. cit.*, no. 190 and pl. 57) are among the earliest monuments which illustrate the event in a narrative manner. But despite a number of iconographical similarities, the latter is not derived from the same archetype, since Moses is shown averting his face from the Godhead and receiving the Law in the conventional form of a tablet. Yet the Leningrad pyxis has the same two onlookers standing in the background with hands raised. One, however, is a young, beardless man without an attribute, while the second, flanked by two younger figures, is an older, bearded man holding a staff (PL. XVII, fig. 14). The standing onlookers can be identified as Joshua, who followed Moses up to the mountain, and Aaron with his rod (Exod. XXIV:9 and 13). Unfortunately, it is not possible to identify the corresponding figures on our pyxis as Joshua and Aaron, since both are youthful and each holds a staff, which is meaningful only for Aaron. In a previous discussion of the pyxis (K. Weitzmann, *D.O.P.*, 14, 1960, p. 60), I pointed out that the staffs are decorated with an incised spiral pattern which in the classical theater typifies the scepter held by a king (cf. the fragment of a Roman sarcophagus in the Louvre, *ibid.*, fig. 31). The choice of a royal figure as the model for the onlooking

Israelites is not an inappropriate one, for, according to certain Jewish legends, when Moses went up the mountain "the kings of the earth trembled in their palaces" (Ginzberg, *op. cit.*, III, p. 91 and VI, p. 35, note 198). The combination of Jewish and classical sources is in no way contradictory, because any Jewish pictorialization of a biblical scene would be just as dependent as a Christian one on a classical model.

The two youthful persons flanking Aaron on the Leningrad pyxis can be identified as Nadab and Abihu (Exod. XXIV:9), but there is no reason to assume that the ecstatic youth on our pyxis, for whom there is no parallel among the many representations of this scene, could be identified by either name. If, however, we are correct in believing that the two standing onlookers were derived from a classical theater scene, one might also suggest the same source for this third figure. Previously (*D.O.P.*, 14, 1960, p. 60), I suggested that an illustration of Odysseus feigning madness, from the prologue of Euripides' *Palamedes*, may have been the model, although admittedly this is only one of several possibilities. But, whatever the source, one would have to raise the question of why this highly emotional figure was introduced into the Moses scene in the first place. Again, I would suggest that a phrase in a Jewish legend, "Flashes of lightning ... moved the people with mighty fear and trembling" (Ginzberg, *op. cit.*, III, p. 91 and VI, p. 35, note 198), might best explain the frenzied behavior of the Israelite on the ground.

The story of Daniel in the Lions' Den occupies the major area of the pyxis (PL. XVI, C, D; PL. XVII, A). Dressed simply in a short tunic and without the familiar *lacerna* or cloak, but wearing the Phrygian cap, the prophet is depicted as an orant thrusting out his arms. He is flanked by towers, architectural devices that suggest the den, and by two lions which, in an unusual pose, turn around to roar at him. They in turn are flanked by two angels; the one at the left merely touches the lion's head, while the one at the right holds his hand over the animal's mouth, thus literally illustrating the text, "My God hath sent his angel, and hath shut the lions' mouths, that they have not hurt me" (Dan. VI:22). The addition of a second angel must be understood as an artistic convention necessary to achieve a symmetrical composition. The only parallel yet found for this literal illustration of the protective action of an angel is on another ivory pyxis, found at Nocera Umbra and now in the Museo dell'Alto Medioevo in Rome (formerly in the Museo delle Terme) (Volbach, *op. cit.*, no. 164 and pl. 53). The rarity of this feature is easily explained by the fact that the more frequent source of the Daniel story is the apocryphal fourteenth chapter of the Book of Daniel, in which the story is told a second time in combination with that of the prophet Habakkuk who is lifted up by an angel and brings food to the imprisoned Daniel (Dan. XIV:33). The latter version appears on another ivory pyxis in the British Museum, London (Volbach, *op. cit.*, no. 167).

To the right of this scene is an idol in the conventional form of a nude god or hero, leaning on his lance and standing on a high spiral column around which a huge serpent is coiled (PL. XVII, A). In connection with the Daniel story, the idol and the serpent may be identified as Bel and the Dragon (Dan. XIV:1–27). Apparently lack of space forced the ivory carver to combine in this condensed form what would normally have been two scenes. In the model these two figures were in all likelihood part of two separate narrative scenes that represented the Destruction of Bel and the Slaying of the Serpent as they are related in the fourteenth chapter. The Slaying of the Serpent is not an uncommon

composition in Early Christian art. One may point to a cut glass bowl of the fourth to fifth century in the Louvre, where the serpent episode is coupled with a representation of Daniel in the Lions' Den (F. Cabrol and H. Leclerq, *Dictionnaire d'archéologie chrétienne et de liturgie*, III, 2, Paris, 1914, fig. 3333). But the scene of the Destruction of Bel is to my knowledge non-existent among surviving Early Christian monuments. In fact, the earliest sources for this illustration are the Catalan Bibles of the Middle Ages. One such example is the eleventh-century Bible from Roda (W. Neuss, *Die Katalanische Bibelillustration um die Wende des ersten Jahrtausends und die altspanische Buchmalerei*, 1922, p. 93 and pl. 34, fig. 102), where Daniel is shown personally spearing the tumbling idol and killing the serpent with lumps of pitch (Dan. XIV:27). Since it is generally believed that the miniature cycles of these Catalan Bibles hark back to Early Christian archetypes, they may be used as indirect evidence for the existence of a narrative picture cycle of the Book of Daniel in the Early Christian period.

The remaining iconographic feature to be discussed is the eagle placed beneath the lock panel. The same type of eagle, with head in profile and outspread wings seeming to support the panel, may be found on two other Christian pyxides, one in Livorno (Volbach, *op. cit.*, no. 165), and the other in Vienna (*ibid.*, no. 199, where it is dated seventh to eighth century. I have supported Gombrich's thesis that it is the product of the Carolingian Ada school, imitating an earlier Syrian model [*D.O.P.*, 20, 1966, p. 11]). The subjects decorating these pyxides are all different—the Multiplication of the Loaves and Fishes on that in Livorno, and the Nativity of Christ and the Adoration of the Magi on that in Vienna. On a pagan pyxis in Xanten (Volbach, *op. cit.*, no. 96), decorated with scenes from the life of Achilles, there is again an eagle placed beneath the lock panel, with only the slight variation that its wing tips are turned down. The frequent use of the eagle in this particular place on a pyxis appears to be deliberate. It is tempting to suggest that the panel of the lock here takes the place of the inscription tablet, whose support by an eagle is a common feature of Roman art (cf. the dedicatory miniature of the Filocalus calendar [H. Stern, *Le calendrier de 354*, Paris, 1953, p. 144 and pl. IV, no. I], where a Victory is depicted writing a dedication on a shield supported by the wings of an eagle). In a recent study by L. Wehrhahn-Stauch (see bibliog. *infra*, pp. 105 ff.), the eagle on various ivory pyxides is explained as a symbol of the Resurrection. This motif could have acquired such a connotation only on Christian pyxides with New Testament scenes like those of Livorno (Volbach, *op. cit.*, no. 165) and Vienna (Wehrhahn-Stauch, *op. cit.*, fig. 21), but it seems unlikely that such an interpretation should be applied to the pagan pyxis at Xanten (*ibid.*, fig. 24), or, for that matter, to a pyxis with Old Testament scenes. The more logical explanation for the latter seems to be that the eagle is merely a decorative element similar to that in the miniature of the Filocalus calendar.

The iconographic originality of our pyxis, in which two Old Testament episodes are depicted with a number of unique details, is matched by a lively and highly dramatic style. Moses is shown eagerly striding forward to take possession of the Law, and the ecstatic pose of the Israelite who has thrown himself to the ground is unique. His counterpart in terms of a theatrical pose is Salome, the midwife with the withered hand who figures prominently in the Nativity scenes on the pyxides in Berlin and Vienna, which belong to the same group as ours (Volbach, *op. cit.*, nos. 174 and 199). At the same time,

the rhythmic quality of the two Israelites, standing with their hands raised and their scepters held at the same angle, is a calculated counterbalance to the extreme emotion of the other two figures of this composition. In the Daniel scene, also, a contrast is created between the dynamic pose of the Prophet and the movement of the angels on the one hand, and the static symmetry of the towers and the heraldic pair of lions on the other. Although the carver was an artist of considerable compositional ability, the execution of the individual figures, while competent, is rather sketchy and lacks a certain refinement. Nevertheless, ours ranks among the best of the rather large group of pyxides.

Its style may be related to that of several other pyxides, and Volbach ennumerates four as being particularly pertinent—those in Leningrad, the Cluny Museum, Berlin, and the Vatican (*ibid.*, p. 79). The greatest affinity exists, I believe, with the pyxis in Leningrad, on which several of Christ's miracles are represented (*ibid.*, no. 179). The second onlooker in the Moses scene of our pyxis may be compared with the various Christ figures of the Leningrad piece. All stand quite at ease, with a convincing sense of plasticity inherited from antiquity; the folds of the drapery are defined in a sketchy way but adhere still to the classical conventions of a natural fall. The curled hair of the head and the eyes with their prominently drilled pupils, typical of this school of ivory carvers, are also quite similar. On the Leningrad pyxis, however, the heads are slightly too large, while on our piece the proportions are generally more natural. The three other pyxides reflect the gradual deviation from the classical mode toward a greater ornamentalization. The pyxis in the Cluny Museum (*ibid.*, no. 180) shows a figure of Christ whose stance is less easy, whose drapery is rendered with fewer folds simplified into parallel lines, whose head has become too big, and whose face has developed a mask-like expression. In the two other pyxides, those in Berlin (*ibid.*, no. 174) and the Vatican (*ibid.*, no. 181 and pl. 56, where it is erroneously numbered 182), all these features have become increasingly exaggerated. Volbach dated the Leningrad pyxis fifth to sixth century and the other three into the sixth, thereby clearly implying that it is somewhat earlier. However, on the basis of the above stylistic criteria, the Dumbarton Oaks pyxis must be dated at least as early as the Leningrad pyxis and therefore may likewise belong to the end of the fifth century rather than to the sixth, as Volbach proposed.

More difficult and still unsolved is the problem of the localization of our pyxis. Realizing the inconclusiveness of the attempts made so far to determine the provenance of the ivory workshops, Volbach usually refrains from making attributions to any of the disputed centers. It is generally admitted that the Dumbarton Oaks and the four related pyxides belong to a group whose most prominent piece is the well-known diptych from Murano, now in the Museo Nazionale at Ravenna (*ibid.*, no. 125 and pl. 39), an ivory of the sixth century in which the style described above is somewhat hardened and more abstract than in our pyxis. The Murano diptych and the Maximianus cathedra (*ibid.*, no. 140 and pl. 43) have been considered by most scholars to be the rallying points of the great mass of Early Christian ivories. C. R. Morey (see bibliog. *infra*, pp. 43 ff.) and K. Wessel (see bibliog. *infra*, pp. 63 ff.), among others, have suggested that the two groups, though contradictory in so many points of style, were nevertheless made in the same center, namely Alexandria. But another group of scholars, following D. V. Ainalov (*The Hellenistic Origins of Byzantine Art*, New Brunswick, 1961, pp. 106–7, especially pp. 264 ff.),

who made the most penetrating stylistic analysis of the Murano diptych, attributes it to a Syrian workshop.

Most writers have tried to solve the problem of localization by confining themselves to the ivory material proper, and their dilemma has been that within the disputed groups no incontrovertible facts with regard to localization have so far emerged. In full realization of this situation, Ainalov linked the style of the ivories with that of contemporary miniature painting, and it was on the basis of parallels between these two media that he established a Syrian school of ivory carving separate from an Egyptian one. This, in my opinion, is a legitimate procedure, and, indeed, the tubular figure style of the Murano diptych is based on the same concept of corporeality as that of the miniatures of the Vienna Genesis and the Rossano Gospels, manuscripts generally attributed to the Syro-Palestinian region. On the other hand, the style of the Maximianus cathedra, with the figures marked by a certain rectangularity, has its parallel in the miniatures of the Cotton Genesis, generally accepted as being Alexandrian. While this characterization is admittedly an over-simplification, it is an attempt to find a broader basis for the two different styles. From this point of view, I prefer an attribution of the Dumbarton Oaks pyxis to a Syro-Palestinian atelier, being well aware that definite proof for such a localization cannot be given at the present state of scholarship.

The Abbey Church of Moggio (Udine).
Bliss Collection, 1940.

A. Venturi, "Opere d'arte a Moggio," *L'Arte*, 14, 1911, pp. 469 ff. and figs. 1–3. *Art of the Dark Ages*, Worcester Art Museum, 1937, no. 57 and pls. C. R. Morey, "Art of the Dark Ages," *Art News*, 35, 1937, p. 15 and figs. p. 10. A. Goldschmidt, in *Parnassus*, 9, March 1937, p. 29. C. R. Morey, "The Early Christian Ivories in the Eastern Empire," *D.O.P.*, 1, 1941, p. 43 and figs. 1–2. *Pagan and Christian Egypt*, Brooklyn Museum, 1941, no. 105 and pl. *Bull. Fogg.*, 10, 1945, p. 108 and fig. p. 114. Volbach, *Elfenbeinarbeiten*, no. 168 and pl. 54. K. Wessel, "Studien zur oströmischen Elfenbeinskulptur," *Wissenschaftliche Zeitschrift der Universität Greifswald*, 2, 1952–53, p. 71. *D.O.H.*, 1955, no. 227 and pl. W. Volbach, *Early Christian Art*, New York (n.d.), no. 236 and pl. K. Weitzmann, "Survival of Mythological Representations in Early Christian and Byzantine Art and Their Impact on Christian Iconography," *D.O.P.*, 14, 1960, pp. 59–60 and fig. 29. *D.O.H.*, 1967, no. 277 and pl. L. Wehrhahn-Stauch, "Aquila-Resurrectio," *Zeitschrift des Deutschen Vereins für Kunstwissenschaft*, 21, 1967, p. 123 and fig. 22.

19. Flask
 Ornament
 Uncertain date
 Height 15.6 cm. Width 4.5 cm.
 Acc. no. 38.68 PLATE XVIII

The flask is in good condition, except for small chips on the feet. Originally it probably had a small lid, also in ivory.

Narrow at the top, the slender body of the flask bulges outward toward the bottom and rests on a conical foot. The ornament on the body consists of three broad registers of concentric rings, with a band of circles enclosing dots about midway in each of the registers. On the foot, two cherubim and two simple crosses with flaring arms are incised between narrower registers of concentric rings (PL. XVIII, B, C), and on the bottom there is a slightly more elaborate cross with knobs at the ends of the arms (PL. XVIII, D). All ornaments are incised, but at the neck and above the foot simple projecting moldings add an element of plasticity.

Because of the religious symbols, it has been suggested that the flask was a container for holy water, a so-called aspergillum. There is a bone vessel of similar form and with similar geometric ornament in the Berlin museum, but it lacks the religious symbols (Wulff, *Altchristliche Bildwerke*, p. 138, no. 570 and pl. xxv). The simplicity of the ornamental style, which remained unchanged for centuries, makes it difficult to propose even an approximate date; however, an origin in Coptic Egypt and a date in the Early Christian period are reasonable assumptions.

Bliss Collection.

D.O.H., 1955, no. 250. *D.O.H.*, 1967, no. 279.

20. Plaque
The Nativity
Syro-Palestinian, end of the seventh to eighth century
Height 9.3 cm. Width 19.1 cm. Thickness 0.6 cm.
Acc. no. 51.30

PLATES XIX, XX
COLOR PLATE 3

The rectangular plaque is carved in relief with the Nativity of Christ. A strip of ivory extending across the top of the plaque and widening into a triangle at the right has broken off. Included in the area of loss are the finials of the domed structures, the top of the head of the ox on the left, the ass behind the manger, and the upper parts of the architectural structures at the right. On the left half of the plaque the lost strip has been restored, including the finials and the visible horn of the ox. The recessed ledge as restored along the top probably repeats an original feature, since that at the bottom is similar. The sides of the plaque were cut at a slight angle, and the lower right-hand corner has broken off. The whole surface shows a *craquelure* of horizontal lines which may well be the result of warping. The highest parts of the relief, especially the face of the Virgin, have been affected by rubbing, and these are very light in color; the deeper parts are various shades of brown, while the background is quite a dark brown (COLOR PLATE 3). Two holes, one at the lower left corner and one beneath the couch, point to an attachment to a wooden core. But pegs alone would hardly have provided a sufficiently secure fastening, and the plaque's recessed ledges at the top and bottom indicate that they were held in place by counter ledges.

The center of the plaque is occupied by the Virgin lying on a mattress in a relaxed pose, her arms resting on her thighs (PL. XIX, B). The mattress, depicted in bird's-eye view, is covered with a dotted circle pattern and is propped up by three turned legs of different length. The Virgin's head is turned to one side for no obvious reason. One may deduce from this pose that the model for our plaque had a vertical format and included the customary detail of the bathing of the newborn child which the Virgin watches—a detail which had to be abandoned when the horizontal format was chosen. Behind the Virgin, Joseph sits on a stool with turned legs, his chin cupped in his hand in a pensive gesture; his left leg is bent as if it were meant to rest on the stool (PL. XX, A). At the other side of the Virgin is a seated woman with her legs crossed, though it is not clear whether she is sitting on a low bench or on the ground (PL. XX, B). She leans her right elbow on the edge of the mattress, her chin resting in her hand in a thoughtful mood. Dressed like the Virgin in a *paenula*, she is apparently Salome, who usually is shown washing the Christchild; but since this scene was eliminated, the artist had to find a new place for her in the composition. Not only are the Virgin and Joseph nimbed, but so also is Salome, which is quite uncommon. The manger is rendered as a masonry altar with a niche in the center, which seems to be hung with a piece of drapery (and does not enclose two doves, as suggested by Migeon, see bibliog. *infra*). On top of it lies the Christchild in swaddling clothes, flanked by the ox and ass; the ox gently nuzzles the child, while only part of the chest of the ass is preserved.

Normally a Nativity of this type is set in a cave, but our artist has placed it before a background so densely packed with architectural features (PL. XIX, A) that it can be explained only as the result of a *horror vacui*. At the extreme left there is the traditional Greco-Roman walled city with an open gate. Three domed buildings, one with a panelled door, are tightly fitted within the octagonal wall, while in the open gate stands an altar under a baldachin with a hanging lamp. Next to the city is an ambiguous structure in which the building proper and the wall seem to be fused. At the right there is, next to the ass, part of a column which surely belonged to a larger structure, another schematized domed building, and finally a structure with a panelled door which served as base for a colonnaded tempietto, though now only the column bases survive (for a similar structure, cf. Goldschmidt, IV, no. 122, pl. XL).

A conspicuous iconographical feature is the altar-like manger with a niche. This also appears as a prominent feature on the painted lid of the reliquary of the Sancta Sanctorum, a pilgrim's souvenir from Jerusalem, datable to the seventh century (C. Cecchelli, J. Furlani, and M. Salmi, *The Rabbula Gospels*, Olten-Lausanne, 1959, color fig. on p. 34). It also occurs on two icons from Sinai, which we should like to ascribe to a Palestinian workshop. One, datable in the eighth to ninth century (K. Weitzmann, "Some Remarks on the Sources of the Fresco Paintings of the Cathedral of Faras," *Kunst und Geschichte Nubiens in christlicher Zeit*, Recklinghausen, 1970, p. 331 and fig. 329), clearly shows the niche, but it is damaged in the center so that the object within is no longer recognizable. On the second, however, which I should like to date in the ninth to tenth century (Sotiriou, *Icones*, II, figs. 17–19, and I, p. 33, where it is dated seventh century), the object is clearly a hanging lamp. This seems, indeed, to be an appropriate object for an altar niche and thus can be assumed to have been in the archetype. This niche occurs also in the manger of

the Maximianus cathedra (C. Cecchelli, *La cattedra di Massimiano*, Rome, 1936–44, pl. xxv), a work variously attributed to Alexandria and Constantinople—an indication that this once distinctly local feature spread into other artistic provinces. The earlier of these two Sinai icons, though rather rough in style, has other details which relate to our ivory. Although in Byzantine art Joseph normally sits either on the bare ground or, as becomes popular during the Middle Byzantine period, on a donkey saddle, on both the Sinai icon and our ivory he sits on a small bench—a motif which is quite rare. In addition, his meditative pose, in which he leans his head on one hand and rests the other on his knees, is similar in both panels. Another comparable detail is the vase, which in the ivory stands on a wooden tripod and in the icon on top of a wavy groundline. With its small foot, swelling body, and narrow neck, it resembles the vessels in the London plaque of the Miracle of Cana, which also belongs to our group of ivories (Goldschmidt, IV, no. 312, pl. LXXIX).

Special emphasis is placed on the baldachin structure within the gate of the walled city. Between its front columns is a grill, and for such a grill I know of only one parallel: on one of the ampullae of Monza, it is seen behind the Virgin who lies on the couch. A. Grabar has identified, in my opinion correctly, this structure with the one which stood in the cave of the Nativity Church in Bethlehem (*Ampoules de Terre Sainte*, Paris, 1958, p. 19 and pls. v and vii). What is only sketched in the little ampulla is depicted on the ivory more accurately and in greater detail as a real ciborium with a grill; consequently, one has good reason to believe that the carver of the ivory intended to represent the *locus sanctus* of the Nativity Church within the walled city, which is thus meant to be Bethlehem.

So far every detail for which a parallel can be cited is found on Palestinian works of art of the seventh century or shortly thereafter: the Monza ampulla, the reliquary of the Sancta Sanctorum, and the Sinai icons. Yet, for one motif I have not been able to find a parallel, and that is the type of Salome, with her pensive gesture which is as vivid as it is classical. In the Casa de Cinque Scheletri at Pompeii, there is a fresco of a pensive Odysseus who displays a remarkably similar gesture, one which in other Byzantine works of art, like the frescoes in Castelseprio, has been used for the brooding Joseph (K. Weitzmann, *The Fresco Cycle of S. Maria di Castelseprio*, Princeton, 1951, p. 36, figs. 45–46). It may be that our Salome is an invention of the gifted carver of our plaque who, when faced with the necessity of replacing the group of Salome bathing the Christchild, made her into a companion figure to Joseph and gave her a similar purpose: to brood over the incomprehensible miracle of Christ's birth.

Stylistically, our plaque belongs to a not very extensive group of fourteen pieces (Goldschmidt, IV, pp. 34 ff., nos. 112–24 and 312) whose date, localization, and purpose have provoked widely divergent opinions. Hans Graeven, writing in 1899 ("Der heilige Markus in Rom und in der Pentapolis," *Römische Quartalschrift*, 13, 1899, pp. 109 ff.), dated them to the end of the sixth century and connected them with a cathedra of St. Mark, which supposedly came from Alexandria and was presented as a gift by the Emperor Heraclius to the cathedral of Grado. Thus, he assumes an Egyptian origin for the ivory plaques. This opinion, essentially shared by Goldschmidt, Maclagan, and others, was contradicted by Venturi, Toesca, and most forcefully by Bertaux and Volbach, who dated the ivories in the eleventh to twelfth century and localized them in Italy.

Their conclusion was based chiefly on the fact that three of the plaques with New Testament subjects served as models for the antependium of Salerno, which has been dated around 1084, the year a new altar was consecrated in the cathedral. Both dates seemed unsatisfactory to the present writer, who, therefore, undertook a new investigation of the whole group (see bibliog. *infra*). The results may here be briefly summarized. Three arguments speak against the early date: (1) the literary evidence for an ivory cathedra of St. Mark in Grado at an early time is inconclusive and contradicted by the fact that Venice had in the sanctuary of San Marco a marble cathedra venerated as that of St. Mark; (2) our group is stylistically unrelated to any monument which is dated or datable around A.D. 600; and (3) as noticed by Toesca and Volbach, the impact of Islamic art is clearly recognizable. The eleventh-century date is based chiefly on two arguments: the relationship to the Salerno antependium and the evidence of Islamic influence. However, while some of the plaques, including our Nativity, had an iconographic influence on the Salerno antependium (PL. XXI, fig. 15), its style is very different indeed; so there is no reason to assume that the models belonged to the same period as the copy. Moreover, in the Salerno antependium Byzantine ivories of the tenth century are used as a second major source, a source which is not reflected in our group of fourteen ivories; hence, they must be earlier than the tenth century. Finally, as far as the Islamic influence is concerned, all traceable elements are found in Umayyad art and therefore need not be later than the eighth century.

Having abandoned the idea of a St. Mark cathedra in Grado, there is no longer any need to connect our ivories with a cathedra or any other single object. The stylistic differences within the group are so great that, in my opinion, the plaques should be viewed as products of a workshop which was active over several generations. One can distinguish two groups among the ivories, an "earlier" group and a "later" group. Our Nativity belongs, in my opinion, to the "earlier" group, as does the plaque closest to it in style, that of the Annunciation in the Castello Sforzesco in Milan (PL. XXI, fig. 16) (Goldschmidt, IV, no. 123, pl. XLI). Both share a relatively better understanding of the classical tradition than the ivories of the "later" group, which is centered around the plaques depicting scenes from the Life of St. Mark (*ibid.*, nos. 112–16, pls. XXXIX–XL). In the Nativity and Annunciation plaques there is a stronger sense of corporeality, expressed by means of natural proportions and clinging drapery, than in the plaques of the "later" group, in which the bodies are comparatively more dematerialized and the drapery rendered in a more linear and ornamental fashion. In spite of the rubbed surface of our plaque, one will notice that the folds of the Virgin's *paenula* are like heavy strands rising above the surface of the garment; on the Annunciation plaque, because of its almost perfect state of preservation, this feature is more pronounced. The rubbing has also somewhat obscured the strongly linear treatment of the eyes so characteristic of this whole group, which consists in surrounding the eyeball with a sharply incised double line, creating the effect of a fixed stare. Typical also are the hands, which, with their long spidery fingers, have a very mannered effect—in the Annunciation even more so than in our Nativity.

Yet, while these two plaques are so similar in their treatment of the bodies, they differ fundamentally in their architectural backgrounds. The temple front of the Annunciation

plaque is derived from a classicizing model, while the background of the Nativity plaque, practically filled with a variety of buildings, is based on a different tradition. The emphasis on the *locus sanctus* of Bethlehem suggests that this source was Palestinian. Moreover, I believe not only that the models were Palestinian, but that the workshop itself which produced our ivories was located in Palestine. I propose for them an eighth-century date, not excluding the possibility that the earliest pieces of our group, the Nativity and the Annunciation, may have been made at the end of the seventh century. For a fuller discussion of the arguments which led to these conclusions, I refer once more to the study which was written as a background to this entry (see bibliog. *infra*).

As similar as the Nativity and Annunciation plaques are, they were not necessarily carved by the same hand. They could, nevertheless, have been attached to a single object on which several carvers cooperated. Probably they belonged to a larger cycle of New Testament scenes in which vertical and horizontal plaques alternated. Such alternation is hardly likely to occur on a bishop's throne, to judge from the Maximianus cathedra— the only one left for comparison—where the New Testament scenes are higher than they are wide, some of them terminating with an oblique upper frame in order to fit the back of the throne. On the other hand, the alternations seen in our ivories are typical for the decoration of doors such as those of S. Ambrogio in Milan (A. Goldschmidt, *Die Kirchentür des Heiligen Ambrosius in Mailand*, Strasbourg, 1902) and S. Sabina in Rome (J. Wiegand, *Das altchristliche Hauptportal an der Kirche der Hl. Sabina*, Trier, 1900). That such doors existed also in the Christian East is proven by the door in the Coptic church of St. Barbara in Old Cairo (A. Patricolo and U. Monneret de Villard, *La Chiesa di Santa Barbara*, Florence, 1922, pp. 45 ff. and figs. 27–28). It is true that all these doors are made of wood, not ivory. In Egypt, however, there are doors inlaid with ivory, such as those in the monastery of Der es Surian in the Wadi Natrun (H. S. Evelyn-White, *The Monasteries of the Wâdi 'N Natrûn*, III, New York, 1933, pp. 197 ff. and pls. LVIII–LX, LXIV–LXV). It should be noted that these doors are not—as in the Latin churches quoted above—placed at the main entrance from the narthex into the interior, but in a more sanctified location: the smaller of the two doors in Der es Surian leads into the choir, while the larger leads into the sanctuary—the "haikal." In such areas, doors of precious but fragile materials were both more appropriate and better protected. These doors date in the period of Abbot Moses of Nisibis (926–27). Thus, we believe it most likely that our ivories were attached to a door leading into the sanctuary of an East Christian church. It is true that on the Wadi Natrun doors only the upper row of plaques has figured carvings, while the lower rows are exclusively ornamental. But this is easily enough explained by the fact that art in Egypt had gradually adapted to Islamic customs by the tenth century; and it should be remembered that about this time the use of ivory for inlay on doors became a characteristic feature of mosque decoration.

It may be mentioned that the only plaque of our group with a known provenance is that with the Raising of Lazarus in the British Museum (Goldschmidt, IV, no. 118, pl. XL). According to an old tradition, it had been in the church of St. Andreas in Amalfi since the fifteenth century. If at least an essential part of this ivory group, including our Nativity plaque, were in Amalfi at an early time, this fact would explain its availability to the carvers of the antependium in nearby Salerno.

Albin Chalandon Collection, Lyons.
Georges Chalandon Collection, Paris.

A. Darcel, "Exposition rétrospective de Lyon," *Gazette des beaux arts*, 16, 1877, p. 181. *Catalogue. Exposition rétrospective de Lyon*, 1877, p. 52, no. 811, pl. IV. G. Migeon, "La collection de M. G. Chalandon," *Les arts*, June 1905, pp. 23–24 and fig. p. 22. *Catalogue. Exposition d'objets d'art du moyen âge et de la Renaissance ... ancien Hôtel de Sagan*, Paris, 1913, pp. 51–52, no. 102. Goldschmidt, IV, no. 124, pl. XLI. L. Becherucci, "Gli avori di Salerno," *Rassegna storica Salernitana*, 2, 1938, p. 78. Volbach, *Elfenbeinarbeiten*, no. 249. *D.O.H.*, 1955, no. 230 and pl. *D.O.H.*, 1967, no. 290 and pl. K. Weitzmann, "The Ivories of the So-called Grado Chair," *D.O.P.*, 26, 1972, pp. 43 ff.

MIDDLE AND LATE BYZANTINE IVORIES

21. Plaque
 The Incredulity of Thomas
 Constantinople, about middle of tenth century
 Height 10.6 cm. Width 8.8 cm. Thickness 0.9 cm.
 Acc. no. 37.7

PLATES XXII, XXIII
COLOR PLATE 4

Originally the plaque was mounted in the sunken field of a wooden panel and held in place by ivory pegs, for which there is a hole near each corner of the plaque, and by overlapping metal bands. The color of the ivory is light brown, except for the cross on the nimbus of Christ and the crossbars of the doors. It is likely that these parts were originally gilded, and having been thus protected, have not darkened much in tone (COLOR PLATE 4). The incised inscription was undoubtedly filled with color, probably red, which made the letters more legible, and some color was probably used in the pupils of the eyes, greatly enhancing the impression of sharply piercing glances. Whether additional color was used can no longer be ascertained.

The Incredulity of Thomas is rendered in a hieratic, centralized composition, with Christ in an isolated, frontal position. Though about to move to our right, He turns back toward Thomas in a lively pose which reveals His momentous reaction to the approaching Apostle. Christ's right hand is held out toward Thomas in a human, inviting gesture, and He looks down at the doubting Apostle with a compassionate glance. The Apostles are arranged in two rows at either side, with the exception of Thomas who is singled out and placed in the foreground on a third plane; but in order to accommodate him in this manner the artist had to reduce his size. The scene is set in front of a high wall with a closed door in the center, leaving only enough space in the corners for the inscription TⲰN / ⲐVPⲰ[N] / KE / KⲖEIC / MENⲰ[N].

Iconographically the scene is correct insofar as there are only eleven disciples present at this event (John XX:26), Judas not being included. This point was not always taken into consideration by Byzantine artists, and the closest parallel to our ivory, a miniature of the lectionary fragment in Leningrad, cod. gr. 21, from the middle of the tenth century (Goldschmidt-Weitzmann, II, p. 29, fig. 9; K. Weitzmann, *Die byzantinische Buchmalerei des 9. und 10. Jahrhunderts*, Berlin, 1935, pp. 59 ff. and pl. LXVI, 394), has twelve Apostles depicted in accordance with the conventional number. However, there were artists, especially in the more ambitious medium of mosaic, who were careful about the number eleven—the mosaics of Hosios Lucas and Daphni are the most outstanding examples (E. Diez and O. Demus, *Byzantine Mosaics in Greece, Hosios Lucas & Daphni*, Cambridge,

43

Mass., 1931, figs. 10–11 and 103–04). Our ivory also accords with these mosaics in placing Peter at the head of the group at Christ's left; but, while in the monumental compositions he is placed closest to Christ, in the ivory he is in the foreground of the group of Apostles, a position which allowed the artist to make him fully visible. Paul, characterized by his balding forehead and rather full beard, stands behind Peter, but closer to Christ, and by this subtle arrangement the artist gives equal importance to the two princes of the Apostles. The only other Apostle who has distinct features is Andrew, characterized by his dishevelled hair. In Daphni he stands next to Paul, but in Hosios Lucas at the extreme right; our ivory follows the latter tradition. As is usual at this period, the other disciples remain unidentified.

In the mosaics referred to above, Thomas thrusts forth his index finger and is about to touch the wound of Christ in order to dispel his doubts. But in the ivory Thomas is merely pointing to Christ's wounds from some distance; the moment of physical contact is thus avoided. This is in line with a development in mid-Byzantine art whereby emotions are restrained and vigorous action avoided in order to achieve the effect of aristocratic behavior. A similar restraint is evident in the gesture of Christ, Who, on the ivory, gently draws His tunic to the side to make the wound visible, whereas in Hosios Lucas He energetically pulls the tunic open. In Daphni, Christ does not touch the tunic at all but merely holds the sash of His mantle. The ivory, therefore, stands midway between the vigorous action of Hosios Lucas and the complete tranquility of Daphni. An unusual feature of the ivory is the rendering of the sash of the mantle, which is drawn open in such a way as to form a circular frame for the wound.

Stylistically the ivory represents perfectly the so-called "painterly" group, a definition which must be understood not merely as the application of painterly means of expression, but literally as the direct copying of painted models. These models could have been either icons or miniatures, but the latter is more likely because of certain distinct classicizing elements which have found their most adequate expression in book illumination. One detail reveals clearly the dependence on a painted model: Paul's suspended foot, which in the model must have rested on a painted strip of ground. Furthermore, although the relief appears to be rather high, the surface of the individual figures is quite flat, and only in the outlines of Christ and the Apostle groups did the artist cut deeply into the ground at a right angle (PL. XXIII, B). The dense, irregular folds are more a reflection of brush strokes than an attempt at plastic modelling. The crowding and overlapping of the figures also speak in favor of a painted model, but here the carver had difficulties, since he wanted to render the heads as fully rounded as possible, yet had no space for showing more of the bodies. Typical of this group are the intense expression of the eyes, achieved in part by the angular eyebrows, and the ornamental treatment of the hair.

Another notable feature is the toga-like mantle worn by the Apostles, for the artist clearly wanted to use frequently the classical motif of the right arm in a sling. This feature and the desire to have the figures move freely in space are expressions of the Macedonian Renaissance of the tenth century (K. Weitzmann, *Geistige Grundlagen und Wesen der Makedonischen Renaissance*, Cologne, 1963, *passim*). This movement is also reflected in the background architecture. Traditionally, as indicated in the mosaic of Hosios Lucas, a framed closed door sufficed to indicate the setting. In the ivory, however, the door is

crowned by a double cornice with acanthus frieze, and from its corners are suspended draperies which fall upon a wall pierced by slit windows. This type of architecture is a standard motif occurring in various contexts in miniatures associated with the Macedonian Renaissance, such as the Evangelist portrait of a tenth-century Gospelbook in the Vatican, cod. gr. 364 (*ibid.*, p. 31 and fig. 25). It can be explained as a derivation from a classical model such as the fresco of the Villa Farnesina, where one recognizes within the temenos wall of a holy precinct a garden gate with the typical draperies suspended from it (*ibid.*, fig. 26). Furthermore, it will be noticed that the closed doors of the ivory do not terminate on the ground, but seem to rest on a low wall. Such walls occur in classicizing miniatures, frequently in connection with theater architecture, and suggest a hyposcenium wall (cf. the Evangelist Mark in Philotheu cod. 33, *ibid.*, fig. 22). In our ivory the two traditions—from garden architecture and the stage—seem to be fused.

Within the field of Byzantine ivory carvings, the Macedonian Renaissance is conspicuously evident in the products of the "painterly" group, and especially in the representations of the great feasts, such as the Entry into Jerusalem in the Berlin Museum and the Crucifixion in the Metropolitan Museum, New York (*ibid.*, p. 37 and figs. 33–34; Goldschmidt-Weitzmann, II, no. 3, pl. I and no. 6, pl. II). This suggests not only that the model was a manuscript, but that it was specifically a lectionary with full-page miniatures of the great feasts, the earliest example of which is the fragment in Leningrad, cod. gr. 21, mentioned above. This has classicizing feast pictures such as the Incredulity of Thomas alongside traditional miniatures which lack classical features. One may infer that at the time this lectionary was illustrated, about the middle of the tenth century, the renaissance had affected New Testament illustrations and led to the creation of a classicizing feast cycle. Our ivory can be dated not long thereafter, i.e., in the second half of that century.

It has been noted in the Corpus (*ibid.*, p. 28) that the Thomas plaque belongs to the same group of icons as a plaque in Berlin with the Raising of Lazarus (PL. XXIV, fig. 18) (*ibid.*, no. 14, pl. IV), which is in the same style and has the same measurements. Another plaque certainly belonging to this set is the Koimesis, formerly in the Kofler-Truniger Collection in Lucerne and now in the Museum of Fine Arts, Houston (PL. XXIV, fig. 19) (H. Schnitzler, F. Volbach, and P. Bloch, *Skulpturen. Sammlung E. und M. Kofler-Truniger*, I, Lucerne, 1964, p. 13, no. S 13 and pl.). Its measurements (10.5 by 8.7 cm.) differ from those of our ivory by only 1 mm., and, more importantly, it has the same figure style. A plaque in the British Museum with the Nativity of Christ (PL. XXIV, fig. 17) (Goldschmidt-Weitzmann, II, No. 5, pl. II) belongs to a similar though not the same set, since it is slightly larger (11.5 by 10.2 cm.). All four of these plaques have a strongly classical flavor, and the Lazarus scene, like the Incredulity of Thomas, is set against an equally classicizing architectural background. Thus, it may be concluded that all four ivories copy miniatures from a lectionary, since each represents a feast picture belonging to a cycle of the twelve great feasts. Furthermore, certain technical features which these four plaques share suggest that they stand apart from other ivory plaques of the "painterly" group. They are comparatively small in size; they have a somewhat squarish format compared with the normal proportions of ivory plaques, usually considerably higher than wide; and, finally, they have a rather narrow frame of equal width around the four sides. The fact that the top and bottom borders were not made

wider to allow for the attachment of ledges indicates that they were not central plaques of triptychs.

Within the "painterly" group of ivories, the four plaques mentioned seem to be the only survivors of such sets of the twelve great feasts of the Orthodox Church, a cycle which became more or less standardized in the tenth century and achieved wide acceptance in subsequent centuries (cf. K. Weitzmann, "Byzantine Miniature and Icon Painting in the Eleventh Century," *Proceedings of the XIIIth International Congress of Byzantine Studies, Oxford, 1966*, London, 1967, pp. 207 ff.). In the first set, to which the Dumbarton Oaks plaque belongs, the Raising of Lazarus would be no. 6, followed by the Entry into Jerusalem, the Crucifixion, and the Anastasis. Normally no. 10 would be the Ascension, but not infrequently its place is taken by the Incredulity of Thomas, as is the case at Hosios Lucas and Daphni. With the Pentecost as no. 11, the last feast of the cycle would be the Koimesis, preserved in the Houston plaque (cf. text figs. b and c).

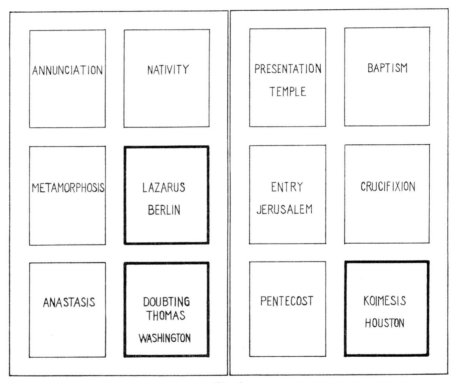

Fig. b

I should like to suggest that each set of twelve plaques was mounted on a wooden panel so as to constitute a collective icon of the cycle of the great feasts. This suggestion is based on an icon in St. Catherine's monastery on Mount Sinai from the end of the eleventh or early twelfth century (Sotiriou, *Icones*, I, figs. 57–61; Weitzmann, "Byzantine

Miniature and Icon Painting," pp. 222 ff. and pl. 42), which has, in addition to the twelve feasts, all twelve Apostles. The Sinai icon is the only case known to me combining these two elements. Normally the twelve feasts by themselves form an entity, as we surmise to be the case in our postulated icons composed of ivory plaques. The precise form of these collective icons cannot, however, be determined, since several possibilities exist: the plaques may have been mounted on single panels, but they might just as well have been mounted either as diptychs with six feasts on each wing (text fig. b) or as triptych with six feasts in the center and three on each wing (text fig. c). All these types exist among the painted icons on Mount Sinai (Sotiriou, *op. cit.*, figs. 39–40 [diptych]; a twelfths century triptych of Sinai is unpublished). It will be noticed that in the reconstruction-

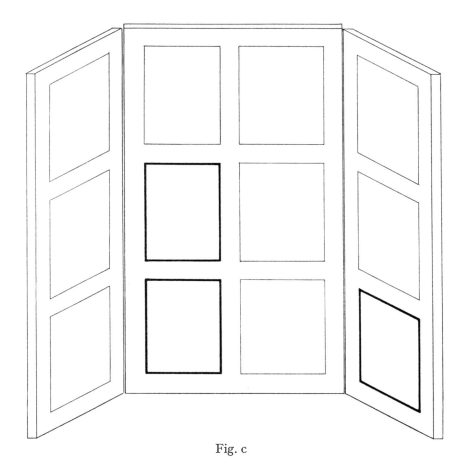

Fig. c

drawings of either a diptych or a triptych, the Raising of Lazarus is placed directly above the Incredulity of Thomas. Wooden panels—and this would apply to a wing as well as to the central plaque of a triptych—quite commonly split vertically, which may explain why these two scenes both survived.

Spitzer Collection, Paris.
Germanisches Museum, Nuremberg (No. K.P. 2267).
Bliss Collection, 1937.

M. Alfred Darcel, *La collection Spitzer*, I: *Les ivoires*, Paris, 1890, no. 33. *Catalogue des objects d'art ... de la collection Spitzer*, Paris, 1893, I, no. 68 and pl. III. W. Josephi, *Kataloge des germanischen Museums. Die Werke plastischer Kunst*, Nuremberg, 1910, no. 618 and pl. LX. *Exposition byz.*, Paris, 1931, no. 103. Goldschmidt-Weitzmann, II, no. 15 and pl. IV. *Arts of the Middle Ages*, Museum of Fine Arts, Boston, 1940, no. 116. *Bull. Fogg*, 9, 1941, p. 75 and fig. 8. *D.O.H.*, 1955, no. 236 and pl. *Athens Exhibition Catalogue*, 1964, no. 59 and pl. *D.O.H.*, 1967, no. 281 and pl.

22. Plaque from a Rosette Casket
 Standing Warrior
 Constantinople, tenth century
 Height 5 cm. Width 4.1 cm. Thickness 0.7 cm.
 Acc. no. 52.11 PLATE XXII

The slightly warped plaque originally decorated a rosette casket, like No. 23 *infra*, to which it was fastened by ivory pegs inserted through the three holes in its frame. The spear in the left hand of the soldier is partly broken, and his helmet, which originally may have been slightly pointed, is rubbed at the top.

The plaque is carved in high relief with a warrior standing at ease, holding a spear in his left hand and resting his right on the rim of a shield, the strap of which is visible at the top. His head is turned to the side, enhancing the contrapposto pose. Iconographically he belongs to a series of soldiers copied from illustrations of the Book of Joshua. At first, whole scenes were taken over from this source, specifically, in all likelihood, from the Joshua Rotulus in the Vatican (cf. the plaques in New York and London, Victoria and Albert Museum, Goldschmidt-Weitzmann, I, nos. 1–4, pl. I). This manuscript of the Macedonian Renaissance must have been an inspiration for the ivory carvers almost as soon as it was produced in the imperial court scriptorium (K. Weitzmann, *The Joshua Rotulus. A Work of the Macedonian Renaissance*, Princeton, 1948, p. 35). But shortly thereafter, the warriors were taken out of their original context and distributed individually on single plaques. In the earliest group of caskets, such as the one in La Cava (Goldschmidt-Weitzmann, I, no. 6, pls. II–III), the copies are quite faithful to the poses and proportions of the figures and the details of the military costume, but soon the proportions change, and, under the impact of classical nudes, the warrior is gradually transformed into a playful putto. Our plaque belongs to the early phase before this transformation had begun.

Although there is no doubt about its ultimate source, our ivory figure has no precise parallels with any figure in the Vatican Rotulus, and this is so apparently for two reasons. First, although there are soldiers in the manuscript in the same pose, i.e., holding a spear and leaning on a shield (*Il rotulo di Giosuè. Codice Vaticano Palatino Greco 431*, Milan,

1905, pl. XI), they hold the spears in their right hands and lean on the shields with their left. This surely is the correct way, and our ivory plaque is thus actually a mirror image, perhaps made in order to balance another soldier on the same side of the casket. Secondly, while our ivory figure is an ordinary soldier, he wears the chlamys which in the Rotulus is a garment reserved for Joshua. It should be observed that the soldiers mentioned as parallels in the Rotulus belong to Joshua's bodyguard and always stand next to him. Apparently, when our carver took the figure out of context he fused the leader with the ordinary soldier type. The only close parallel to our soldier on a rosette casket occurs on a somewhat later example in the Walters Art Gallery in Baltimore (Goldschmidt-Weitzmann, I, pl. XXII, 40c), though here the carver had to squeeze the figure into the low format of a lid plaque, and, as a result, the soldier seems to squat on his shield.

The rosette caskets of the highest quality, including that which our plaque decorated, belong to the "painterly" group, a Constantinopolitan atelier which has already been discussed in connection with the Incredulity of Thomas ivory (No. 21). Common to this group is a high relief, which, however, does not produce a figure in the round; for, although the figures are deeply carved, instead of receding gradually, they are cut out at a right angle to the picture plane, and the surface of the relief is actually quite flat. These caskets share a sensitive treatment of details, especially the illusionistic treatment of their dense folds of drapery. The closest stylistic parallel is the casket in La Cava, already mentioned. Since five plaques are missing from the latter (the three on the front and one on each short side), one might ask whether our plaque could be one of the five. Although the measurements indeed agree precisely, I do not think that our plaque could actually have come from this casket, because the figures of its plaques have more slender proportions, a different treatment of the leather strips below the *pteryges* of the armor, and a more elaborate design of the hair. I do not know of any other plaque which might have belonged to the same casket as ours.

Berl Collection, Austria.

D.O.H., 1955, no. 239. *D.O.H.*, 1967, no. 284 and pl.

23. Rosette Casket
 Warriors, Dionysiac Figures, and Animals
 Constantinople, second half of tenth or first half of eleventh century
 Height 15.7 cm. Length 23 cm. Depth 16 cm.
 Acc. no. 53.1 PLATES XXV–XXXI

The casket has a truncated, pyramidal lid, a feature common to several others in this group with classicizing subjects. The individual plaques and ornamental strips are mounted on a wooden box which, except for the bottom, seems to be original. Although there are a few cracks and small fillings in the ornamental borders, the decoration of the casket as a whole is remarkably well preserved. A rather modern red silk with a

golden floral design lined the interior of the casket when it was acquired by Dumbarton Oaks. This has been removed.

Contrary to Byzantine custom, our rosette casket has been reinforced with elaborate metal fittings: on the front, a lock and latch richly decorated with pairs of confronted peacocks; on the lid, a handle; and along each corner, three fittings; all are in gilded copper relief with niello inlay. Metal fittings are common on the painted Siculo-Arabic caskets of the twelfth and thirteenth centuries (P. B. Cott, *Siculo-Arabic Ivories*, Princeton, 1939), and there are a number of Byzantine caskets which were reinforced with fittings of the Siculo-Arabic style. However, the metalwork on our casket is much more richly ornamented, and, in fact, on only one other Byzantine casket, that in Ivrea (Goldschmidt-Weitzmann, I, no. 64, pl. XLIV [hereafter, in this entry, cited as G–W, I]), are the fittings as splendid.

The present lock replaces the original one, which apparently was slightly smaller. At the time of the replacement there was another, more significant alteration: the lid was reversed. Evidence indicating the original position of the lid is found in the existence of a number of holes in it, some stained green from oxidized copper. On what is now the front of the slanting lid (PL. XXVI) there are two sets of holes, equidistant from the edges, which must have been used for a pair of hinges, and hinges obviously belong at the back of a casket. These hinges were replaced at an unknown date by the present iron hooks. On the top of the lid (PL. XXV), in the middle of the border above the heads of the warriors, is another hole which must have been for a hinged latch. When the lid is turned around to its original position, this hole is a little off-center toward the left, as it should be to connect with the lock whose keyhole is placed slightly toward the right. Additional evidence for the reversal of the lid is the pair of rings in each short side, one fastened to the lid and the other to the side of the casket (PLS. XXVI, XXVII). At present they are placed unevenly, but when the lid is turned around, each pair is located with one ring directly above the other, and was obviously intended to hold a string or chain. Therefore, contrary to the opinion expressed in the Corpus, the replacement of the lock did indeed cause the changed position of the lid. At the same time the two relief plaques on the top must have been reset in the opposite direction in order to face the new front.

The casket is decorated with eleven figured plaques, most of which represent warriors drawn from different sources (G-W, I, pp. 13 ff.). In the earliest and best caskets of this category, the various types are still distinct enough to determine the iconographic realm from which they are derived, and two basic groups can be distinguished. The first includes warriors connected with illustrations of the Book of Joshua, and the second represents those from a Dionysiac cycle, chiefly the episodes of the Indian war, for which an illustrated copy of the epic poem of the *Dionysiaca* of Nonnus of Panopolis may have been the source (K. Weitzmann, *Greek Mythology in Byzantine Art*, Princeton, 1951, pp. 179 ff.; E. Simon, "Nonnos und das Elfenbeinkästchen aus Veroli," *Jahrbuch des Deutschen Archäologischen Instituts*, 79, 1964, pp. 279 ff.). A third and somewhat later group includes those warriors who may originally have belonged to one of the two groups just mentioned but who have lost their distinguishing features, as well as others who come from mythological or historical battle scenes where they were never distinguished. Because the figures are taken out of context, their original meaning is soon lost, and a

process of assimilation and gradual change begins whereby the figures, first partially and then completely, shed their armor and garments. At the same time the proportions change to a putto-like appearance and the movements become exaggerated, a stride turning into a dance-like motion which, as time goes on, becomes progressively wilder.

The figures on our casket reflect the beginning of this transformation. In some cases their ultimate source can still be determined; in others it may be only suggested, while for a few it is completely obscure. The left plaque of the lid (PL. XXVIII, A) is typical of the ambiguity resulting from the process of assimilation. Dressed only in a *tunica exomis*, our warrior holds a lance in his right hand and thrusts out his left arm in a commanding gesture. His stance and gesture are identical to those of a warrior on a casket in La Cava (G-W, I, pl. III, 6b), but the latter retains the identifying helmet, armor, and shield of the original soldier type. The source of these two figures must have existed in an illustrated manuscript of the Book of Joshua. In the Joshua Rotulus in the Vatican, there is an illustration of Joshua sending the Israelites into battle against the men of Ai which depicts him in a similar commanding pose, though he has the shield shouldered there (*Il rotulo di Giosuè. Codice Vaticano Palatino Greco 431*, Milan, 1905, pl. IX; K. Weitzmann, *The Joshua Roll. A Work of the Macedonian Renaissance*, Princeton, 1948, p. 21 and pl. IX, 31 [the figure at the extreme right]. Cf. also the corresponding figure in the Octateuch, Vat. gr. 747, *ibid.*, fig. 32). Were it not for the spear our warrior holds, his association with the soldier type would have been lost altogether. On the other hand, it is not impossible that the ivory carver deliberately made the changes in order to give him the appearance of a mythological hero, for among a group of plaques in Liverpool, originally from a casket, there is a figure quite similar in pose and gesture whom I have identified as Hippolytus repudiating Phaedra (G-W, I, pl. XV, 30e; Weitzmann, *Greek Mythology*, p. 175, pl. LV, 219). Therefore, we may see here a fusion of a biblical and a mythological type.

Also based on an illustration of the Book of Joshua is a plaque on the front (PL. XXVIII, E), which I believe depicts one of the two messengers who announce to Joshua the flight of the kings of the Amorites (*Il rotulo*, pl. XIII; Weitzmann, *Joshua Roll*, p. 27 and pl. XII, 42). Both of these messengers are included on a casket in the Victoria and Albert Museum (G-W, I, pl. I, 4). However, the identification of the single figure on our plaque presents no difficulty because the artist has so accurately duplicated the original outline of the messenger on the right, from the position of the spear and shield to the gesture of speech; he has transmitted even the sense of haste. Yet, again the armor and helmet are abandoned. On the left side of the casket (PL. XXIX, D), the same type occurs again, though further removed from the original source. The pose is precisely the same, but the shield has been eliminated and the helmet is changed into a Phrygian cap. Moreover, under the impact of the classical repertory the gesture of speech has been turned into a gesture of astonishment, a change demonstrating how little the artist cared about the original meaning.

The warriors drawn from the Dionysiac realm, chiefly from representations of the battle between Dionysos and the Indians, have quite different and very distinct characteristics. Based essentially on the traditional types of Pan and Silenus, the figures are bald-headed or bearded, have potbellies, and generally are partly nude. On the back

of our casket (PL. XXIX, C) just such a bearded, potbellied fighter wields a sword, defends himself with a shield, and steps forward in a dancing motion. Related to him is a similar bald-headed fighter on a rosette casket in the Metropolitan Museum which, like ours, contains several Dionysiac warriors (G-W, I, pl. VI, 12 c; Weitzmann, *Greek Mythology*, pl. LVIII, fig. 244). The warrior on the lid (PL. XXVIII, B) belongs to the same category. The relationship of this figure to the original Pan type is not immediately apparent, but on the basis of the corresponding figure on the Metropolitan Museum casket, whose small horns are quite visible over the forehead, its derivation from the Pan figure may be assumed (G-W, I, pl. VI, 12 b; Weitzmann, *op. cit.*, pl. LVIII, fig. 242). A third warrior belonging to this iconographic realm is the one on the right side of our casket (PL. XXVIII, G), who strides forward, his shield thrust out before him, as he attacks with his spear. This rather conventional manner of attack is also found in the battle scenes of the Joshua Roll, but the seminudity of this figure and the almost dance-like motion of his stride point rather to the Dionysiac realm.

In three cases the warrior types have become so conventional that their ultimate source can no longer be determined (PLS. XXVIII, C, F and XXIX, A). The first two seem to reflect a fusion of the two traditions, while the third—an archer—is too common a type to associate with a specific literary source, although it is possible that the lost part of the Joshua Rotulus provided the model.

The two remaining figures are actually putti rather than warriors. But because they are represented on the same scale as the warriors in order to fill the prescribed format of the plaques, the two types have become interchangeable, and the iconographic source for the putti is thus no longer clear. The one on the left side (PL. XXIX, E), pouring wine from a skin into a kantharos, is obviously to be derived from a bacchic vintage scene, and this seems also to have been the source for the second putto (PL. XXIX, B), who holds a cup upside down in his right hand and carries a long-necked vessel in his left. A similar figure on a casket in Palermo (Weitzmann, *op. cit.*, pl. XXIV, fig. 43 b) is also drawn from a Dionysiac source.

On the oblique sides of the lid, where rosette caskets of this shape usually continue the same repertory of human figures, our casket has a frieze of animals within the medallion-like loops of a rinceau. Although there is another casket with an animal frieze on the lid (*ibid.*, no. 20, pls. VII–VIII), it is much simpler and has neither the rinceau nor the variety of animals. As in the case of the human figures, illustrated manuscripts provided the main source of inspiration. Of the sixteen animals represented, nine can be derived with varying degrees of certainty from an illustrated Physiologus or some related animal treatise. For parallels we must depend mainly on Latin copies of a Greek archetype, since the only fully illustrated Physiologus, the one in Smyrna, was destroyed in the 1922 fire in that city.

The series begins on the front of the lid with a bird (PL. XXX, A) that turns its head around and pecks at a vine tendril. This is the charadrius, who indicates by turning its head back toward a sick man that he will survive, and by turning it away that he will die (F. Lauchert, *Geschichte des Physiologus*, Strasbourg, 1889, no. 3). By isolating the bird the idea of the unfavorable omen is, of course, lost. An illustrated example is found in the tenth-century Latin Physiologus in Brussels, Bibliothèque Royale cod. 10066–77

(R. Stettiner, *Die illustrierten Prudentiushandschriften*, Tafelband, Berlin, 1905, pl. 177, no. 4). Next to the bird is an ass (PL. XXX, B), an animal mentioned twice in the Physiologus (Lauchert, *op. cit.*, nos. 9 and 45). Its parallel may be found in a Job manuscript of Patmos (cod. 171), dating from the seventh to eighth century, in which there is a similar animal representing the "wild ass in the wilderness" (Job XXXIX:5–8; G. Jacopi, "Le miniature dei codici di Patmo," *Clara Rhodos VI–VII*, pt. III, 1932, fig. 113). This illustration, however, is one of a whole series of pictures which we believe was taken over into the Job manuscript from a Physiologus (*ibid.*, pp. 574 ff. and 584 ff.) to illustrate the chapter dealing with the Creation of the Universe. The rather plump bird in the fourth medallion (PL. XXX, D) is characterized as a peacock, a species included in some later versions of the Physiologus (Lauchert, *op. cit.*, p. 39). The last animal on the front (PL. XXX, E), partly cut off by the oblique frame, is the lion with which the Physiologus begins (*ibid.*, no. 1). Walking with one foreleg raised and his head erect, he corresponds in type to the one described in the first of the three chapters dealing with the different natures of the lion, which tells how the lion obliterates his footprints with his tail. This detail the ivory carver lost by cutting off the hind-part of the animal. In the other two chapters, the lions described are in quite different poses, but all three types are illustrated in the ninth-century Latin Physiologus in Bern, Burgerbibliothek cod. 318 (C. Steiger and O. Homburger, *Physiologus Bernensis*, Basel, 1964, pl. of fols. 7ᵛ and 8ʳ).

On the right side of the lid is a male goat with beard and long curving horns (PL. XXX, F). The Physiologus mentions only a she-goat, the dorca or caprea (Lauchert, *op. cit.*, no. 41), who is able to distinguish the dangerous hunter from the harmless wanderer. The fact that ours is a male goat does not invalidate the argument that he is derived from a Physiologus, since the illustrators of this text were not overly concerned with the sex of the animals and depicted the caprea with a beard (cf. H. M. James, *The Bestiary*, Roxburghe Club, Oxford, 1928, pl. fol. 13ʳ). A typical female caprea may be found in the twelfth-century Latin Physiologus in Klagenfurt (H. Menhardt, *Der Millstätter Physiologus und seine Verwandten*, Klagenfurt, 1956, p. 64).

Also drawn from a Physiologus is the bird on the back (PL. XXXI, A), characterized as an ostrich by its curled tail feathers (Lauchert, *op. cit.*, no. 49). The most striking parallel for it is another miniature in the Patmos Job mentioned above (Jacopi, *op. cit.*, fig. 114; Job XXXIX:13–18). This same manuscript (PL. LXIX, fig. 42) provides a parallel for the griffin on the back (PL. XXXI, D), an animal which occurs in some manuscripts of the later Physiologus recension (Lauchert, *op. cit.*, p. 39; Jacopi, *op. cit.*, pl. XXI, a).

The left side of the lid begins with a siren (PL. XXXI, E). The Physiologus (Lauchert, *op. cit.*, no. 13) describes sirens as half human and half bird, and so they were depicted in the Physiologus in Smyrna (J. Strzygowski, *Die Bilderkreise der griechischen Physiologus*, Leipzig, 1899, p. 16 and pl. II; K. Weitzmann, *Ancient Book Illumination*, 1959, p. 17 and pl. X, 20). In addition, they are usually shown with various musical instruments with which they accompany their alluring songs. It was probably the mere lack of space that caused our siren to be depicted as a bird whose head only is human.

There are three other birds, in all probability also derived from the Physiologus, which have lost the distinguishing features of the model, thus making their identification uncertain. Next to the siren is a bird nesting on top of a palmette (PL. XXXI, F). The

plant may be merely ornamental, but it is equally possible that the bird is derived from the hoopoe (Lauchert, *op. cit.*, no. 8), which in the Bern Physiologus is depicted nesting on a similar palmette-like plant (Steiger-Homburger, *op. cit.*, pl. of fol. 11r). As for the two fat, shortwinged birds (PLS. XXX, H and XXXI, B), I prefer not to attempt any identification.

The last animal to be traced to the Physiologus is placed not on the lid, but on a narrow plaque beneath the lock on the front (PL. XXVIII, D). It represents a serpent whose four natures are described in the Physiologus (Lauchert, *op. cit.*, no. 11), three of which are illustrated in the Bern manuscript (Steiger-Homburger, *op. cit.*, pls. of fols. 11v, 12r, 12v). In the ivory the rendering is obviously so stylized that the original narrative context is lost.

A different source seems to have been used for the grazing goat with long curved horns (PL. XXXI, G) on the left side of the lid. Peaceful grazing is not a characteristic attitude of animals in the Physiologus, and there is on the opposite side, moreover, a goat which better fits the character of the Physiologus illustrations. Possibly a bucolic scene was the model for the grazing goat.

The figure—a satyr shooting an arrow (PL. XXX, C)—in the center of the front stems from yet another source. It is wrongly described in the Corpus as a centaur, but is clearly derived from a constellation picture of Sagittarius such as that in a fifteenth-century Greek manuscript, Vatican cod. gr. 1087, fol. 306r (PL. LXIX, fig. 43). This has the illustrations but not the explanatory text of what must have been one of many commentaries to the *Phaenomena* of Aratus (F. Boll and W. Gundel, in Roscher, *Mythologisches Lexikon*, VI, Suppl. col. 967 and fig. 16). The rearing bear, partly hidden by a palmette (PL. XXX, G), occurs several times among the constellation pictures of the same manuscript (*ibid.*, col. 869, fig. 1).

There seems to be only one animal which is not derived from a miniature, namely the hybrid creature with the foreparts of a winged lion and the tail of a peacock (PL. XXXI, C). This fantastic animal is particularly common on Sassanian silks and their Byzantine copies (W. F. Volbach, *Il tessuto nell'arte antica*, Milan, 1966, figs. 21 and 57), and it is likely that the ivory carver used a textile as the model. This is not a unique case, for it has been demonstrated that the model for the ivory casket in Troyes was a Chinese textile (G-W, I, p. 63, fig. 37 and pl. LXX, 122 d). In sum, we believe that four different sources were used for the animal frieze: the Physiologus (which plays the most important role), constellation pictures, bucolic scenes, and, finally, a textile.

These caskets with classicizing figures and animals are called rosette caskets after the ornamental bands of eight-petalled rosettes which frame the four sides. The ornamental strips were not carved to fit a specific area but were cut from longer strips without regard for the completeness of the final rosette. Simple strips with the bead and reel motif or with circle patterns were used as fillings for narrower spaces. Rosette strips on other caskets have traces of gilding, but none is visible on ours.

A relative chronology of the caskets can be established because of the gradual transformation of the classical model into a figure type which loses natural proportions, movements, and behavior, and turns first into a dancing and finally a twirling creature, floating in the air. The figures on our casket differ stylistically from those on the Veroli

casket in London (G-W, I, pls. IX–X, 21a–c), which is still rather close to the classical source. A closer parallel is the casket in the Musée de Cluny in Paris (*ibid.*, pl. XXIII, 41a–e), where we find similarly exaggerated dancing steps and the beginning of a weakened sense of proportion, although our casket goes a step further in this direction. On the other hand, the general layout of the Dumbarton Oaks casket—its truncated lid and, more specifically, the fitting of the lid's oblique sides with a rinceau pattern into which human figures and ornaments are enclosed as if in medallions—has direct parallels on three caskets in Novgorod, Leningrad, and New York (*ibid.*, nos. 47–49, pls. XXVI–XXXI). On these, however, some figures have already begun to twirl, and we must thus conclude that our casket is slightly later than the Cluny casket and slightly earlier than the other three.

The treatment of the garments with their drilled folds, the expression of the faces with their contracted brows, and other details make it clear that the caskets were manufactured in the same Constantinopolitan workshop as the ivories of the so-called "painterly" group, to which the plaque of the Incredulity of Thomas belongs (No. 21). The most classical ones must be placed, therefore, in approximately the same period, the second half of the tenth century, whereas those further removed from the classical models date well into the eleventh. As for our casket, it is impossible to be sure whether it belongs still to the tenth or already to the eleventh century.

Maurice de Rothschild Collection, Paris.

L. Brehier, "Le coffret byzantin de Reims," *Gazette des beaux-arts*, 73, I, 1931, pp. 265 ff. and figs 6, 7, 14. Goldschmidt-Weitzmann, II, no. 236, pls. LXXVI–LXXVII. *D.O.H.*, 1955, no. 238 and pl. *D.O.H.*, 1967, no. 289 and pl.

24. Plaque of a Diptych (?)
 Crux Gemmata with Emperor Medallion
 Constantinople, middle of tenth century
 Height 28.8 cm. Width 13.3 cm. Thickness 0.8 cm.
 Acc. no. 37.18 PLATES XXXII, XXXIV

There is clear evidence that the plaque has been used for two different purposes. Four large holes, one in the center of each side of the frame, indicate that it was attached to a wooden ground by means of ivory pegs (PL. XXXIV, B), while three small holes along the right side, corresponding to cuts into the edge of the frame, were made to hold metal hinges fastened with nails (PL. XXXIV, A). This hinged *montage* led to severe damage to the lower right corner, which was broken off and is now glued on. A triptych in the Palazzo di Venezia in Rome (Goldschmidt-Weitzmann, II, no. 31, pl. X), with hinges of a similar type, is another case where such cuts have badly damaged the frame; but here, also, the hinges are later, as will be discussed below. The upper two nail holes are now filled with ivory pins.

In the lower left field a piece of ivory in the form of a heraldic shield has been cut out. It seems a plausible suggestion that at one time a Western owner inserted here his coat of arms, which was subsequently removed or lost. The plain piece of ivory now replacing the heraldry must, however, be a repair of considerable age, for the cracks in this piece correspond almost exactly to those of the plaque proper. Because of the Gothic form of the shield, one is tempted to suggest that perhaps it was a Crusader who brought this and the corresponding plaque in Gotha (see *infra*) to the Latin West and had a diptych made from them. At that time, the sunken field on the reverse (PL. XXXIV, B) may have been cut, but for what purpose is not absolutely clear. Surely it is too shallow to hold wax, as was customary in such writing tablets as the consular diptychs. Moreover, there is no evidence that tenth-century Byzantium still adhered to the ancient custom of writing with a stylus on wax-filled tablets of ivory or wood. It is possible that the artist wanted to cut a frame for some painted representations which are now lost, but this could have happened only after the plaque had been separated from the wooden backing and turned into a diptych. A second possibility, to be discussed below, is that the sunken field was made to hold one or several parchment sheets in place.

The background of the palmette frieze is painted green, but this seems to be a later addition, probably of the Gothic period. If there was any original color, it would, in the Byzantine tradition, have been gold. There are several vertical cracks on the ivory, but none has split the plaque. The rather lightcolored surface of the obverse is covered with a dense *craquelure* of vertical lines that contrasts with the smooth but darker surface of the reverse. The emperor's face shows signs of rubbing which somewhat disfigure the nose and mouth, but otherwise the plaque is well preserved.

Framed by a broad and rather simple palmette frieze is a *crux gemmata* of monumental character, filled with large squares imitating precious stones set *en cabochon*. The arms of the cross terminate in pairs of drops. Due to the narrow shape of the plaque, the cross-arms are rather short. At the intersection of the bars is a medallion containing the bust of a youthful emperor who turns to his left in a gesture of prayer or supplication. He wears the loros, which is usually decorated with stones and pearls, but which on our plaque, because of its small scale, is simplified and embellished merely by three rows of pearls. His crown, adorned with a double row of pearls, is also simplified by the omission of the headstone, but the surmounting cross is retained. The rendering of the pendulia, however, which end in three pearls carefully displayed on the emperor's shoulders, is very precise.

The face of the emperor with its soft features is rather that of a child than a youth, and this precludes his identification as Constantine the Great, as was tentatively suggested at a time when the plaque was known only through an engraving whose faithfulness could not be judged (Goldschmidt-Weitzmann, II, no. 37—the location of the plaque was unknown at the time the Corpus was written). The face is reminiscent of the youthful Emperor Romanos II (945–49), as he is represented on the well-known coronation plaque in the Cabinet des Médailles in Paris (PL. XXXV, fig. 23) (*ibid.*, no. 34, text fig. 12 and pl. XIV), and since our ivory is a product of the same workshop and must be almost contemporary with it, the identification of our emperor as Romanos II, who was six years old when crowned, has the greatest probability. Yet, other emperors represented in their

youth, like the three sons of Romanos I Lecapenos, cannot be entirely excluded as possibilities (J. Deér, see bibliog. *infra*).

Even when only the engraving of the emperor plaque was known, it was realized that it formed a pair with a plaque in Gotha (PL. XXXIII, fig. 20) (Goldschmidt-Weitzmann, II, no. 36, pl. XIV), which has the same measurements and the same cross and ornaments, and differs only in that the medallion at the intersection represents Christ seen in frontal view, blessing and holding the Gospel-book. This Pantocrator has a nimbus of a form typical of the Romanos group. That these two plaques once formed a diptych is indicated by the three holes at the right edge of the emperor plaque which correspond to those at the left edge of the Christ plaque (PL. XXXV, fig. 22). In describing the Gotha plaque in the Corpus, it was suggested that the reverse was used for the writing of liturgical texts (PL. XXXV, fig. 21). This idea seems to me to be correct, except that such texts were at this time no longer written on wax, but either directly on the ivory or on parchment sheets, and it was perhaps for these latter that the sunken field was cut.

As a parallel for the custom of cutting parchment sheets to fit the shape of such ivory plaques, the two pairs of plaques in Bamberg, which belong also to the Romanos group, can be adduced (*ibid.*, nos. 65–66 and pls. XXV–XXVI). They enclose the prayer books supposedly written for the private use of the German Emperor Henry II and his wife Kunigunde. Obviously the ivory plaques were not made to serve as bookcovers, but were so used only after they had been imported to the Latin West. So far we have no evidence that parchment sheets cut to the size of ivory plaques were produced in Byzantium, while in the Latin West the case of the Bamberg prayer books is not isolated. For example, there is a late twelfth-century manuscript in Paris which has the Laudes of Sorrows written on parchment sheets in the shape of diptych wings (E. Kantorowicz, *Laudes Regiae*, Berkeley, 1946, pp. 191 ff. and pl. XI). The four plaques in Bamberg representing Christ, the Virgin, Peter, and Paul, and the fragment of a fifth with the Archangel Gabriel originally served, according to the author's theory, as the decoration of the precious epistyle of an iconostasis (K. Weitzmann, "Die byzantinischen Elfenbeine eines Bamberger Graduale und ihre ursprüngliche Verwendung," *Festschrift für K. H. Usener*, Marburg, 1967, pp. 11 ff.).

The question should therefore be raised whether the emperor and Christ plaques were actually intended as a diptych, or whether they may originally have been part of another setting and were only at some later time (presumably in the Latin West) united in the form of a diptych. Both technical and artistic considerations favor the latter assumption. The use of metal hinges on diptychs and triptychs is perfectly acceptable in the Byzantine period, but generally the manner of attaching them is quite different from that used on these plaques, where the hinges are inserted into lateral cuts on the side of each wing (PL. XXXIV, A; PL. XXXV, fig. 22). On all triptychs which still have their original hinges, these are not inserted but are instead attached to the surface of the ivory with nails (Goldschmidt-Weitzmann, II, nos. 38, 39, 40, 46, 55). Hence, it is likely that the hinges on the two plaques are not of Byzantine workmanship but are a later addition.

We have hinted above at the close relationship of our emperor portrait to the figure of Romanos II on the plaque in the Cabinet des Médailles, where he flanks Christ on one side and his wife Eudocia on the other. One may therefore ask whether in our case

also there may have existed at least one other cross-plaque with a medallion representing the Empress Eudocia. This would create a more balanced composition akin to that of a Deesis group. Perhaps we are even dealing here with the remnants of a still larger set of plaques that were originally mounted on a wooden beam, thus forming a parallel to the beam reconstructed on the basis of the Bamberg ivories. On such a beam the ivories would be placed in sunken fields and held in place by overlapping metal strips. Additional fastening could be done with ivory pegs, as in the case of the Dumbarton Oaks plaque, but this was not necessarily required; the Gotha plaque, for example, has no such nail holes.

With only two plaques surviving, it would be hazardous to attempt any further reconstruction or to suggest who may have been represented in additional medallions. Whether such a beam was part of an iconostasis or of another piece of church or palace furniture—even this question cannot be answered in the present state of our knowledge. On the other hand, there is no doubt that there existed in Byzantine art the motif of a series of recessed arches, each enclosing a cross, such as that on a marble frieze found recently at the excavation of the church of St. Polyeuktos in Istanbul (PL. LXX, fig. 44) (R. M. Harrison and N. Fıratlı, "Excavations at Saraçhane in Istanbul. First Preliminary Report," *D.O.P.*, 19, 1965, p. 234 and fig. 6). I am aware that I have proposed only an alternate solution, based on the reconstruction of the iconostasis beam to which the Bamberg plaques belong. There still remains the possibility that our plaque, together with that in Gotha, formed a diptych and that no other plaques are lost.

While the emperor plaque shows all the characteristics of the Romanos group (Goldschmidt-Weitzmann, II, pp. 14 ff.), the execution is less detailed and rather summary. It shares this almost sketchy treatment with the Bamberg plaques, and the explanation may well be their similar purpose, namely to decorate a piece of furniture not intended to be seen at close range. Therefore, the summary treatment and simplification of detail may be intentional and need not be explained as a sign of either inferior quality or provincialism.

Francesco Maria Fiorentini Collection, Lucca.
Bliss Collection, 1937.

Seb. Donatus, *Dei dittici degli antichi profani e sacri*, Lucca, 1753, Lib. III, Cap. II, p. 188 and pl. V. A. F. Gori, *Thesaurus Veterum Diptychorum*, III, Florence, 1759, pp. 142 ff. and pl. XXI. Goldschmidt-Weitzmann, II, no. 37 and pl. XIV. *Arts of the Middle Ages*, Museum of Fine Arts, Boston, 1940, no. 118. *Bull. Fogg*, 10, 1945, fig. p. 112. *D.O.H.*, 1955, no. 235. J. Deér, "Das Kaiserbild im Kreuz," *Schweizer Beiträge zur allgemeinen Geschichte*, 13, 1955, pp. 64 ff. and pl. VII. *D.O.H.*, 1967, no. 282.

25. Left Wing of a Triptych
 The Emperor Constantine
 Constantinople, about the middle of the tenth century
 Height 16.5 cm. Width 6.5 cm. Thickness 0.5 cm. PLATE XXXVI
 Acc. no. 47.11 COLOR PLATE 5

The slightly warped plaque once formed the left wing of a triptych. This is indicated both by its rounded right edge, which allowed the wing to turn easily, and by the holes for the dowels with which the wings were attached. At the top, just below the frame, is a hole of obviously later date which must have been made to suspend the plaque after it had been detached from the triptych. This is now filled with a small piece of ivory. The plaque is in perfect condition and has a warm, creamy tone on the obverse; the reverse is slightly darker, and a number of scratches mar its surface. The ground of the ivory has been cut so thin that when held against the light it is translucent like alabaster, the opaque figure of the emperor silhouetting clearly (COLOR PLATE 5).

The plaque shows an emperor in frontal position but turned slightly to his left, his head inclined in the same direction and with his left hand extended in a gesture of supplication. In order to give emphasis to this gesture he is not standing on axis, but sways slightly to our left in an off-balance pose which diminishes the impression of bodily weight. He is represented in the full regalia of a Byzantine emperor, wearing the jewel-studded loros, pearl-studded shoes, and a crown with pendulia, and holding a scepter carved with a bead and reel motif which terminates in a cross. The reverse of the plaque is decorated with a slender cross resembling those in metal, the tongue of which is fastened into a pedestal of five steps. This joint is covered by a disc like that marking the intersection of the arms.

The fact that there is no inscription—unless there was a painted one now lost—speaks in favor of the identification of the emperor as Constantine the Great. Yet, it will be noted that the face with its rather full beard is quite similar to the portrait on the Coronation plaque in Moscow (PL. XXXVI, fig. 24) (Goldschmidt-Weitzmann, II, no. 35, pl. XIV), which is inscribed Constantinos Autocratoros and no doubt represents Constantine VII Porphyrogenitus (913–59). Thus, it seems to us more than likely that the figure on our plaque, which is roughly contemporary with the one in Moscow, is also meant to represent Constantine Porphyrogenitus, though in the guise of Constantine the Great. It is worth noting that in two other instances this particular Emperor was depicted in the guise of another. A pair of painted wings of a triptych at Sinai shows on one side King Abgarus of Edessa enthroned, holding the Mandylion in his hands. It has been demonstrated that the head of Abgarus is likewise similar to that of Constantine Porphyrogenitus on the Coronation plaque in Moscow and on the coins of this Emperor (K. Weitzmann, "The Mandylion and Constantine Porphyrogennetos," *Cahiers archéologiques*, 11, 1960, pp. 182 ff. and figs. 17–19). The fact that the emperor on our plaque is nimbed does not refute the theory that this is a contemporary ruler. Although the emperor on the Coronation plaque in Moscow has no nimbus, other emperors of that period do, as, e.g., Romanos II on the famous Coronation plaque in the Louvre (Goldschmidt-Weitzmann, II, no. 34, pl. XIV).

As already suggested in the Corpus, the corresponding right wing of our triptych certainly must have had a representation of St. Helen. Since the wife of Constantine Porphyrogenitus was also named Helen, it seems only natural to assume that she was represented on the lost right wing in the guise of another Helen, the mother of Constantine the Great. The missing plaque between these wings in all likelihood depicted a Crucifixion, as on the central plaque of a triptych in the Cabinet des Médailles in Paris (*ibid.*,

no. 39, pl. XVI). In this case, Constantine and Helen are represented in diminutive scale at either side of Christ on the cross, and it is quite likely that we are again dealing with Constantine Porphyrogenitus and his wife in disguise. We know that he was an ardent collector and worshipper of relics, and in the two cases discussed here he is represented in the act of venerating a holy relic: the Cross on the ivory of Paris (presumably also on our ivory) and the Mandylion on the icon wings at Sinai.

Graeven (see bibliog. *infra*) proposed that a Crucifixion plaque which, like ours, was in the Stroganoff Collection in Rome (*ibid.*, no. 157, pl. LIV) formed the center of the triptych to which our emperor belonged. While the height does indeed fit, the reconstruction of the damaged Stroganoff Crucifixion would lead to a width of 14 cm., which is too wide for a pair of wings each measuring 6.5 cm. Moreover, the Stroganoff Crucifixion is a representative of the pure "triptych" group and does not show the mixture of styles evident in the emperor plaque, which is also superior in quality.

The relief is rather low, as is typical of triptych wings (the central plaques normally have a higher relief). The head of the emperor is sensitively carved and is very much in the style of the Romanos group, but the proportions of the body are thicker and lack the elegance of the figures in that group. The simplified, soft treatment of the folds of his robe corresponds more to the style of the so-called "triptych" group (*ibid.*, pls. XLVII–LXIV). Our ivory represents, thus, a mixture of the styles of two ateliers which worked contemporaneously in Constantinople where, we believe, our plaque also originated.

Stroganoff Collection, Rome.
Arthur Sachs Collection, New York.

G. Schlumberger, *L'épopée byzantine à la fin du dixième siècle*, I, Paris, 1896, fig. p. 45. H. Graeven, *Frühchristliche und mittelalterliche Elfenbeinwerke in photographischer Nachbildung*, I, *Aus Sammlungen in Italien*, Rome, 1900, pp. 39–40, nos. 73–74 and pls. 73–74. A. Muñoz, *Pièces de choix de la collection du Comte Grégoire Stroganoff*, II, Rome, 1912, p. 165, pl. CXVIII, 1. Goldschmidt-Weitzmann, II, no. 75, pls. XXIX, LXIII. *Early Christian and Byzantine Art*, Baltimore, 1947, no. 148, pl. XXIX. *Bull. Fogg*, 10, 1947, p. 230. *D.O.H.*, 1955, no. 233 and pl. *Athens Exhibition Catalogue*, 1964, no. 90 and pl. *D.O.H.*, 1967, no. 285 and frontispiece.

26. Central Plaque of a Triptych
 The Hodegetria between John the Baptist and St. Basil
 Constantinople, second half of tenth century
 Height 16.2 cm. Width 10.6 cm. Thickness 0.8 cm. (with ledge, 1.7 cm.)
 Acc. no. 39.8 PLATES XXXVII, XXXIX, XL
 COLOR PLATE 6

The three figures were originally part of a plaque the background of which was cut away, presumably because it had splintered or broken. Such damage occurs frequently in good ivories where the background is so thin as to be translucent. The cutting around

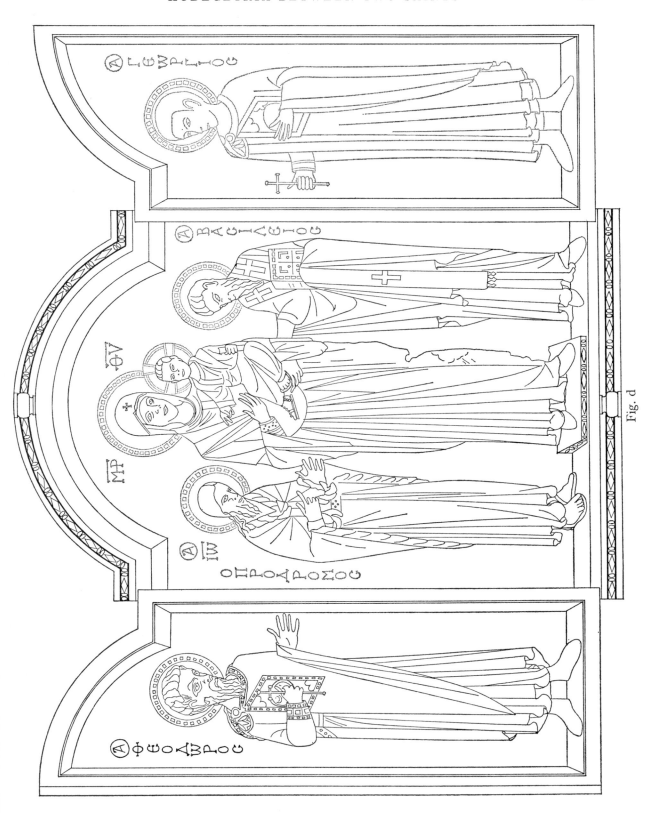

Fig. d

the figures was carelessly executed: all four figures surely had nimbi which were cut away, the thumb of the bishop's right hand was lost and a small section of the Virgin's *paenula* near her left knee has broken off. Otherwise, the figures are well-preserved and the surface shows hardly any traces of rubbing; the crispness of the sharply cut folds of the drapery reflects the original quality of the carving (PL. XXXIX, COLOR PLATE 6).

That the plaque formed the central panel of a triptych is indicated by the remains of a ledge fastened with ivory pegs to the lower frame. Such ledges, added to the top and bottom, served to hold the wings in place by means of dowels. The left half of the bottom ledge is original and is decorated with a bead and reel motif, while the right half is a modern repair. The original system of attaching wings to a central plaque may be seen in the intact triptych at Liverpool (Goldschmidt-Weitzmann, II, no. 155, pl. LIV). I have been able, if I am not mistaken, to identify one of our missing wings as the plaque in the Louvre

Fig. e

that represents St. Theodore (PL. XXXVIII, figs. 25, 26) (*ibid.*, no. 74, pls. XXIX and LXII), which will be discussed below. On the basis of this plaque we can reconstruct the central panel very precisely (text figs. d, e). The Louvre plaque is 18.2 cm. high. To determine

the original height of our central plaque, that of the ledges on the top and bottom, measuring 0.8 cm. each, must be added, so that we arrive at an original height of 19.8 cm. The width of the Louvre wing proper is 6.6 cm. Projecting from the wing 0.3 cm. is half of the colonnette which overlaps the other wing when closed, and it is therefore not included in the actual width. The total width of both wings, each measuring 6.6 cm., is thus 13.2 cm., which corresponds to the width of the central plaque.

The standing figure of the Virgin holding the Christchild on her left arm harks back to the Hodegetria, the most famous icon of Constantinople, which according to tradition was sent, in the fourth century, by the Empress Eudocia in Jerusalem to her sister-in-law Pulcheria in Constantinople, where it served as the palladium of the city. While normally the Virgin holds the Child so that her left hand touches Christ's leg, in our ivory she holds Christ's left foot with a firm grip. Nevertheless, the Christchild does not sit firmly on the Virgin's arm, but is rendered in a manner suggesting a weightless body. In contrast to other representations of the Hodegetria type, Christ's blessing hand is directed downward toward John the Baptist. The last of the prophets is depicted in a gesture of supplication, exactly as in the Deesis where, especially in some ivories of the Romanos group (*ibid.*, pls. x–xiii, 31–33), he is standing at the right side of Christ; indeed the whole composition seems to have been conceived, in its formal aspect, as an imitation of the Deesis. John is dressed in a girdled tunic with a fur-trimmed mantle knotted over his chest, precisely as in the plaque in Liverpool (*ibid.*, no. 52, pl. xxii), so that his identity can hardly be doubted. The only possible alternative would be the prophet Elijah, who is customarily represented in the same costume.

To the Virgin's left stands a bishop who holds the Gospelbook with his covered left hand and extends his right toward her in a gesture of supplication. When first published by Peirce and Tyler (see bibliog. *infra*), the bishop was called John Chrysostom. However, in a review of their study I pointed out that the facial type clearly is that of St. Basil and not John Chrysostom, because the latter is characterized by a bald forehead and sparse beard, while Basil has a narrow forehead and long beard. This new identification has been accepted by S. Der Nersessian (see bibliog. *infra*). An ivory triptych of the Romanos group in Berlin (*ibid.*, no. 72, pl. xxviii), which shows the two church fathers side by side on the right wing, makes these differences very clear. Thus we can quite safely restore the inscriptions of the lost background as M͞P Θ͞V Ⓐ I͞W Ο ΠΡΟΔΡΟMOC and Ⓐ BACIΛEIOC, in characters of the same type as those on the Louvre wing (text fig. d).

The choice of John the Baptist and Basil to flank the Virgin as supplicants is rather unusual, perhaps even unique, and requires some explanation. The workshop that produced the so-called Romanos group was closely connected with the imperial court, as indicated by the two coronation plaques, the one in Paris with Romanos II and Eudocia, and the other in Moscow with Constantine VII Porphyrogenitus (*ibid.*, nos. 34–35, pl. xiv). It has been argued that the triptych in the British Museum (*ibid.*, no. 38, pl. xv) was also made for a member of the imperial court, in this case Anna, the daughter of Constantine Porphyrogenitus and younger sister of Basil II, because it gives such a prominent place to St. Anne. Thus, it is thought that a saint might be represented on a plaque because the member of the ruling house for whom the plaque was made was that saint's namesake.

It may be for this reason that the figure of the church father Basil was chosen; this would mean that his namesake could only be Basil II (976–1025), since stylistically the ivory points to a date around the turn of the tenth to the eleventh century. In a work made for this Emperor, the choice of John the Baptist would also have special significance, for we know that the venerated relic of the head of John the Baptist was brought by the abbot of the Studios monastery to the dying Basil II.

As mentioned above, I believe that a triptych wing in the Louvre with St. Theodore (PL. XXXVIII, figs. 25, 26) (*ibid.*, no. 74, pl. XXIX) originally formed the left wing of our triptych. The figure scale and such details as the expression of the eyes, the treatment of the hair, the extended hand with its short, stiff fingers, and the hemline of the tunic agree to such an extent that they should be understood as the personal style of the carver. The reverse of the Theodore plaque shows five interlaced disks with rosettes, enclosed within a circle, and at the outer edge a colonette with a garland decoration which was meant to keep the wings in place when closed. This colonette rested on a small base which is preserved in the middle of the ledge of our plaque, and we can confidently assume that the missing upper ledge had a corresponding capital. Thus the wings were conceived as gates, like the royal doors of an iconostasis which, when opened, give access to the sanctuary and reveal the image of the Virgin, in mosaic or fresco, in the apse.

St. Theodore, a soldier-saint, is depicted not in armor but in ceremonial court dress, i.e., a long, girdled tunic with a decorated roundel on the shoulder and the chlamys with an ornate tablion. This costume enhances the imperial character of the triptych and is one more example of the prevalence of imperial iconography in the Romanos group. There are two soldier-saints by the name of Theodore, the Tiron and the Stratelates. Both have long beards, but the Stratelates seems to be the more popular and is more often represented; thus I believe him to be the one depicted in the Louvre plaque.

The lost right wing surely must have contained another soldier-saint in a similar costume, holding the cross of martyrdom in one hand and extending the other in supplication toward the Virgin in the center (text fig. d). The companion of Theodore the General in all probability was St. George, since no other saint is so often associated with him, not only in other ivories (*ibid.*, pl. X, 31a; pl. XV, 38a), but in icons and other media as well. If I am not mistaken, St. Theodore and St. George are the two saints who flank the Virgin on a sixth-century icon from Sinai which I believe to be Constantinopolitan (K. Weitzmann, M. Chatzidakis, K. Miatev, and S. Radojčić, *Frühe Ikonen. Sinai; Griechenland; Bulgarien; Jugoslavien*, Vienna, 1965, pp. ix–x and pls. I–III). The only distinction between the figures of St. Theodore and St. George is that the latter is always depicted beardless.

In terms of the nobility of the poses, the restrained gestures, the refinement of the aloof facial expressions, and the sharp, pristine carving of the draperies, the ivory ranks among the very finest of the Romanos group and may, indeed, have been made for the Emperor. Moreover, it is evidence of the widespread veneration of the Hodegetria that she occurs several times as a very stately figure in this group of ivories. In two cases, the plaques in New York and Hamburg (Goldschmidt-Weitzmann, II, nos. 48–49, pl. XX), the background around the figures has been cut away as it has in our plaque, while a third example, a Virgin in London (*ibid.*, no. 51, pl. XXI), has been carved as a statuette

in a size larger than normal—a unique instance among Byzantine ivories. Two plaques, one in Utrecht (*ibid.*, no. 46, pl. XX) and the other in the cathedral of Liège (*Athens Exhibition Catalogue*, no. 64 and pl.), terminate in a recessed arch such as is postulated in the reconstruction of our ivory. In all these examples the Virgin is large and appears more monumental because she alone fills the panel. The supplicants could have been represented only on the wings, while in our case they occupy both the central panel and the wings, thus emphasizing more strongly the Virgin's role as intercessor.

Bliss Collection, 1939.

Arts of the Middle Ages, Museum of Fine Arts, Boston, 1940, no. 119 and pl. I. H. Peirce and R. Tyler, "Three Byzantine Works of Art," *D.O.P.*, 2, 1941, pp. 11 ff. and pls. 1–2. *Bull. Fogg*, 9, 1941, p. 75 and fig. 7. H. Swarzenski, in *Art Bull.*, 23, 1941, p. 77 and pl. K. Weitzmann, review of Peirce and Tyler, *Art Bull.*, 25, 1943, pp. 163 ff. *Bull. Fogg*, 10, 1945, pl. p. 105. *D.O.H.*, 1955, no. 234 and pl. S. Der Nersessian, "Two Images of the Virgin in the Dumbarton Oaks Collection," *D.O.P.*, 14, 1960, pp. 74 ff. and fig. 1. *Athens Exhibition Catalogue*, 1964, no. 67. *D.O.H.*, 1967, no. 286 and pl.

27. Central Plaque of a Triptych
The Descent from the Cross
Constantinople, second half of tenth century
Height 17.1 cm. Width 13 cm. Thickness 0.9 cm.
Acc. no. 52.12

PLATE XLI
COLOR PLATE 7

There is evidence that this plaque once served as the central panel of a triptych. The frame around the plaque is slightly wider at the top and bottom for the attachment of ivory ledges, into which the wings were inserted by means of dowels. The fact that there are more holes in the frame than are normally required for the fastening of these ledges may mean that the extremely fragile original *montage* was damaged and required a repair for which new holes were drilled. The ledges were usually decorated with a carved bead and reel (cf. the Virgin plaque, No. 26), but on our plaque, contrary to custom, this motif was repeated on the underside of the ledge. It must have been carved after the ledge was attached, because a narrow edge of this ornament is visible on the plaque proper (PL. XLI, B).

In the underside are three oblong incisions which indicate that the plaque was once fastened onto a base. Since such incisions are not common in Byzantine ivories, we assume that this mounting was of a later period. Corresponding to these cuts are five holes in the upper edge, indicating that a piece also crowned the top. The appearance of this mounting may be illustrated by a plaque in the Louvre with the seated figure of Christ (Goldschmidt-Weitzmann, II, no. 61, pl. XXIV). In this case, pieces of ivory carved with the four Evangelist symbols were added in the Romanesque period to the top and

bottom of the plaque so that it would fit into a bookcover. It is quite likely that the additions made to our Deposition plaque served the same purpose.

The plaque is well preserved, although a few minor cracks starting just above the body of Christ have slightly damaged the baldachin. The highest points of the relief are slightly rubbed, but this affects neither the crisply cut folds nor the delicately carved faces. Both figures and architecture are deeply cut, leaving the background so thin that when held against the light the ivory is as translucent as alabaster (COLOR PLATE 7).

The Descent from the Cross forms a balanced composition enclosed by a richly decorated baldachin. The large cross, braced by three pegs, rises from the hill of Golgotha and fills the background, its arms extending behind the arch and the *tabula ansata* hidden behind the baldachin. Christ's arms have been freed from their nails and His body slumps limply over the shoulder of Joseph of Arimathaea, who reaches up to support Him; in contrast to His limp body, Christ's legs remain erect on the *suppedaneum*. The Virgin, standing at the left with veiled hands, has taken hold of the right hand of Christ and kisses it with restrained sorrow. John stands at the other side of the cross in a stately and unemotional pose, displaying the Gospel in his left hand. In front of him is a youthful figure, surely meant to be Nicodemus, who, with a chisel in his left hand and a hammer in his right, loosens the nail so that it can be removed with a pair of tongs from Christ's left foot, the action normally represented in the Deposition. The inscriptions are confined to the three main figures: IC̄ XC̄, MP̄ ΘV̄, and Ⓐ IѠANNHC.

In Byzantine ivories of the tenth and eleventh centuries the Deposition is depicted in four distinct phases which gain in emotional intensity as the drama unfolds. In the first (Berlin, Constance, and Coll. Ludlow, Goldschmidt-Weitzmann, II, nos. 207–9, pl. LXVIII), Christ appears exactly as in the Crucifixion proper, but Joseph of Arimathaea has ascended the ladder and extends his arms, ready to support Christ's body when it is freed from the cross. Nicodemus may be represented either standing on a ladder removing the nail from Christ's left hand, or standing on the ground and removing the nail from His foot. The second phase, as represented by ivories of the "painterly" group (Munich, London, Victoria and Albert Museum, and Quedlinburg, *ibid.*, no. 22, pl. VI; no. 23, pl. VII; no. 25. pl. VIII), shows Christ's right arm already freed from the cross and held by the Virgin, while Nicodemus in all three instances is busy removing the nail from Christ's left arm, In the third phase (Ravenna and Pesaro, *ibid.*, no. 204, pl. LXVII and no. 211, pl. LXIX), both arms of Christ are freed, and Joseph of Arimathaea must make a greater effort to support His limp body. Nicodemus, no longer needed to remove the nail from Christ's hand, is concerned with the nails in His feet. In the last and most dramatic phase (Hannover, *ibid.*, no. 40, pl. XVII), the body of Christ breaks sharply at the knees; though His lower legs are still in position on the *suppedaneum*, the rest of His body has been lowered nearly to the ground by Joseph, and the Virgin helps Joseph in this task.

Our plaque reflects essentially the third phase, though it does not agree in all points with the two parallels quoted; in fact, it takes a unique position among the Middle Byzantine ivories of the Deposition. To a large extent, the iconography can be explained as the artist's endeavor to combine the dramatic action of the "painterly" group with the compositional principles of the Romanos group, which aim at a hieratic and iconic

quality. By drawing from two different sources, however, the artist was confronted with formal problems which were not altogether satisfactorily solved.

It will be noted that in representations of the first three phases, Joseph of Arimathaea always stands on a ladder in order to reach Christ. In our ivory the genre element of the ladder has been eliminated, but Joseph's pose has not been altered. Thus he stands with his foot illogically suspended, in a position identical to that seen when he is actually climbing up the ladder. Furthermore, this change causes Joseph to appear as the largest figure in the relief because, having placed him on the ground, the artist simply elongated his body to enable him to reach the body of Christ. But such a solution is neither stylistically nor iconographically satisfactory, since he thus dwarfs both the Virgin and St. John. The desire to place the figures on a groundline corresponds to the hieratic tendencies of the Romanos group, and it is noteworthy that the only other case where Joseph is standing on the ground occurs on an ivory of the Romanos group, the Deposition plaque in Hannover. Another feature which our ivory has in common with the Hannover plaque is that both Joseph and Nicodemus are dressed in long tunics and mantles, whereas normally they wear the short tunic of the workman. Thus, once more a genre element has yielded to a more hieratic representation.

The characterization of the figure who must be identified as Nicodemus is also unusual because he is shown as a youth. The standard iconography of the ivories shows both Joseph and Nicodemus bearded, for as types the two were not distinguished from one another. The explanation for this change on our plaque may be found in an ivory triptych of the "painterly" group in Munich (*ibid.*, no. 22, pl. VI), where, in addition to Joseph and Nicodemus on the ladder, there is a third workman, a youth without a beard, who is busy removing the nail from Christ's right foot. We therefore assume that the youthful figure on our plaque is based on this third workman from a more elaborate archetype. When Nicodemus on the ladder was eliminated, the artist simply took over the youthful figure of the third workman as his model for him.

Unique on Byzantine ivories is the motif of loosening the nail with a hammer and chisel instead of a pair of tongs. Yet this is not an invention of our artist but occurs also in a Carolingian manuscript in Angers (G. Millet, *Recherches sur l'iconographie de l'Evangile*, Paris, 1916, p. 468 and fig. 492). This rare motif was surely not invented twice independently; thus we assume a common archetype prior to the eighth century, whose origin must be sought in Byzantium.

The Virgin stands erect and motionless under the cross with her veiled hands raised, in a position similar to that in the Crucifixion triptych in Berlin, the work of the Romanos group closest to our ivory (Goldschmidt-Weitzmann, II, no. 72, pl. XXVIII). When this Virgin type, invented for a Crucifixion, was adapted to a Deposition, she was made not only to hold the right hand of Christ, as is common, but actually to kiss it. For this action we find only one contemporary parallel—although later this motif occurs frequently—namely, the plaque in Quedlinburg (*ibid.*, no. 25, pl. VIII), an ivory of the "painterly" group where one expects such an emotional feature to occur. John, who stands erect and motionless, is basically the same type as seen in the Berlin Crucifixion, except that, instead of pointing to Christ or raising his hand toward his cheek in an expression of sorrow, he holds his right arm in the sling of his mantle and grasps its edge.

Though a rare motif, it does occur in a miniature of the Deposition in the Gregory manuscript in Paris, cod. gr. 510, dated between 880 and 886 (H. Omont, *Miniatures des plus anciens manuscrits grecs de la Bibliothèque Nationale du VI au XIV siècle*, Paris, 1929, pl. XXI).

The Descent from the Cross had, as seen in its earliest stage, developed from the Crucifixion proper, and, in the course of time, the composition became more and more independent and acquired a distinct character of its own. Yet, like the Crucifixion, it was a feast picture for Good Friday, and the two were thus interchangeable. It is only because of this liturgical importance as an alternate icon for one of the greatest feasts that the Deposition could be chosen as the central subject of a devotional triptych. Its wings could have had other scenes from the feast cycle, similar to those on the triptych in Munich.

Corresponding to the mixture of iconographic elements from the "painterly" and Romanos groups, our plaque reveals a mixture of styles. A striking feature derived from the "painterly" group is the deeply undercut baldachin with its openwork columns and dome, which rests on a curved architrave decorated with a palmette motif (Goldschmidt-Weitzmann, II, pls. I–II). Although the inclination for straight lines is in harmony with the hieratic style of the Romanos group, the treatment of the dense folds and their deep grooving is more characteristic of the "painterly" group. On the other hand, the facial treatment, aiming at a rather calm expression, and the soft and delicately combed hair reveal a close study of Romanos ivories, although the staring eyes indicate that the artist was probably not a member of this imperial court workshop. The same holds true for the Crucifixion triptych in Berlin, with which our plaque shares other details, such as the design of the hill of Golgotha which seems to suggest plants rather than the more usual rocks. However, the Berlin triptych does not reveal as close a dependence on the drapery style of the "painterly" group as does the Dumbarton Oaks plaque, and, therefore, in spite of their close relationship it seems unlikely that both ivories were the work of the same hand. Furthermore, it will be noted that the carver of our ivory left the nimbi undecorated.

In spite of certain shortcomings which obviously result from the iconographic and stylistic fusion of features from two different workshops, the execution is quite delicate and the composition as a whole shows a nobility and elegance which we associate with the capital. An origin in Constantinople seems to us, therefore, very likely, although the plaque cannot be fitted into one of the major workshops.

Spitzer Collection, Paris.
Chalandon Collection, Lyons and Paris.

Alfred Darcel, *La collection Spitzer*, I: *Les ivoires*, Paris, 1890, no. 18. *Catalogue des objets d'art ... de la collection Spitzer*, I, Paris, 1893, no. 53 and pl. III. E. Molinier, "A propos d'un ivoire inédit du Musée du Louvre," *Mélanges Julien Havet*, Paris, 1895, p. 248, no. 6. *Idem, Histoire des arts appliqués à l'industrie du Ve à la fin du XVIIIe siècle*, I, *Ivoires*, Paris, 1896, p. 111, no. 6. G. Schlumberger, *L'épopée byzantine à la fin du dixième siècle*, I, Paris, 1896, fig. p. 201. E. Molinier, "La Descente de croix," *Monuments Piot*, 3, 1896, p. 125 and fig. 1. G. Schlumberger, "Ivoire byzantin de l'ancienne collection

Bonnaffé," *Monuments Piot*, 6, 1899, p. 93 and pl. VII, 1. G. Migeon, "La collection de M. G. Chalandon," *Les arts*, June 1905, p. 24 and fig. p. 23. *Catalogue de l'exposition d'objets d'art ... chez M. Jacques Seligmann*, Paris, 1913, no. 103. E. Hannover, "Kornedtagelsen en Fransk Elfenbensskulptur fra Middelaldern i den Langaardske Samling," *Kunstkultur*, 8, 1920, p. 197 and fig. 3. Goldschmidt-Weitzmann, II, no. 7, pl. XXVIII. *D.O.H.*, 1955, no. 232 and pl. *Athens Exhibition Catalogue*, 1964, no. 76 and pl. *D.O.H.*, 1967, no. 280 and pl.

28. Central Plaque of a Triptych
 Half-Figure of the Hodegetria
 Constantinople, second half of tenth century
 Height 12.6 cm. Width 11.7 cm. Thickness 0.9 cm.
 Acc. no. 46.14 PLATE XLII

The plaque has served successively two different purposes. Originally it formed the central panel of a triptych, and although the ledges into which the wings were inserted are now missing, four large holes, symmetrically placed at the corners of the frame, provide evidence of their existence. A hole was also drilled vertically into the top of the frame so that the triptych could be hung on a wall. Numerous small holes in the lower frame and the background indicate that in its second usage, the plaque was fastened to a wooden panel, in all likelihood a bookcover; for within the group of ivories to which ours belongs, there are no fewer than six plaques with the half-figure of the Hodegetria mounted on bookcovers (Goldschmidt-Weitzmann, II, nos. 80, 87, 87a, 124–26, pls. XXXII, XXXV, XLVI and p. 52, fig. 24). In two cases the manuscripts are as early as the beginning of the eleventh century (*ibid.*, nos. 87a and 125), which means that the triptychs were taken apart soon after they were made. Moreover, since all the bookcovers belong to Latin manuscripts, one may conclude that the triptychs were deliberately dismantled in the Latin West for the decoration of books.

The ivory is quite badly warped, having a curvature of 0.8 cm. This warping has caused severe cracks, two of which pass through the two holes in the upper frame. There is some small damage to the baldachin, but otherwise the plaque is well preserved and shows only slight traces of rubbing on the surface.

Whereas the Hodegetria appears frequently in the Romanos group as a full-length figure (cf. No. 26)—reflecting in this respect the archetype—in the Nicephoros group to which our plaque belongs she is more often represented as a half-length figure. Furthermore, while the artists of the Romanos group are quite faithful to the iconographical details of the archetype, those of our group exhibit a greater artistic freedom. In the archetype, the Virgin held her right hand before her breast, as she does in every Hodegetria ivory of the Romanos group as well as in some of the Nicephoros group (e.g., Altötting and Paris, Coll. Marquet de Vasselot, *ibid.*, no. 84, pl. XXXIV and no. 80, pl. XXXII; and Berlin, H. Schlunk, "Neuerwerbungen der frühchristlich-byzantinischen Sammlung. Arbeiten in Elfenbein," *Berliner Museen*, 60, 1, 1939, pp. 5ff. and fig. 5); but in our

plaque she uses her right hand to steady the Christchild, a gesture which is paralleled in other ivories of our group and is surely a deviation from the archetype (Stuttgart and Paris, Bibl. Nat., Goldschmidt-Weitzmann, II, no. 87, pl. XXXV and no. 125, pl. XLVI). The greatest liberty is taken by the artist of a plaque in Leningrad (*ibid.*, no. 81, pl. XXXII), where the Virgin supports the Christchild with both hands, thus exerting the physical effort usually avoided by Byzantine artists in this iconographical context. Normally, the Christchild is supported only by the Virgin's left hand, which does not show in our ivory. The gesture of the Christchild—blessing with His right arm stretched out toward the side—is one common to most ivories, but again there are deviations in the Nicephoros group. In the Altötting plaque, He does not bless at all, but rests His hand on the right arm of the Virgin. In this feature as well as in that of the steadying hand of the Virgin, the Nicephoros group shows a trend toward a more human behavior which is to be understood as a conscious deviation from the iconic concept guiding the artists of the Romanos group. There is also a variation in the manner in which Christ holds the scroll. The original version, shared by all examples of the Romanos group and by most of those of the Nicephoros group, shows Christ holding the scroll at its middle, but in our plaque, as well as in those in Altötting and Stuttgart, He holds the scroll, which rests on His thigh, firmly at its top. This motif has apparently been introduced in order to steady the position of Christ. Slight touches of realism can be sensed in the fuller and somewhat fleshier faces of the Virgin and the Christchild. This is a typical feature of the Nicephoros group, named so after the cross reliquary in Cortona made for the Emperor Nicephoros II Phocas (963–69) (*ibid.*, no. 77, pl. XXX). The human expression of the faces is combined with a greater sense of physical reality, especially evident in the rather large scale of the Christchild, a disposition for sturdier bodies, and, in this plaque particularly, voluminous drapery. A characteristic trademark of this workshop is the central row of pearls decorating the cross of Christ's nimbus. Typical also is the baldachin, composed of a row of palmettes, which rests on a pair of spiral columns. Because of the rather elaborate and sure treatment of the drapery, our Virgin plaque, along with those in Altötting and Berlin, is among the best products of the Nicephoros group, which surely was produced in Constantinople.

Collection Dr. Emil Delmar, Budapest.

Bull. Fogg., 10, 1947, pl. *D.O.H.*, 1955, no. 240. *D.O.H.*, 1967, no. 287.

29. Central Plaque of a Triptych
 The Koimesis
 Constantinople, end of tenth century
 Height 14.5 cm. Width 11.5 cm. Thickness 0.7 cm.
 Acc. no. 37.5 PLATE XLIII

That the plaque once formed the center of a triptych is indicated by four holes in the upper and lower frame which were made to fasten ledges for the attachment of the wings.

In addition, a hole was drilled vertically into the top of the frame so that the triptych could be hung on the wall. At a later date, three crosses were painted on the background, perhaps in gold, the color most often used on ivories, and although the paint has now completely flaked off, the crosses are preserved as light areas against a darker ground. There are several small cracks, but otherwise the ivory is in good condition.

The rigid body of the Virgin lies on a high bier which is flanked by two groups of Apostles. Behind the bier stands the erect figure of Christ, holding in His arms the soul of the Virgin in the form of a small child. An angel swoops down with veiled hands to receive the soul, and he is shown again flying off with the soul in his hands toward heaven, indicated by a segment which contains a small star. This is clearly a conflation of two sucessive stages of this event. In the earlier phase, as represented by the impressive ivory of the "painterly" group in Munich (Goldschmidt-Weitzmann, II, no. 1, pl. 1) and two of the Nicephoros group (*ibid.*, no. 110, pl. XLI and no. 112, pl. XLII), two angels with veiled hands swoop down to receive the soul. In the so-called "triptych" group, to which our ivory belongs and in which the Koimesis enjoyed a particular popularity (*ibid.*, no. 113, pl. XLII; nos. 174–81, pls. LIX–LX), a second action is added, that of the angel carrying the soul to heaven. In this conflated composition the soul of the Virgin is depicted twice, and this iconography is used exclusively in the "triptych" group. There are only slight variations among the ten plaques of this group. Christ may stand erect, pressing the soul to His shoulder, as in our plaque, or He may be shown in a contrapposto pose, turning His head toward the Virgin while lifting her soul up in the opposite direction, toward the approaching angel (*ibid.*, nos. 113 and 178). If this latter variation is regarded as a distinct phase, one could then actually speak of three successive stages of this event.

A standard feature of the Koimesis is the division of the Apostles into two groups, the one at the left being headed by Peter, who swings a censer, and the one at the right by Paul, who bends over to kiss the Virgin's feet, his left hand touching her foot in a tender gesture. In addition to Peter and Paul, only two Apostles can be identified. One is John, who sometimes is isolated from the other Apostles and placed between the Virgin and Christ. Always bearded in this scene, he is shown behind the bier bending over the Virgin. John is given this preferential position over the other Apostles because Christ on the cross had called him the Virgin's son and entrusted the Virgin to his care. The only other Apostle ever individualized, as he is in our plaque, is Andrew, who stands behind Peter and is recognizable by his dishevelled hair.

The number of mourners may vary considerably, ranging from the twelve Apostles proper, as in a Koimesis of the Nicephoros group (*ibid.*, no. 112) and in two of the "triptych" group (*ibid.*, nos. 177 and 179), to as many as sixteen. According to apocryphal sources, three of these additional mourners were bishops who were present at the Dormition: Dionysios the Areopagite, Hierotheos, and Timotheos. In our plaque the figure behind Paul is characterized as a bishop and consequently must be one of the three. Therefore, when the group does not number more than fifteen (*ibid.*, no. 175), one may normally expect the inclusion of the three bishops. This is not true, however, in all cases. For example, on the Munich plaque, where there are fifteen mourners (*ibid.*, no. 1), one of them is a veiled woman. A more unusual case is a plaque of the "triptych" group (*ibid.*, no. 181), which includes among the fifteen mourners no fewer than three women and one

bishop, thus even omitting one of the Apostles. According to some scholars (L. Wratislaw-Mitrovic and N. Okunev, "La Dormition de la Sainte Vierge dans la peinture mediévale orthodoxe," *Byzantinoslavica*, 3, 1931, pp. 138ff.), one of the bishops should be James, the brother of the Lord. In cases where only one bishop is included, this theory has much to recommend it, especially when he is given a preferred position as in our ivory. Yet, this identification is not supported by any text, and John of Damascus, in a passage whose authenticity has been questioned (Migne, *PG*, XCVI, col. 749), mentions only Timotheos and Dionysios the Areopagite. Therefore, additional persons should often be considered simply as anonymous members of a crowd of mourners. Byzantine ivories are the earliest monuments on which the number of the obligatory mourners was expanded, and it is likely that this practice began toward the end of the tenth century and continued in subsequent centuries.

The "triptych" group is the product of a workshop which, in contrast to the Romanos group, functioned not for the court but for a larger clientele. Its less skilled craftsmen decorated smaller plaques with a limited and repetitive repertory of scenes. The organic structure of the bodies is not always sure, and the treatment of the drapery and its folds is rather sketchy. Yet the artist of our plaque, who is, relatively speaking, one of the best within this mass-production workshop, pays considerable attention to the detailed carving of the heads, where he clearly follows the better models of the Romanos group. In many examples of this group, the cross in Christ's nimbus with its pearled outlines imitates a workshop device of the Romanos group, though in our ivory it does not—in fact, here the cross of the nimbus is left undecorated.

That the "triptych" group is, however, contemporary with and not later than the Romanos group is proved by the fact that one of its Koimesis plaques (*ibid.*, no. 176, pl. LIX) was reused as the decoration of the bookcover of a Reichenau lectionary belonging to the eleventh century (Wolfenbüttel, Landesbibliothek cod. 84.5 Aug. fol. Cf. K. Weitzmann, "Various Aspects of Byzantine Influence on the Latin Countries from the Sixth to the Twelfth Century," *D.O.P.*, 20, 1966, pp. 15ff. and figs. 27–28). If some interval is allowed between the time the triptych was used as a devotional object and the time it was dismantled to decorate a Latin manuscript, then the ivory must be dated in the tenth century. Nor does the inferior quality of the "triptych" group warrant relegating its workshop to a location outside the capital, for its close stylistic relationship to the Romanos group tends to disprove this. The differences in quality seem to be explained sufficiently by the assumption that the two workshops served different clienteles.

Collection of the Ducal House of Mecklenburg.
Bliss Collection, 1937.

Art of the Dark Ages. Worcester Art Museum, 1937, no. 63 and pl. *Arts of the Middle Ages*. Museum of Fine Arts, Boston, 1940, no. 120. *D.O.H.*, 1955, no. 237. *D.O.H.*, 1967, no. 288.

30. Rosette Casket
 Deesis with Apostles and Saints
 Constantinople, second half of tenth century
 Casket: Height 12.8 cm. Length 41 cm. Depth 17.5 cm.
 Plaques: Christ, Virgin, Archangel: Height 6.4 cm. Width 4.4 to 4.6 cm.
 Apostles: Height 5.8 cm. Width 4.1 to 4.5 cm.
 Soldier-saints: Height 5.5 cm. Width 4 and 4.3 cm.
 Paul and Peter: Height 4.7 and 5.2 cm. Width 4 cm.
 Acc. no. 47.9 PLATES XLIV–XLIX

The sixteen ivory plaques and the ornamental bands of rosettes which now form a casket were once mounted as the bookcover of a Gothic missal formerly in the collection of the Cortlandt Bishop Library. Following the sale of the missal in 1938, the bookcover was dismantled by the dealer who acquired it and who gave me his kind permission to prepare a reconstruction of the original position of the plaques on a casket. When the ivories were acquired by Dumbarton Oaks in 1947, the author made the final layout which forms the basis of the present reconstruction. The plaques are now mounted on a modern wooden casket with a sliding lid and fastened with the usual ivory pegs. Three of the figured plaques and a certain number of the decorative bands are missing, and these areas are filled with blank pieces of modern ivory.

The position of the figured plaques is generally correct, although the precise sequence of the Apostles on the long sides cannot be certain. But, since no problem of rank is involved—with the exception of the princes of the Apostles, Peter and Paul, who are placed together on the right side (PL. XLVII, A)—it is not essential to establish the sequence. It is, however, surprising that Peter and Paul are depicted on the smallest plaques, but there is a technical reason for this. Originally there was a lock on the right side, and in order to provide space for it beneath the lid, which slides out to this side, these plaques had to be smaller. It is likely that the blank filler strips now mounted under the plaques should be above them, and in this detail the reconstruction should be corrected.

The casket belongs to that large group called rosette caskets after their ornament, the basic motif being a rosette with eight diamond-shaped petals. Our casket has a great variety of rosette forms, some with eight loop-shaped petals and others with petals in the form of four horseshoes; these may alternate with five-petaled leaves, probably meant to be vine leaves, or with medallion heads deriving from coin types. Narrow strips with a palmette frieze or a zigzag wicker pattern were used to fill the spaces between the figure plaques and the rosette strips.

The distribution of the ornamental strips is inevitably arbitrary. The most elaborate pieces, those in which the rosettes are interspersed with medallion heads, were placed on the lid, which is the focal point of the decoration. The simpler strips of rinceaux in which rosettes alternate with five-lobed leaves, though also often on the lid, were usually placed on the sides where there was sufficient space to accommodate them.

The figured plaques, though roughly cut, are generally well-preserved. In a few cases, especially the Virgin plaque (PL. XLVIII, B) and the two Apostles on the right front (PL. XLVIII, G, H), a lower grade of ivory was used which in certain spots is slightly porous.

Although no trace of color remains, it may be assumed that some gold or red, or both, was used on our casket, at least for the identifying inscriptions which one would expect for each figure.

Represented on the lid is a Deesis (PLS. XLIV; XLVIII,A,B,C). In the center is the bust of Christ Pantocrator, holding a Gospelbook in His left hand and blessing with His right, which emerges from the sling of His mantle. To His right is the bust of the Virgin, turning toward Him in a gesture of supplication. On the other side of Christ there was undoubtedly a bust of John the Baptist, now lost, in a corresponding pose. Flanking the Virgin is the bust of an archangel in frontal view, dressed in the imperial loros and holding a scepter and orb. At the extreme right of the lid, the missing plaque was surely another archangel in comparable dress and pose. The placement of the archangel plaques is, of course, interchangeable.

In the Museo Nazionale in Florence, there is another Apostles casket (Goldschmidt-Weitzmann, I, no. 99, pls. LVIII–LIX) which corresponds to ours remarkably closely. On the lid there is again a Deesis (PL. L, fig. 28) differing, however, in that Christ is not flanked by the figures of the Virgin and John the Baptist, and in that these latter figures are depicted in a strictly frontal position rather than in the customary attitude of intercession. Because there were only four plaques on the lid, the two archangels could not be included; instead, the figure of St. John Chrysostom is introduced. Despite these differences, the similarities are numerous. It is particularly in the depiction of the Apostles that the two caskets agree in almost every detail.

Among the individual Apostles on our casket, there are slight differences in the rendering of the drapery and in the manner in which the book or scroll is held, and these variations are exactly those found on the casket in Florence. Moreover, the Evangelists (PL. XLVIII,E,F,G) are distinguished by holding codices rather than the scrolls held by the other Apostles; precisely the same distinction is made in the Florence casket (PL. LI, fig. 31). Since the name of every Apostle is inscribed on the latter, we are in a position to identify the individual figures on our casket, where there are no inscriptions.

Only three Evangelists are preserved on the Dumbarton Oaks casket, but the fourth was surely depicted on the one missing plaque. To accommodate the fourth Evangelist plaque, which was presumably mounted alongside the other three, our reconstruction should be modified, and one of the plaques now mounted on the front should be transferred to the back. The Evangelist in the center with a particularly big head (PL. XLVIII,F), who steadies the codex with his right hand, his thumb pressed against the edge, corresponds to the one on the Florence casket inscribed John Theologos (PL. LI, fig. 31); not only is the position of the hand identical, but the drapery also is the same. The Evangelist to his left on our casket (PL. XLVIII,E) is quite similar and differs only in one small detail, namely, that the thumb of his right hand steadying the codex is not visible. In this respect he agrees with Mark on the Florence casket, who also has the same short, curly hair and thick beard. The figure to the right of John on our casket (PL. XLVIII,G) holds the Gospelbook with both hands unveiled, his right hand holding the upper edge of the codex. In both these details there is full agreement with the figure in Florence inscribed Luke. Thus, it is the plaque of Matthew which is missing from our casket. On the Florence casket, he is distinguished by having his right hand extended in front of the Gospelbook and

a mantle draped over both shoulders. There is a plaque corresponding in style and iconography to this, which may be identified as the missing Evangelist, Matthew (PL. XLIX, fig. 27). It was formerly in the Stroganoff Collection in Rome (Goldschmidt-Weitzmann, I, no. 103, pl. LIX), but its present location is unknown. (N.B. The measurements given in the Corpus, 6.5 by 4.5 cm., are slightly larger than those of our plaques, but the author has not seen the piece and therefore has some doubts about these measurements.) This plaque must have been detached from the casket before the ivories were mounted as a bookcover, for the bookcover was complete when it was seen by the author in 1938.

Since Early Christian times, two Apostles, Peter and Paul, have always been characterized individually. Placed at the right end on our casket, they are conceived as a pair turning toward each other (PL. XLIX, E, F). Paul holds a codex with both hands, and Peter raises his right hand in a gesture of speech while holding in his left a scroll. On the Florence casket they are in strict frontal pose, each blessing and holding a scroll (PL. L, fig. 29).

Of the six remaining Apostles, two are usually depicted as young men. On the Florence casket the one inscribed Thomas holds a scroll with one hand at either end, and the other, inscribed Philip, holds the scroll in a strange horizontal position in his veiled left hand, his right hand raised in a curious gesture (PL. LI, fig. 32). Corresponding exactly to these plaques are those placed at the extreme ends of the back of our casket, Thomas at the left and Philip at the right (PL. XLIX, A, D). Once again the drapery agrees, as well as the gestures. In both instances Thomas' mantle falls vertically over both shoulders, while that of Philip is pulled diagonally across his chest. The ninth Apostle to be identified, mounted in the center of the back, is distinguished by his long, shoulder-length hair which is parted in the center (PL. XLIX, C). Long hair is characteristic of Andrew, and the Florence casket confirms this identification. The last Apostle on the reverse, second from the left (PL. XLIX, B), who holds a scroll in his left hand and blesses with his right, must be Simon the Zealot because of his similarity to that Apostle on the Florence casket. Of the two remaining Apostles on the front, the one at the extreme left (PL. XLVIII, D) holds a scroll in his left hand and is blessing with his right, which is in the sling of his toga-like mantle. His counterpart on the Florence casket is the Apostle inscribed James the son of Zebedee. The only significant discrepancy between the two caskets involves the Apostle at the extreme right (PL. XLVIII, H) who, by elimination, must be Bartholomew. But while the Apostle so inscribed on the Florence casket (PL. LI, fig. 31) holds the scroll in his left hand and grasps the edge of his mantle sling with his right, our remaining Apostle holds the scroll in his right hand and raises his veiled left hand without holding anything in it. Undoubtedly, the deviation is in our plaque, since it is not customary to hold a scroll with the right hand. To summarize, the artist of our casket followed the Florence casket so closely for no fewer than nine Apostles that one is inclined to think that he used this very casket as his model.

Both caskets have a pair of soldier-saints on the left end. In Florence (PL. L, fig. 30) they are inscribed Sergios and Bacchos and are characterized by torques around their necks. The two saints on our casket differ from those in Florence in that they wear no torques and in that the one at the left is bearded and the one at the right is youthful and beardless (PL. XLIX, G, H). This distinction makes it quite certain that we are dealing

with Theodore Stratelates and George, the most popular of all the soldier-saints, who are often represented together (cf. p. 64).

Underlying this selection of saints is the well-formulated program of an illustration of the prayer of intercession of the liturgy (E. H. Kantorowicz, "Ivories and Litanies," *Journal of the Warburg and Courtauld Institutes*, 5, 1942, pp. 56ff.). The first and foremost intercessors are the Virgin and John the Baptist, and they are placed on either side of Christ; then follow the archangels, after them the Apostles, and finally the saints, where the choice is very wide. From the programmatic point of view, our casket, though artistically inferior, is more consistent than the one in Florence, where the three persons of the Deesis (PL. L, fig. 28) are incorrectly arranged. The order may, of course, be the result of a later restoration, but that John Chrysostom should be placed ahead of the Apostles is an iconographic irregularity. There is a third Apostles casket in the Metropolitan Museum in New York (Goldschmidt-Weitzmann, I, no. 100, pl. LX). It, however, belongs to the "painterly" group, and the characterization of the individual Apostles is quite different from that on the caskets discussed above. Yet programmatically it is as consistent as our casket: the lid shows the Deesis with Christ enthroned and two archangels, and on the four sides are the twelve Apostles; other saints, however, are missing. Thus, our casket is iconographically the most complete of the three.

A program such as this was hardly invented for the decoration of an ivory casket, and we must thus raise the question of what form its source might have taken, in which all the figures could be shown on one plane. The main place for the Deesis with its accompanying intercessor figures is the epistyle of the iconostasis, the history of which is only gradually emerging, mainly on the basis of iconostasis beams found at Mount Sinai. Among these beams is one with busts under arches, as in the casket of Florence, which displays the same program as our casket, though in a somewhat restricted form (Sotiriou, *Icones*, I, figs. 117–24 and II, pp. 112ff.; K. Weitzmann, "Die byzantinischen Elfenbeine eines Bamberger Graduale und ihre ursprüngliche Verwendung," *Festschrift für K. H. Usener*, Marburg, 1967, p. 16 and fig. 7). There are no archangels flanking the Deesis, and the number of the Apostles is restricted to six, but there are two soldier-saints at the extreme ends, in this case St. George and St. Procopios. We thus presume that the ultimate source for the program of our casket was the epistyle of an iconostasis, like that of Sinai but more complete.

The style is that of the "triptych" group, the workshop which may be said to have transformed the noble style of the Romanos group into a more popular style. We have seen how a work of the Romanos group, namely the Apostles casket in Florence (which was dated in the first volume of the Corpus in the twelfth century and corrected in the second volume to the tenth), was probably used as a model for our casket. However, a comparison with various Deesis ivories of the "triptych" group (Goldschmidt-Weitzmann, II, pl. LIII, 151, 153–54) makes it quite obvious that our artist also used a model of this group for the Deesis figures. Furthermore, these comparisons give us a clear idea of what the lost plaque with John the Baptist must have looked like. Even the plaques of Peter and Paul, which deviate from those of the Florence casket, can be explained as deriving from the standard repertory of the "triptych" group, where the Apostles turn toward each other and Paul holds a codex. Busts of these two princes of the Apostles occur frequently on

the wings of triptychs like those in Leningrad (*ibid.*, pl. LXI, 186), and these wings and others have busts of St. Theodore and St. George of precisely the type used for our casket. Thus, it is quite clear that the carver of our casket drew upon two sources: the Romanos group and models current in his own workshop. Like the Koimesis plaque (No. 29), also belonging to the "triptych" group, we believe our casket to have been made in Constantinople at the end of the tenth century, a *terminus ante quem* being provided by the plaques of this group, mentioned above, which were used on covers of Ottonian manuscripts.

Cigerza Collection.
Cortlandt F. Bishop Collection, New York.

American Art Association. Anderson Galleries, New York: Sale of the Cortlandt F. Bishop Library, Pt. I, April 5–8, 1938, no. 273. *Early Christian and Byzantine Art*, Baltimore, 1947, no. 112. *D.O.H.*, 1955, no. 231 and pl. *D.O.H.*, 1967, no. 283.

31. Pyxis
 Ceremonial Scene with the Cantacuzene Family
 Constantinople, fourteenth century (*ca.* 1355)
 Height 3 cm. Diam. 4.2 cm.
 Acc. no. 36.24 PLATES LII, LIII

As has happened with many Early Christian pyxides, its tightly fitting bottom has caused this pyxis to split into two halves which are now held together at the top by a metal ring. A similar ring must have encircled the bottom, for there are traces of green metal oxide. The extremely thin, translucent lid lacks a small piece of its edge (PL. LII, B). It is decorated with a series of concentric rings, one of which is wider than the others, and inlaid with tiny metal disks; a small metal knob decorates the raised center of the lid. Around the pyxis the entire surface of the frieze, especially that of the faces, has been rubbed.

Two imperial families provide the focal point of the frieze (PL. LIII, B, C). Each consists of an emperor with a long beard, his wife, and their son between them, the child at the left being the younger. Each emperor as well as his son wears the loros and holds a scepter in his right hand and the *akakia* in his left; each empress holds only a scepter in her right hand. All of them stand in rigid frontal pose in conformity with ceremonial behavior. At the left the imperial families are flanked by the model of a city which is offered to them by a kneeling youth (PL. LIII, A); the space beneath the city is filled by a peacock in profile. At the right is a group of entertainers, consisting of musicians and dancers (PL. LIII, D, E, F). The first musician is a kneeling drummer, shown in profile, whose drum is placed before him on the ground; behind him stands a flutist in frontal pose. Next comes a lyre player, in three-quarter view, who is seated on a very low bench, his legs crossed, in a pose similar to that of David in the title miniatures of some Psalter manuscripts. Then

comes a trumpeter, moving to his right while turning around and raising his trumpet in the opposite direction. He is fashionably dressed in a tight-fitting tunic buttoned down the front, and in his right hand he holds the end of a short mantle which is wrapped around his right shoulder. The fifth musician is a lute player, skillfully rendered in a half-kneeling pose so that he fits beneath the arm of the trumpet player at his right. Another trumpet player dances spiritedly toward him, kicking one leg out behind; he twists around at the waist to play the trumpet which he holds with both hands. The last of the musicians, whose legs are broken away, is in a semi-frontal pose and blows an instrument resembling a syrinx. The musicians play an accompaniment for two female dancers, one of whom, her arms akimbo, dances with a graceful turning motion. The other, half hidden by the offerer of the city, holds behind her head a veil which, if more space had been available, would probably have been shown billowing over her head.

The main problem presented by the pyxis is the identification of the two imperial families. The first emperor is inscribed IⲰ(ANNHC), his wife ЄIP(HNH), and the boy ANΔP(ONIKOC), in raised letters (PL. LII, C, D). In the most thorough treatment devoted to the pyxis so far, A. Grabar (see bibliog. *infra*) identified the emperor as John VI Cantacuzenus, the empress as his wife Irene, an offspring of the Bulgarian house of Asen, and the child as their grandson Andronicus, the future Emperor Andronicus IV, who was the son of John V Palaeologus. One might ask why the boy could not be the son of John Cantacuzenus who was named Andronicus, but the fact that this son died of the plague in Constantinople in 1348, i.e., before the date we believe the pyxis to have been made, speaks against such an identification. (C. Du Cange, *Historia Byzantina*, Pt. I, *Familiae Byzantinae*, Paris, 1680, pp. 260–62; most of our information about dynastic relations is based on this source). Grabar gives credit to Professor Charanis for having made the identification of this first imperial family, but actually Strzygowski had already proposed it in 1901 ("Das Epithalamion," see bibliog. *infra*).

The second family, which has been variously interpreted, represents, according to Grabar's study, the Emperor John V Palaeologus, his wife Helena (the daughter of John Cantacuzenus), and one of their sons. This marriage, which took place in 1347, had been arranged by John Cantacuzenus in order to establish a closer tie with the Palaeologan house, but the joint rule of the two Johns lasted only until 1352, when he repudiated his young co-ruler. According to Grabar, there are no inscriptions for this couple, and he explains this as a conscious erasure, intended as a *damnatio memoriae* following the dissolution of the joint rule. This statement becomes the point of departure for a complicated theory postulating two stages in the execution of the pyxis. In the first stage, the emperor at the left was supposedly meant to be John V and the empress his wife, Helen, with their son Andronicus between them, while the couple at the right were John VI and Irene, with their son Matthew. In the second stage, after the break, John VI was moved over to the left, the name of Helen was changed to that of Irene, and the inscription for the right-hand group erased. So, according to Grabar, the theme of the pyxis originally was the reconciliation between the houses of Cantacuzenus and Palaeologus through the marriage of John V with Helen.

However, this elaborate theory presents difficulties. First, in 1352, the date Grabar suggests as most likely for the pyxis, John V was only twenty years old (born June 18,

1332), and it does not seem very likely that either of the two emperors, both of whom wear very long beards, could be this young. Second, the inscription ЄIP(HNH) does not show any signs of being altered. But the main argument against the theory of the two Johns is the fact that the emperor at the right is actually identified by the letter M and therefore must be a ruler whose name begins with that letter. The most likely candidate is, in our opinion, M(ATΘAIOC), Matthew, the oldest son of John Cantacuzenus, who in 1355 was crowned emperor in Blachernae and named *Matthaeus Cristo Deo Fidelis Imperator et Moderator Romanorum Asanes Cantacuzenus*. His wife was Irene Palaeologina, daughter of the Despot Demetrius and granddaughter of the Emperor Andronicus II. Thus, she was an offspring of the house of the Palaeologi and an imperial princess in her own right. We do not know the year of Matthew's birth, but the fact that earlier in the reign of John Cantacuzenus he was made ruler of Western Thrace and later of the district of Adrianople (G. Ostrogorsky, *Geschichte des byzantinischen Staates*, Munich, 1952, pp. 419 and 421) clearly indicates that he had quite a political career behind him before being crowned emperor. This makes it likely that he was older than John V, in which case the long beard would be perfectly justified. The child between Matthew and Irene Palaeologina would most likely be John, their oldest son, who was given imperial rank by his father in 1356. Grabar stressed John Cantacuzenus' emphasis on legitimacy by focussing on the relationship with the family of the Palaeologi as the chief meaning of the pyxis (cf. on this point, F. Dölger, "Johannes VI Kantakuzenos als dynastischer Legitimist," *Seminarium Kondakovianum*, 10, 1938, pp. 19 ff.). This emphasis on legitimacy would be strengthened if John V were replaced by Matthew, both because of the presence of the young Andronicus between his grandparents and because of the inclusion of Irene Palaeologina, the granddaughter of Andronicus II. However, the new identification requires that Grabar's idea of the reconciliation of the two ruling houses, which is based on the identification of the two Johns, be discarded. The emphasis of the new interpretation of the pyxis would be rather on its presentation of the house of Cantacuzenus as a hereditary dynasty. There can be no doubt of such dynastic intentions on the part of John Cantacuzenus (Ostrogorsky, *op. cit.*, p. 422), though his dream was short-lived. In 1354 John abdicated, and while Matthew held out for three more years, in 1357 he too was forced to abdicate, and this spelled the end of the dynasty. Thus, I believe that 1355, which is the year of the coronation of Matthew, is the most likely date for our pyxis, since it seems to depict this event.

The model of the city offered to the emperors (PL. LIII, A) has been assumed, correctly, to be Constantinople. However, since the coronation of Matthew took place at Blachernae, the only question one might raise is whether the structure in the ivory is not specifically meant to be the palace of Blachernae rather than the city of Constantinople in general. Favoring such an interpretation is the fact that the structure is not the usual circular walled city, such as Constantine holds in the tenth-century mosaic in the narthex of St. Sophia, but rather looks like a single fortified building. However, since any model of a city would be extremely simplified, this suggestion must remain in the realm of hypothesis.

The size of this structure is far too large for the scale of the pyxis, and in order to hold it, the person offering it had to be rendered in a kneeling position. He holds the

model of the city only by its left corner in a rather precarious manner. The model occupies about two-thirds of the height of the frieze, which is the amount of space reserved for the locks on pyxides of the Early Christian period. The Daniel pyxis in London may be cited as a typical example (O. M. Dalton, *Catalogue of the Ivory Carvings of the Christian Era*, London, 1909, p. 11, no. 13 and pl. VIII). An actual lock was never contemplated by the carver of our tiny pyxis, but an early pyxis may have inspired him to place this architectural structure in its place for the formal purpose of marking the beginning of the frieze. In my opinion, the reason this donor scene differs so from the normal scheme is that the carver started out by replacing the area usually occupied by the lock with the large city model, and was then forced to add a drastically reduced figure of the donor in an attempt to weld the two into a homogeneous composition.

The influence of Early Christian pyxides is further evident in the placement of a bird beneath the city. The custom of filling the space under the lock by either a cross or an eagle with spread wings, and the possible symbolic significance of the latter, was discussed in connection with the so-called Moggio pyxis (No. 18). The fact that other animals also are used in this place, such as the two swans in the Daniel pyxis in London (Dalton, *loc. cit.*), indicates that even in the Early Christian period such birds were used also for purely decorative purposes. The choice of the peacock follows this latter tradition, and rather than having any symbolic meaning it may simply hint at the splendor of a palace garden, in which peacocks were quite customary.

Half the surface of the pyxis is occupied by the entertainers of what we believe to be a coronation feast (PL. LIII, D, E, F). Grabar, in his study, goes to great length to associate these performers with festivities in the hippodrome, and this leads him to an extensive study of athletes and acrobats and their role in these festivals. But the fact is that on our pyxis there is not a single athlete or acrobat; the performers are exclusively musicians and dancers. Thus, any connection with the hippodrome is highly questionable, and the entertainment depicted on the ivory frieze could have taken place anywhere within the palace. In the fourteenth-century manuscript of the Chronicle of John Skylitzes in Madrid, there is a miniature illustrating the arrival of Nicephoros Phocas in Constantinople for his coronation (PL. LXX, fig. 45) (S. C. Estopañan, *Skyllitzes Matritensis*, Barcelona-Madrid, 1965, p. 153, no. 375, fol. 145 b and pl. 349), where the Emperor is met by a group of musicians, including three trumpeters, a drummer, and a harpist. In another miniature of this manuscript (PL. LXX, fig. 46) (*ibid.*, p. 98, no. 199, fol. 78 v and pl. 290), a group of musicians, consisting of a lute player, a flutist, a cymbalist, and a harpist, dressed mockingly in sacerdotal vestments, entertains the iconoclastic Emperor Michael III. In these miniatures then, we find the same combination of musicians (except that the syrinx player is replaced by a cymbalist), who make up what might be called the "palace orchestra." Moreover, the compositional layout of the latter miniature is not unlike that of our ivory frieze: in both the rulers stand in a frontal ceremonial pose—in the miniature the Emperor is accompanied by the patriarch—with the musicians lined up on the right. Thus it seems quite likely that the model of our ivory was a miniature of the type seen in the Skylitzes Chronicle.

Apparently the Skylitzes manuscript represents a common type of illustrated chronicle, and it is reasonable to assume that other chronicles, similarly enriched with extensive

picture cycles, must also have existed. One likely candidate would be the Four Books of the *Historiae*, that rather biased account of the reign of John Cantacuzenus, written by the Emperor himself. It seems quite likely that such a text would have been illustrated in the imperial scriptorium, where standard chronicle illustrations would have depicted events like a coronation and other palace festivals in conventional compositions, in which only such details as costumes—like those of the musicians in our ivory—were brought up to date. The reason that there is no relationship, as Grabar has noted, between the musicians and dancers of our pyxis and those on the Byzantine rosette caskets of the tenth century is that the repertory of the latter is based largely on the classical tradition of Bacchic types. Furthermore, because of the conventionality of such representations of court festivals one should not expect to find in the text of a historical chronicle the same detail in the description of events as in their rendering in pictorial form. Lending support to the idea that an illustrated copy of the *Historiae* of John Cantacuzenus existed is the fact that another text by this author, the *Theological Writings* (Paris, Bibl. Nat. cod. gr. 1242), was adorned with illustrations. This manuscript, written after his abdication when he retired to Mount Athos as a monk, has several splendid title miniatures with the portrait of the Emperor, in which he is shown with a long, forked beard, an image which compares favorably with that of the emperor on our pyxis (H. Omont, *Miniatures des plus anciens manuscrits grecs de la Bibliothèque Nationale du VI au XIV siècle*, Paris, 1929, pp. 58–59, pls. CXXVI–CXXVII). Thus, I should like to suggest that an illustrated copy of the *Historiae* may well have been used by the carver of the pyxis.

As a piece of fourteenth-century ivory carving, our pyxis has so far been considered unique, and no attempt has been made to integrate it into the history of this medium. The carving of ivory seems to have been gradually abandoned after its most flourishing period, which culminated in the tenth century, and steatite came to be used in its place. Attempts to date some ivories in the twelfth century have not met with general approval, and there can hardly be any doubt that there was a lapse until the Palaeologan period, when ivory was reintroduced. Yet this revival, perhaps because of the preciousness of the material, was seemingly of very limited scale, both in number of objects and in their size. It is scarcely likely that our pyxis was actually unique, and we would expect it to be the product of a workshop which produced other ivories in the same style. Few of these are known, but one ivory I should like to date in the fourteenth century is a plaque in the Walters Art Gallery in Baltimore, hitherto unpublished (PL. LIV, fig. 33), and published here with the kind permission of the Walters Art Gallery. It represents four of the twelve great feasts and once formed the center of a triptych, whose wings may well have been decorated with the remaining eight feasts on their obverse and reverse. Preserved are the Crucifixion, the Anastasis, the Ascension, and the Pentecost. In the latter two scenes, the scale of the figures is quite small and their height, 2.5 to 3 cm., corresponds quite closely to that of the figures on our pyxis. What is characteristic of both ivories is the treatment of the drapery, which hardly models the figures but, in its sketchiness, seems almost to imitate brushstrokes. Indeed, in both cases—and this may have been characteristic of these Palaeologan ivories in general—the models were not earlier ivories, but apparently contemporary miniatures. We have already suggested that an illustrated chronicle was the source for our pyxis, and the Baltimore ivory may be compared with

the picture menologion in Oxford, Bodleian Library cod. gr. th. f. I (O. Pächt, *Byzantine Illumination*, Oxford, 1952, figs. 16 and 24), whose miniatures are likewise executed on an unusually small figure scale. Another ivory which we should like to date in the Palaeologan period, but somewhat later than the pyxis, is a plaque with Christ Enthroned (PL. LIV, fig. 34), also in the Walters Art Gallery (Goldschmidt-Weitzmann, II, p. 11 and fig. 1), which forms the center of an icon with a painted frame. With dimensions of only 9.6 by 5.7 cm., this ivory is on a considerably smaller scale than any Middle Byzantine plaque with the same subject. Here, too, the dependence on a painted model is very clear, especially in the mannered exaggeration of the drapery design. These two examples must suffice, within the limits of this catalogue, to demonstrate that our pyxis forms a kind of nucleus around which other pieces may be grouped. It is too early to say how long this tradition continued in Constantinople, but it can be demonstrated that these ivories of the Palaeologan period, characterized by their small figure scale, provided the stimulus for those produced in Russia from the sixteenth century on. There, ivory carving flourished again on a considerable scale (for examples of these Russian ivories, see C. R. Morey, *Gli oggetti di avorio e di osso del Museo Sacro Vaticano*, Vatican City, 1936, p. 91, no. A 120, pp. 95 ff., nos. A 127–A 130, pls. XXXI, XXXIV–XXXV).

Stroganoff Collection, Rome.
Bliss Collection, 1936.

J. Strzygowski, in *B.Z.*, 8, 1899, p. 262. *Idem*, "Die byzantinische Kunst auf dem Orientalistenkongress in Rom," *B.Z.*, 9, 1900, pp. 320–21. *Idem*, "Das Epithalamion des Paläologen Andronikos II," *B.Z.*, 10, 1901, p. 566. *Exposition byz.*, Paris, 1931, no. 141. A. Grabar, *L'empereur dans l'art byzantin*, Paris, 1936, pp. 56–57, 155 and pl. VIII. F. Dölger, review of Grabar, *Gnomon*, 1938, p. 208. *Arts of the Middle Ages*, Museum of Fine Arts, Boston, 1940, no. 122, pl. V. *D.O.H.*, 1955, no. 241. A. Grabar, "Une pyxide en ivoire à Dumbarton Oaks," *D.O.P.*, 14, 1960, pp. 121 ff. and figs. 1–7. *D.O.H.*, 1967, no. 291 and pl.

WESTERN MEDIAEVAL IVORIES

32. Plaque from the Shrine of St. Aemilianus
Christ in Majesty
Spanish, 1060–80

Central plaque: Height 22.7 cm. Width 10.5 cm.
Including ivory mandorla: Height 27 cm. Width 13.7 cm.
Height of relief at head, knees, and footstool *ca.* 2.5 cm.
Acc. no. 48.12

PLATES LV–LIX
COLOR PLATE 8

The figure of Christ is cut from a length of tusk; its curving form is apparent at the edges of the central plaque but is obscured by the addition of the four pieces of ivory forming the mandorla (PLS. LV, LVII). Its cavity, visible on the reverse, is hidden within the high relief (PL. LVIII, A). Christ's head and raised arm are fully three-dimensional, as are His feet which rest on an elaborate footstool composed of an openwork arcade (PL. LVIII, B). A similar deeply cut arcade also supports the nimbus and raises it obliquely from the ground (PL. LIX, B). These arcades are obvious imitations of goldsmiths' work. The relief is in excellent condition, with only slight damage to the vertical border decorating Christ's tunic and to the tip of His beard, which has been restored. The eyes are original beads of black agate (COLOR PLATE 8, PL. LIX, A). An even *craquelure* covers the central plaque as well as the additional pieces at the left and bottom; those at the top and right are very smooth and therefore could perhaps be a later restoration. Goldschmidt mistakenly describes the plaque as being in the original frame of gilt silver, while in fact the frame, which he reproduces, is wood and surely later in date. Presumably it was added when the plaque was removed from the shrine in the early nineteenth century.

Goldschmidt was the first to recognize that the Dumbarton Oaks plaque once decorated the ark of St. Aemilianus, a reliquary shrine richly decorated with gold repoussé plaques and ivory reliefs, all set in a gold, jewel-encrusted revetment. In 1809, during the Napoleonic war, it was stripped of its precious jewels and metalwork, and a number of its ivories were dispersed. Some of these are still lost, but others have been identified in the museums of Florence, Berlin, Leningrad (Goldschmidt, IV, pl. XXVIII, nos. 86–91), and Boston (E. J. Hipkins, in *Bulletin of the Museum of Fine Arts*, Boston, 35, 1937, p. 10 with fig.).

Although the ark was destroyed, there exists a detailed description of it written in the early seventeenth century by Prudencio de Sandoval (*Primera parte de las fundaciones de las monesterios del glorioso Padre San Benito*, Madrid, 1601, pp. 24 ff.). This document not only gives a clear idea of the decoration of the shrine but provides a sure basis for the date. According to Sandoval, two of the plaques of the ark, both of which are now

83

lost, represented King Sancho and his wife Queen Placentia. The king may be identified as Sancho IV, King of Navarra, who reigned from 1063 until his death in 1076. Also on the front was the plaque, still preserved on the shrine itself, depicting the Abbot Blasius, who ruled from 1070 to 1080 (Goldschmidt, IV, pl. XXIX, no. 84q). On the back of the shrine, however, were the portraits of two other donors—one, King Ranimirus I of Aragon, who died in 1063 (plaque in Leningrad, *ibid.*, pl. XXVIII, no. 88), the other, Abbot

Fig. f

Petrus (*ibid.*, pl. XXVIII, no. 89), the predecessor of Abbot Blasius, who ruled from 1061 or 1062 to 1070. In all likelihood the explanation for the two sets of donor portraits is simply that the execution of such an important and lavish work was a lengthy task which spanned the reigns of the two monarchs and their abbots depicted on the shrine. Thus,

the date of the ark can be placed between 1060 and 1080. It should be remembered also that the ark in question is the second reliquary of St. Aemilianus. The construction of a new reliquary must have been occasioned by the transfer of the relics of the saint in 1053 to the monastery at Susa, where, however, the new church was not completed until 1067. Presumably a more sumptuous reliquary was deemed appropriate for the new church, and the one described by Sandoval was commissioned (for a detailed history of the shrine, see A. Kingsley Porter, "Leonesque Romanesque and Southern France," *Art Bull.*, 8, 1926, p. 237, note 6).

Sandoval's description is so explicit that a general reconstruction of the front of the shrine can be attempted (text fig. f). Our Christ in Majesty was placed, of course, in the center of the composition. The only other plaques from this side which are still preserved represent the Abbot Blasius, inscribed *Blasius abbas huius operis effector*, and the Abbot Munio, inscribed *Munio scriba politor supplex* (Goldschmidt, IV, pl. XXIX, nos. 84p and 84q). At present they are incorrectly mounted on the long side of the ark (*ibid.*, pl. XXIX, no. 84r), for the prostrate pose of the figures and the unusual shape of the plaques surely indicate that they formed the lower corners of the front, Blasius to the right and Munio to the left. When so placed, the inside edges of the plaques, which are cut obliquely, conform to the curve of the bottom of the mandorla. Sandoval says that the portrait plaques of the kneeling King Sancho, inscribed *Sanccius rex supradictus*, and his wife, *Dive memoriae Placentiae Reginae*, were also on the front. In all likelihood, they should be placed just above Blasius and Munio, fitting into the unusual indented areas above these plaques. The prayer of the royal couple would then be directed upward toward Christ. It is possible that the inner sides of these two plaques were also adapted to the curve of the mandorla, but this is of course conjectural. Sandoval mentions that there were four more plaques on the front, representing the four Evangelist symbols. One would expect their placement to correspond roughly to that described for the lower half, so that a symmetrical arrangement would have been achieved. Normally the series of symbols begins at the upper left and reads counterclockwise. This means that the angel of Matthew and the eagle of John would have been squeezed into plaques shaped like those of Blasius and Munio, and, indeed, for a flying angel and an eagle with spread wings such shapes are quite appropriate. The lion of Mark and bull of Luke would have been fitted into plaques corresponding to those of the royal couple and placed to the left and right of the shoulder of Christ. The ground between the ivories was fitted with a sumptuous gold revetment, richly embellished with crystals and precious stones. Decorating the gable of the lid was a relief in gold repoussé, with the Lamb of God within a medallion in the center and a flying angel in each spandrel.

The enthroned Christ, His right hand raised in a gesture of blessing, His left steadying the book resting upon His thigh, is a type common in Romanesque art, and only minor features are typical of Spanish art. As Goldschmidt pointed out, the jewel-studded embroidery around Christ's neck occurs also on other Spanish ivories (*ibid.*, pl. XXXII, nos. 98d and 99), and by imitating the pallium alludes to the priestly role of Christ. The type of throne is also Spanish; it is not the usual jewel-studded golden throne, but an elaborately carved wooden one, the seat supported by two rows of horseshoe arches, the arms supported by posts deeply carved with a scale pattern and ending in small volutes.

While in French, German, or Italian art the *Majestas Christas* resembles the Byzantine Christ Enthroned, in Spanish art He is normally further removed from the Byzantine source. Byzantine art did influence Spanish ivory carving, but to a more limited degree. If one compares our figure with a Byzantine example, such as the Christ Enthroned in the von Hirsch collection in Basel (Goldschmidt-Weitzmann, II, pl. XXII, no. 54), the general similarity in conception and pose is quite apparent, and in the ornamentation of the nimbus one recognizes a motif that is purely Byzantine. The beaded border of both the nimbus and the cross within it is a decorative device of the Constantinopolitan workshop which produced the Romanos group, including the Basel ivory. The Spanish plaque must have copied this nimbus form from a Byzantine ivory of this group. But this is a minor detail, and the differences between the two ivories stand out more sharply than their similarities. In the Byzantine ivory, despite its rather flat relief, the organic structure of the body is extremely well-understood and executed. In contrast, in the Spanish ivory, although the very high relief gives the figure a much greater corporeality, the organic structure is considerably weaker and the right leg is certainly not convincingly joined to the body. The extremely high relief, verging on three-dimensionality, is an unusual feature even in Spanish ivory carving, where normally it is reserved for Christ on the Cross, as on the Crucifix in the Museo Arqueologico in Madrid made around 1063 for Ferdinand I (Goldschmidt, IV, pls. XXXIII and XXXV, no. 100). In fact, the only ivory of the period which is comparable from this point of view is an Ottonian work of around 1050, a relief of the Virgin and Child in the Museum of Mainz (*ibid.*, II, pl. XIII, no. 40). In his discussion of the stylistic relationships of our Christ to other Spanish ivories, Goldschmidt (*ibid.*, p. 2) convincingly suggests that since the ivories of the Aemilianus shrine do not reflect the high quality evident in other Spanish centers, they were made in a local workshop at San Millan de la Cogolla.

Monastery church of San Millan de la Cogolla.
Spitzer Collection, Paris.
Julius Campe Collection, Hamburg.
I. and S. Goldschmidt Collection, Frankfurt am Main.
Otto Kahn Collection, New York.

Alfred Darcel, *La collection Spitzer*, I: *Les ivoires*, Paris, 1890, no. 24 and pl. XII. *Catalogue des objets d'art ... de la collection Spitzer*, Paris, 1893, I, no. 59 and pl. IV. E. Molinier and F. Marcou, *Exposition rétrospective de l'art français des origines à 1800*, Paris, 1900, p. 5. F. Marcou, "L'exposition rétrospective d'art français," *Gazette des beaux arts*, 23, 1900, p. 485. G. Swarzenski, *Die Regensburger Buchmalerei des X und XI Jahrhunderts*, Leipzig, 1901, p. 135. Goldschmidt, *Elfenbeinskulpturen*, IV, no. 85 and pl. XXVIII. M. Gómez-Moreno, *El arte romanico español*, Madrid, 1934, pp. 25–26 and pl. XXIX. W. W. S. Cook and J. S. Ricart, *Ars Hispaniae*, VI, Madrid, 1950, p. 292 and fig. 278. *Art News*, Dec. 1954, p. 20 and fig. p. 18. *Spanish Medieval Art*, Exhibition in Honor of W. W. S. Cook, The Cloisters, New York, 1954–55, no. 20. *D.O.H.*, 1955, no. 242 and pl. *D.O.H.*, 1967, no. 293 and pl.

33. Chessman
King or Vizier
Cordoba, late tenth or early eleventh century
Height 8.1 cm. Width 3.2 cm. Length 6.9 cm.
Acc. no. 66.7 PLATES LX, LXI

Made of a solid piece of ivory, the chessman is in good condition except for the sides where the piece was held. These are considerably rubbed as a result of long use in the game. This point is important because it speaks for the authenticity of the ivory, which has been challenged by Gómez-Moreno (see bibliog. *infra*) who, though he admits that he has no external criteria on which to condemn the piece, stated that a well-known Spanish ivory forger by the name of Pallas claimed to have made it. On the other hand, neither Ferrandis (see bibliog. *infra*) nor Goldschmidt (in a handwritten annotation to the companion piece, to be discussed below) had any doubts about its authenticity. There is some minor damage to the gable and to the lower corners of the back, and a notch has been cut into the center of the lower frame on both sides, probably the result of a mounting when the piece was no longer used for the game. Finally, a small piece of the enthroned figure's head is chipped off.

The tiered shape of the chessman is typical in the Arabic game of both the king and the vizier. The two pieces are distinguished only by their relative sizes, and since the identification of the enthroned figure is not assured either by his costume or by an attribute, one cannot be certain which game piece is meant here. The seated figure is worked fully in the round, with the upper part of the body freed from the ground. The youthful ruler, with his hands lightly touching his knees, sits in a stiff pose on a bench-like throne; he wears a full-length garment with long, wide sleeves, open at the neck and tied at the waist. Although he does not wear a crown, in the Arab world its absence would not contradict his identification as a king. Surrounding the figure is a double border of a rope design, the outer band wide, the inner band narrow. Within this frame, the ground behind and below the figure has been cut away, giving the impression of a niche behind him and a carpet beneath his feet, the latter being decorated with an ornament of two crossed leaves. An intertwined leaf ornament also decorates the top of the piece (PL. LXI, B). On the protruding face of the lower tier a hare is carved in a rather hunched position, facing left (PL. LXI, A). Each of the awkwardly shaped, identically treated side panels is skillfully fitted with a reclining deer, his legs folded beneath him and his elongated neck filling the vertical space. In his mouth he holds a pair of intertwined leaves. A thick quarter-palmette issues from the angle of the "L" and fills the area on either side of the throne (PL. LX, B, C).

Within the gabled panel at the back is a standing falconer (PL. LXI, C), a figure appropriate for the entourage of either a king or a vizier. On his gloved left hand is perched the falcon and in his right he holds the hood he has just taken off the falcon's head. Gómez-Moreno incorrectly described the hood as a baton, presumably mistaking the traces of its long leather strap, which has broken away, for the baton. Hoods with such long straps are illustrated in miniatures of the book of falconry by the Emperor Frederic II (C. O. Willemsen, *Kaiser Friedrich der Zweite über die Kunst mit Vögeln zu jagen*, Frankfurt am Main, 1964, II, pl. x).

In his Corpus (IV, no. 251) Goldschmidt published a companion piece which belonged to a private collector in Frankfurt and represents likewise either the king or vizier from the same set (PL. LXI, figs. 35, 36, 37). It is of slightly smaller dimensions, but not sufficiently so to ensure its identification as the vizier. The enthroned figure and the crouching deer are identical on both pieces; the Frankfurt chessman differs only in that it has an ibis on the lower front side and a soldier, leaning on a spear and holding a shield, on the back. The latter, however, stands within a gabled niche identical to that on our ivory. As a bodyguard of the king or vizier, he is just as appropriate an attendant as the falconer.

When Goldschmidt published the companion piece no comprehensive study of the Hispano-Arabic ivories had yet appeared. Nevertheless, he correctly considered it to be Spanish, but dated it in the thirteenth century, which in my opinion is too late. Gómez-Moreno, as well as Ferrandis, who were acquainted with both pieces, placed them in the midst of a rich body of material, consisting chiefly of caskets and pyxides which were carved at Cordoba in the tenth and eleventh centuries. The figure style may well be compared with that of the pyxis in the Louvre, dated 357 of the Hegira or A.D. 968 (Ferrandis, *Marfiles arabes*, no. 13, pl. XX). In an upper spandrel of the pyxis there are two falconers with triangular chins and sharply rimmed eyes so similar to those of the figures on our chessman that the same workshop tradition may be assumed. Also identical is the style of combing the hair so that it covers only one ear. The lapels of the king's and falconer's garments have parallels on a casket in the Victoria and Albert Museum (*ibid.*, no. 22, pl. XLI), which has also been dated in the late tenth century. The motif of a deer holding a plant in his mouth may be found in the ivory casket in Burgos, where stags and peacocks hold similar split leaves in their mouths and beaks (*ibid.*, no. 25, pl. XLIX). However, the style of this casket, which is dated 417 of the Hegira or A.D. 1026, is much harsher. More comparable to the smooth, rounded carving of the deer on our chessman is that of the deer in the spandrels of a pyxis in the Victoria and Albert Museum, dated 359 of the Hegira or A.D. 970 (*ibid.*, no. 14, pls. XXIV–XXV). The "hunched" hare is a popular feature of this group of ivories, and on a tiny casket in San Isidore in Leon there is a pair facing each other and filling the front panel (*ibid.*, no. 24, pl. XLVII). Finally, the ornament of the top, with its interpenetration of half-leaves and emphasis on loops, is typical of the carvings of the Cordoba school. On the basis of the figure style rather than the more conservative ornament, a date in the late tenth century seems preferable to one in the early eleventh, although the latter should not be excluded.

Count of Almenas Collection, Madrid.
Warren Templeton Collection, New York.
Gift of Mrs. Paul Fagan, San Francisco.

M. S. Byne and A. Byne, *Important Medieval and Early Renaissance Works of Art from Spain. Catalogue of the Spanish Collection of the Conde de las Almenas*, American Art Association, New York, Jan. 1927, no. 324, pp. 166–67. M. Gómez-Moreno, "Los marfiles cordobeses y sus derivaciones," *Archivo español de arte y arqueologia*, 9, 1927, p. 238 and figs. 21–23. W. W. S. Cook, review of Goldschmidt, *Elfenbeinskulpturen*, Vol. IV, *Art Bull.*, 10, 1927, pp. 287f. and fig. 6. J. Ferrandis, *Marfiles y azabaches españoles*, Barcelona, 1928, p. 93. *Idem, Marfiles arabes de occidente*, I, Madrid, 1935, p. 77, no. 18 and pl. XXXI. *D.O.H.*, 1967, no. 294 and pl.

34. Portable Altar. Walrus Ivory
 Scenes from the Gospels and Other Sources
 Lower Rhine, second half of eleventh century
 Casket: Height 10.7–11.1 cm. Length 23.8 cm. Depth 15.5 cm.
 Reliefs: Height 4 cm. Length 18.7 and 11 cm.
 Acc. no. 37.16 PLATES LXII–LXVI

The *altare portatile* is in the shape of a casket, which is one of the three types of this liturgical object, the other two being a plaque and an imitation of an actual altar (Braun, see bibliog. *infra*, pp. 444 ff.). It rests on four feet, each 3 cm. high, carved in walrus in the form of lion paws holding balls (PL. LXII); one of them is largely restored. The sides of the casket are decorated with panels of high relief carved in walrus and placed in deeply sunk fields in the wooden core. Thanks to this protection, and because only a few areas of the reliefs protrude beyond the frame, the ivories are well-preserved. The major damage appears in the reliefs of the long sides, which have warped and cracked. In addition, in the corner of the scene of the Adoration of the Magi the head of the third Magus is broken off. The four sides of the casket are framed by gilded copper strips decorated with a rosette pattern set against a background of red champlevé enamel. The oblique sides between frames and reliefs are now bare but surely were originally covered by repoussé strips like those on the bottom of the altar.

The top of the altar (PL. LXIII, A) is fitted with a porphyry plaque, the consecrated stone indispensable for an *altare viaticum*. It is framed by gilded copper strips with an inscription inlaid in red champlevé enamel which reads:

PLUS VALUIT CUNCTIS IOHANNES / VOCE PRECONIS +

IN QUITEN(S?) AGNE D(E)I TOLLIT QUI CRI / MINA MUNDI +

"John was stronger than all the people, saying with his herald's voice: 'O lamb of God that taketh away the sins of the world.'" The rest of the top is covered with worn crimson velvet of a later date.

The wooden bottom (PL. LXIII, B) is hinged and fastened by two latches obviously later in date. Covering it is a torn, discolored piece of silk, while the interior of the casket is lined with heavy parchment. The bottom edges, between the legs, are covered with strips of copper repoussé decorated with a simple palmette pattern, and similar strips are nailed around the edges of the long sides of the lid-like bottom piece.

Unlike reliquary caskets and others of this shape, the front is not one of the long, but one of the short sides, because in the celebration of the Mass the miniature chalice and paten must be placed one behind the other on the consecrated stone. If the top still had its original decoration, which almost always was a figurative one, it would be easy to determine which of the two short sides of the altar was meant to be the front. Since the subjects of these two reliefs—Christ of the Last Judgment and the *traditio legis*—do not reveal it, the only guide is the inscription, which one expects to start on the front. In this case, it begins in what I believe to be the lower left corner (PL. LXIII, A), which means that the Christ of the Last Judgment is the decoration of the front (PL. LXVI, A).

In the Last Judgment Christ is shown, bearded and with a plain nimbus, enthroned in a mandorla and flanked by two angels. He hands a book and cross-staff to the angels, who rush toward Him as if emerging from the cloud banks. This representation of the Christ of the Last Judgment is based on Matt. XXV:31: "When the Son of Man shall come in his glory and all the angels with him, Then shall he sit upon the throne of his glory," as well as on Apoc. L:7: "Behold he cometh with clouds." The presence of Christ in the Eucharistic sacrifice justifies the inclusion of the Christ of the Second Coming in the program of the altar decoration.

In the *traditio legis* on the rear (PL. LXVI, B), a youthful, beardless Christ, dressed in an embroidered mantle, is again seated within a mandorla; two curving lines suggest that a rainbow was intended as His seat, and although no traces of color remain, it was probably originally painted. To Peter at His right He hands the Keys, and to Paul on His left the Law. But the Law is not in the form of a scroll or codex, the traditional forms since the Early Christian period; rather, we see oblong tablets like those associated with Moses in the Sinai episode. This group is flanked on each side by an angel with spread wings holding an open scroll. The *traditio legis* symbolizes the establishment of the Church, and as such is a particularly appropriate subject for the decoration of an altar.

The iconographical program of the other reliefs was chosen for its thematic relevance to the Eucharistic sacrifice to be performed on the altar. On the right-hand long side are scenes from the Infancy of Christ (PL. LXIV): the Annunciation, the Nativity, and the Adoration, a selection typical of the repertory of portable altars. These are three of the most significant manifestations of the Incarnation of Christ, Whose ultimate sacrifice is re-enacted on the altar in the Mass. The narrative sequence begins with the Annunciation, in which the Virgin, holding spindle and yarn, is represented seated frontally on a throne. She sits under a baldachin whose perforated dome is an unusual feature in Rhenish ivories such as ours but a familiar one in a group of Ottonian ivories from Franconia which were strongly influenced by Byzantine models (Goldschmidt, II, nos. 148–52, pls. XLII–XLIII). Another rare feature is the way in which the Angel Gabriel draws back a voluminous curtain in order to address the Virgin who is seated behind it; on the other side, the curtain billows out beyond the column as if blown by a rush of air accompanying the angel. In the Nativity scene, the Virgin lies on a mattress atop a curved, arcaded bed, and the Christchild is in a manger of similar design. The scene is flanked by two tower-like walled cities, which not only function as scene dividers but also represent, in all likelihood, the holy cities of Bethlehem and Jerusalem. In the scene of the Adoration, the Virgin sits on a throne incised in the background and receives the three Magi with a sweeping gesture, while the latter, represented as kings with diadems, offer vessels as gifts.

More problematic is the iconography of the left side (PL. LXV), which a number of writers have tried to explain. In the scene at the left two angels emerging from a cloud bank are shown receiving a huge, twisted wreath held by a Hand of God, which issues from a segment of heaven. Goldschmidt related this motif to the Crucifixion on the basis of the ivory in Tongres (*ibid.*, no. 57, pl. XVIII), where two angels hold a wreath-like object over the head of the crucified Christ. What they hold, however, is not in fact a wreath but a crown of martyrdom, and therefore not the same motif. Braun (*op. cit.*, p. 510), in connection with a second casket from Melk (Goldschmidt, II, no. 104), more convincingly

takes the wreath as a symbol of God's omnipotence, representing the actual presence of the Godhead during the transformation of the Bread and Wine during the Mass. In a more general interpretation, Wirth (see bibliog. *infra*) associates the motif with the passage in Apoc. I:6: "to him be glory and dominion for ever and ever."

Equally puzzling is the scene at the right, in which an orant figure stands between the personifications of Earth and Sea, the whole framed by two towers. Goldschmidt suggests that the figure is a saint who stands for a group of the resurrected. This reference is obviously based on the similarity of our plaque to one from a casket in Münster (*ibid.*, no. 115, pl. XXXVI), in which there are three figures whom Goldschmidt believes to be resurrected individuals. They are placed between similar personifications and look up to a twisted wreath held in the Hand of God and worshipped by two angels. There can be no doubt that this plaque is closely related to ours, but whether it is a matter of inter-dependence or dependence on a common model is difficult to determine. In any case, the composition in our plaque has been modified: there is a single figure only, he is nimbed, and there is apparently no recognizable reference to the Resurrection. Braun (see bibliog. *infra*) likewise calls this figure a saint. On the other hand, Westwood (see bibliog. *infra*) at one point suggested that the figure was John the Evangelist because of an eagle-like bird beneath the personification of the Sea, though he later repudiated this identification. Wirth (see bibliog. *infra*), in an apparent attempt to find the explanation for the whole panel in the text of the Apocalypse, also identifies the figure as John, but for different reasons. He sees in him the author of Revelations, and he relates the gesture of the figure to that of Christ of the Last Judgment (Apoc. I:7). However, the gesture is surely not one of speech but, rather, of prayer, and the dress is not that of an Apostle. The explanation of Goldschmidt and Braun that the figure is a saint seems to me both more convincing and in agreement with the iconographical programs of portable altars. Quite a number of them include individual figures of saints who represent either the titular saint of the church for which the altar was made or the martyr whose relic is enclosed in the casket. In most cases, including ours, the saint or martyr cannot be identified because inscriptions are lacking and in the eleventh century individual attributes for saints had not yet become a standard feature.

The two reclining, half-nude personifications are of classical descent and correspond to the types of Terra and Mare which are frequently found both in Carolingian ivories, especially in the Liuthard and Metz groups (Goldschmidt, I, nos. 41, 78, 83, 85, 88), and in Ottonian ones (*idem*, II, nos. 37, 51, 57, 74, 86, 115). Here, however, their attributes are not all correct. Mare (or Oceanus), who correctly holds a dolphin in his extended left hand, is leaning on what should be a water urn but appears to us distinctly as the head of a bird. Goldschmidt sees it as a misunderstanding by the artist, in which the water urn was changed into a bird or serpent. Terra (or Ge) holds in her right hand an object which, according to Goldschmidt, looks like a torch, but is taken by him to be a misunder-stood tree branch and by Westwood to be a misunderstood cornucopia. Braun believes the two figures to be personifications of Water and Light, alluding to the torture of the orant saint by water and fire. Wirth follows Goldschmidt in speaking simply of personifica-tions of Land and Sea. A closer examination, however, shows that what Mare rests his hand on is actually intended to be a bird, whose head is turned around and silhouetted

against its wing, and that the object in Terra's hand is unmistakably a torch, prominently displayed. Moreover, there is another attribute visible behind the latter's head; this appears to be a tree branch and must be accounted for. In my opinion, we are dealing with a representation of the four elements: the bird, most likely meant to be an eagle, stands for air, the dolphin for water, the torch for fire, and the tree branch for earth. This would be one of the earliest representations of the four elements, for which no conventional types had been invented at this period (Wirth, *s.v.* "Elemente," Vol. IV, col. 1266, for their iconography). Very different types were used in another mid-eleventh-century work, the Gospelbook from Cologne in Bamberg, Staatsbibliothek cod. bibl. 94 (A. II. 18) (A. Goldschmidt, *German Illumination*, Florence, 1928, II, pl. 92). Our example should be viewed as a transitional rendering of the four elements, whose attributes were simply attached to the traditional types of Mare and Terra. Yet a clearer definition of these personifications has admittedly not brought us closer to an explanation of how the four elements are related to the praying saint. Is it merely that the elements stand for the creation of the universe over which the omnipotent Godhead, symbolized by the wreath, rules?

There can be little doubt that the velvet covering of the top replaces an older figurative decoration. The related altars in Osnabrück, Darmstadt, and Melk (Goldschmidt, II, nos. 102–4) have relief plaques in walrus on the top. Since the top of our altar is not recessed, reliefs were apparently not intended; it is more likely that incised and gilded copper plaques, perhaps filled with enamel, were used. This is the more traditional decoration of portable altars, even of those which have ivories on the sides. The iconographical program varies greatly, but, as a whole, its subjects refer even more directly to the Eucharistic sacrifice. Several have a representation of the Lamb of God in an aureola supported by angels, and it is possible that our altar, too, chose this theme since its inscription refers to the Lamb. Or perhaps John the Baptist himself was represented; but beyond this it does not seem advisable to make suggestions.

Date and style have been clarified by Goldschmidt. He points out that our altar shows the same style as another made, according to its inscriptions, for Svonehild (Svanhild), the wife of Duke Ernst the Courageous of Babenberg (1050–75), whose residence was Melk (*ibid.*, no. 104). This dates both altars in the second half of the eleventh century. The production of portable altars with reliefs of either elephant or walrus ivory was limited primarily to the eleventh century, with a few examples from the twelfth, and geographically it was restricted to the Lower Rhine and Belgium, where the main centers of ivory production were Cologne and Liège. These altars were manufactured in considerable quantity, and besides a number of them preserved more or less intact, there are many separate plaques which originally belonged to altars (*ibid.*, pp. 9–10). Single plaques of the same group as ours appear occasionally, such as those in the Cleveland Museum and the Pitcairn Collection, Bryn-Athyn, Pa. (*idem*, IV, nos. 287–93), and the Courtauld Institute in London has acquired a complete casket whose reliefs of walrus ivory, though probably from two different altars, are also related (J. Gardner, "The Ivories in the Gambier-Parry Collection," *Burlington Magazine*, March 1967, p. 139, figs. 39–40).

The general artistic level of our plaques is not very high. The figures are rather thickset, a feature which stands out all the more since the relief is very high, at times

almost three-dimensional. Goldschmidt also pointed out the ugliness of the faces, whose expressions verge on grimaces. Of somewhat higher quality is the altar in Osnabrück (*idem*, II, no. 102), and ours is more closely related to it than to the second Melk altar as far as the agility of the figures and their free movement in space are concerned. Iconographically there are especially close relations, as discussed above, with the altar fragments now in Münster (*ibid.*, nos. 106–18), which came from Cranenburg. This points to the Lower Rhine as a general provenance, though we may have to look for more than one center of production for portable altars with ivories.

Abbey of Melk on the Danube.
Bliss Collection, 1937.

E. F. von Sacken, in *Jahrbuch der K. K. Zentralkommission*, 2, 1857, p. 132. K. Weiss, "Die kunstarchäologische Ausstellung des Wiener Alterthumsvereines," *Mitteilungen der K. K. Zentralkommission*, 6, 1861, p. 24. A. Darcel, *Les arts industriels du moyen âge en Allemagne*, 1863, pp. 18 ff. K. Lind, "Zwei merkwürdige Tragaltäre im Stifte Melk," *Mitteilungen der K. K. Zentralkommission*, 15, 1870, pp. xxx ff., pl. 1 and fig. 1. Westwood, *Fictile Ivories*, pp. 456–57. H. Otte, *Handbuch der kirchlichen Kunstarchäologie des deutschen Mittelalters*, I, 1883, p. 148 and fig. 155. Ch. Rohault de Fleury, *La Messe*, V, Paris, 1887, p. 23 and pl. cccxlix. *Illustrierter Katalog der Ausstellung kirchlicher Kunstgegenstände*, Vienna, 1887, p. 100, no. 926. B. Kleinschmidt, "Der mittelalterliche Tragaltar," *Zeitschrift für christliche Kunst*, 17, 1904, cols. 43–44. H. Tietze, ed., *Die Denkmale des politischen Bezirkes Melk* (*Österreichische Kunsttopographie*, III), Vienna, 1909, p. 320, fig. 318 and pl. xxiii. Goldschmidt, II, no. 105 and pl. xxxv. J. Braun, *Der christliche Altar*, I, Munich, 1924, pp. 462, 492, 508. M. Rosenberg, *Geschichte der Goldschmiedekunst*, IV, *Niello*, Frankfurt, 1924, p. 17 and fig. 3. *Arts of the Middle Ages*, Museum of Fine Arts, Boston, 1940, no. 124 and pl. xiv. *Bull. Fogg*, 10, 1945, pl. *D.O.H.*, 1955, no. 243 and pl. K. A. Wirth, *Reallexikon zur deutschen Kunstgeschichte*, V, Stuttgart, 1967, *s.v.* "Erde," cols. 1076 ff. *D.O.H.*, 1967, no. 292.

STEATITES

35. Fragment of a Plaque. Steatite
St. George and St. Theodore
Constantinople, eleventh century
Height 3.4 cm. Width 4.2 cm. Thickness 0.6 cm.
Acc. no. 51.25 PLATE LXVII

The triangular fragment, broken on all sides, comes from the center of a plaque which originally showed two saints standing frontally with their heads turned toward each other; only the heads of the two figures are preserved. In the aureola above, the headless bust of Christ holds in each hand a crown of martyrdom. The back seems to have been purposely roughened in order to attach the plaque more firmly to the wooden ground of an icon. The pale green color has a jade-like quality, and there are flecks of gold on the aureola of Christ and on the nimbus of the head at the left.

The youthful head with curled locks is identified as St. George by the inscription [Γ]ЄѠ[P]ΓHOC. The shield below his nimbus apparently belongs to him. At the right stands a bearded soldier-saint in armor and chlamys, who once held in his left hand a spear, traces of which are visible close to the back of his head. Although only a single letter, P, of the inscription remains, it surely should be read as [ΘЄOΔѠ]P[OC].

The subject of Christ crowning warrior-saints, while rare in ivory carving, occurs frequently in steatite. On a piece in the Staatliche Museum, Berlin (Volbach, *Mittelalterliche Bildwerke*, p. 124 and pl. 3 [no. 6725]), a similar bust of Christ holds crowns over the heads of St. George and St. Theodore, while the two saints raise their hands in gestures of prayer, their shields standing on the ground between them. In our fragment, to judge from the visible shoulder of St. Theodore, the two saints did not turn toward each other as in the Berlin steatite, but rather stood frontally, turning only their heads; the shields were not placed on the ground, but hung over their shoulders. Corresponding to the lance which Theodore held, George probably held a sword. Another variation of this theme is seen in an unusually large steatite in the Chersonese Museum, in which Christ crowns three military saints, Theodore, George, and Demetrius (Banck, *Byz. Art in the USSR*, fig. 156), a composition duplicated in a fragmentary steatite found in Veliko Tirnovo in Bulgaria (*idem, Corsi*, p. 367 and fig. 3). In these two cases, where three saints are crowned instead of two, the artist renders them in rigid frontality, whereas the motif of figures turning toward each other is apparently reserved for pairs. Except for their turned heads, the soldier-saints of our fragment must have been almost identical to those of the Leningrad and Tirnovo steatites.

Stylistically, however, our piece is more refined than any of the other three cited. The manner in which Christ holds the crowns differs slightly and is not as rigidly symmetrical

95

as in the others; the sensitive faces of the saints are delicately carved. The closest comparison is with one of the finest steatites in existence, a relief formerly in the collection of the Comtesse de Béarn and now in the Louvre (PL. LXVII, fig. 38) (G. Schlumberger, "Deux bas-reliefs byzantins de stéatite de la plus belle époque," *Monuments Piot*, 9, 1902, p. 232 and pl. XX). It represents the Hetoimasia between two archangels in the upper zone, and four soldier-saints in the lower, St. Procopius being added to the three enumerated above. The heads of St. George and St. Theodore, though rendered in frontal view, are so similar to those of our fragment that the assumption that both pieces were carved by the same hand seems justified. Since the Béarn plaque has a distinct Constantinopolitan character, it follows that our piece is also the product of an atelier in the capital. Dating of steatites of this style has wavered between the eleventh and twelfth centuries, but in her latest study Alice Banck (*Corsi*, p. 361) has preferred the eleventh-century date for the Béarn plaque on palaeographic grounds, a date which we are inclined to accept for our fragment also.

D.O.H., 1955, no. 251. *D.O.H.*, 1967, no. 296. Banck, *Corsi*, p. 368.

36. Fragment of a Plaque. Steatite
 Head of a Saint
 Constantinople, eleventh to twelfth century
 Height 3.2 cm. Width 3.1 cm. Thickness 0.8 cm.
 Acc. no. 63.26 PLATE LXVII

Only the head of a youthful saint and part of his halo are preserved, but the face is complete except for the ear and the bottom row of locks on the right side. The back is rough, which suggests that the plaque may have been mounted on a wooden ground like the Panteleimon icon in Rome (A. Muñoz, *L'art byzantin à l'exposition de Grottaferrata*, Rome, 1906, pp. 120 ff. and fig. 85). Enough is left of the nimbus to show that it was decorated with an incised rinceau pattern. The pale green color of the steatite has a jade-like quality.

The saint cannot be identified, since short, curly locks are typical not only of St. Panteleimon but also of St. George and other soldier-saints. A fragmentary plaque in the Chersonese Museum (Banck, *Byz. Art in the USSR*, fig. 155) shows a youthful soldier-saint, who could be either St. George or St. Demetrius, with a face which is quite similar to that of our fragment, having the same rounded chin, but who is slightly more slender and less stereotyped. Our piece is equally refined but may be slightly later in date. Another comparison is provided by a large plaque, also in the Chersonese Museum, in which Saints George, Demetrius, and Theodore are crowned by Christ (*ibid.*, fig. 156). The faces of these saints, despite the strong similarities in the rendering of the long noses, the thin mouths, the slightly narrowed eyes, and the rows of stylized locks, are somewhat more rigid than in our piece. Alice Banck dates the first Chersonese piece in the eleventh and the second in the twelfth century. I should like to place our steatite between these two centuries, leaving the precise date open.

Although there is no firm evidence to suggest that our head might be identified as St. Panteleimon, a saint frequently represented on the steatites, the icon in Grottaferrata (Muñoz, *loc. cit.*) and a plaque in the Walters Art Gallery in Baltimore (PL. LXVII, fig. 39) (*Early Christian and Byzantine Art*, no. 597, pl. LXXX), which may be cited as contemporary and stylistically close comparisons, lend support to such an identification. For all these pieces, Constantinople is the likely place of origin.

D.O.H., 1967, no. 295 and pl.

37. Amulet. Steatite
 St. Nicholas
 Twelfth century
 Height 4.6 cm. Width 4 cm. Thickness 0.5 cm.
 Acc. no. 58.24 PLATE LXVIII

The amulet has suffered several losses: the saint's figure below the knees, parts of the background, and most of the frame on the left side are missing. The figure stands under a flat, indented arch, which is surmounted by a pierced boss for a chain or strap (cf. the amulet with St. George, No. 38). The color is greyish, with brown stains, and there are traces of gold on the garments, the omophorion, and the nimbus.

The figure of the bishop, in frontal view, is inscribed O A(γιος) NIKOΛΛOS. He carries a codex in his left hand and raises his right in a gesture of blessing. The shape of the plaque resembles that of certain ivories of the Romanos group (Goldschmidt-Weitzmann, II, nos. 34, 38, 39, 46, 55, 61, 71–73, 76).

St. Nicholas is one of the most popular church fathers and is as frequent a subject on steatite as on painted icons. The same type as that shown here occurs on a plaque in the Cabinet des Médailles, Paris, where the saint stands under an arch (*Exposition byz.*, no. 133), and on a plaque at Sinai, where the steatite is painted and set in a fourteenth-century painted wooden frame decorated with the Deesis and saints (Sotiriou, *Icones*, I, pl. 175; II, p. 162). In addition, St. Nicholas appears in precisely the same pose in a group of church fathers on an unusually large plaque in the Hermitage (Banck, *Byz. Art in the USSR*, fig. 152). All three steatites cited as parallels are dated in the twelfth century, and although our amulet is slightly less refined, perhaps only because of its smaller scale, it belongs to the same period. Whether it was made in Constantinople is uncertain, not only because of the slightly summary treatment of the carving, but also because of the color which is not the pale green typical of most pieces attributed to the capital.

D.O.H., 1967, no. 297.

38. Amulet. Steatite
 Bust of St. George
 Asia Minor (?), twelfth to thirteenth century
 Height 3.9 cm. Width 3.1 cm. Depth 0.8 cm.
 Acc. no. 40.5 PLATE LXVIII

The form of the amulet, with a framed recessed arch at the top, is traditional in ivory plaques. Originally it had a pierced boss (now broken away) for a chain or strap, so that it could be worn as a pendant (cf. the amulet with St. Nicholas, No. 37). The color is light green.

The amulet is carved in relief with a bust of St. George in frontal view. In his right hand he holds a sword and in his left a shield, of which only a segment is visible. The armor and chlamys are very roughly indicated by scratched lines. The eyes are wide open and staring, and the hair is rendered in three rows of curly locks; the nimbus is ornamented with a rather crude leaf design in a wavy band. The incised inscription Ϙ̄ (= ὁ ἅγιος) ΓΕ(ωΡ)ΓΕ(ΟC) is also very crude in execution.

This type of soldier-saint with a sword over his shoulder may be compared with the figure of St. Demetrius on the large steatite plaque depicting Saints Theodore, George, and Demetrius in the Chersonese Museum (Banck, *Byz. Art in the USSR*, fig. 156). Our figure shares with that of St. Demetrius the stylized treatment of the hair and the rinceau pattern of the nimbus. These features are typical of many steatites of the twelfth century, the period to which the Russian piece must be assigned. Our amulet, however, is considerably less refined in style, and its rather rough execution is particularly noticeable in the awkwardly designed arm holding the sword, in the treatment of the oversized, staring, slanted eyes, in the sketchiness of the ornament of the frame, and in the insecurity of the lettering of the inscription. These are signs of provincialism, and, since our piece was reportedly found in Asia Minor, it may well have been made there. It is said to have been found with three coins of Michael II (820–29), as well as a gold ring, apparently of the same period (M. C. Ross, *Byzantine and Early Mediaeval Antiquities in the Dumbarton Oaks Collection*, II, Washington, D.C., 1965, no. 111). However, these pieces do not shed any light on the date of the steatite, which has its parallel in the twelfth-century steatite mentioned above. But because our piece is so much more provincial, it could be somewhat later, perhaps of the thirteenth century.

D.O.H., 1955, no. 252. *D.O.H.*, 1967, no. 298.

39. Fragment of a Plaque. Steatite
 Ascension
 Constantinople (?), fourteenth century
 Height 3.3 cm. Width 3.7 cm. Thickness 0.8 cm.
 Acc. no. 51.26 PLATE LXVIII

The right side of the fragment preserves intact part of the original right edge of the plaque; the other edges, and with them the other scenes once represented on the plaque, are broken away. Pale green in color, the steatite is carved in low relief with the Ascension of Christ. However, only Christ's feet and a segment of the mandorla in which He was enthroned are preserved. The mandorla is held by flying angels on either side, and there may have been another pair of angels at the top. Beneath the mandorla the Virgin stands

in profile, facing to our right and leaning slightly forward, her hands raised in a gesture of prayer. Free space isolates her from the flanking angels who approach with veiled hands. The lower portions of the Virgin and the angel at the left are broken off. The angel at the right heads one group of Apostles with only Peter fully visible, while in the group at the left (for the most part missing) Paul is the leader.

The fragment belongs to a group of steatite icons, each representing the cycle of the twelve feasts. There are two such icons completely preserved, one in the Cathedral of Toledo (O. M. Dalton, *Byzantine Art and Archeology*, Oxford, 1911, fig. 149) and the other in the Athos monastery of Vatopedi (*ibid.*, fig. 150), where the feasts are distributed on a single plaque in four rows of three scenes each. In this arrangement, the Ascension must be placed at the lower left corner. But the right side of our fragment is also the original edge of the plaque; thus, it could not have been part of a single panel with all twelve feasts. Another type of feast icon, however, takes the form of a diptych, with the twelve scenes distributed over two wings. The left wings of three such steatite diptychs have been preserved, wholly or in part: that in Cyprus is complete (G. Sotiriou, Τὰ Βυξαντινὰ μνημεῖα τῆς Κύπρου, I (Album), Athens, 1935, pl. 54), while those in the Benaki Museum, Athens, and the Staatliche Museum, Berlin, are fragmentary (Banck, *Corsi.* p. 379 and figs. 7–8 [Athens plaque]; Volbach, *Mittelalterliche Bildwerke*, p. 123 [no. 2427] and pl. 3 [Berlin plaque]). Since each of these reliefs belonged to the left wings of diptychs and the six scenes depicted on them range from the Annunciation to the Raising of Lazarus, the lost right wings must have contained the scenes from the Entry into Jerusalem to the Koimesis. In such an arrangement the Ascension would be placed at the right, in the middle row, with the Anastasis at its left and the Pentecost and the Koimesis below. In all likelihood, then, our fragment was part of the right wing of a diptych. It does not, however, match any of the three left wings mentioned above, since on these the six scenes are grouped under an arch supported by spiral columns which form the lateral frames, while our piece has only a plain, undecorated border.

The figure style of these small scenes is rather sketchy and the carving of the folds of the drapery is more an imitation of brush strokes than an attempt to model the body. Traditionally, these steatites with the feast cycle have been dated in the twelfth century, but recently Alice Banck has argued, very convincingly, for a fourteenth-century date (*Corsi*, p. 377). It is the same stylistic phase which produced the small ivory pyxis with ceremonial scenes (No. 31), with which they share the tiny figure scale; but, while this mature style was apparently used only rarely for ivory carving, it was quite common in steatites. Green is the characteristic color of steatites carved in Constantinople, and the style of our fragment would not speak against an origin in the capital.

D.O.H., 1955, no. 251. *D.O.H.*, 1967, no. 296.

APPENDIX

40. Plaque (fragment)
 Archangel Gabriel
 Constantinople, second half of tenth century
 Height 14.5 cm. Width 7.9 cm. Thickness 1.0 cm.
 Acc. no. 72.21 PLATE LXXI

The plaque, with an Archangel under a recessed arch, is broken at the left, resulting in the loss of the figure's right arm and wing as well as his scepter or lance, of which only a trace remains close to his nimbus. At the bottom the plaque is cut, thus preserving only the upper half of the figure. The surface of the rather flat relief is rubbed, especially over the angel's forehead, nose, and chin, and there are a few scratches. As a whole, the plaque, which has a dark brown color, is in good condition.

On the back is pasted a piece of paper on which is written: "Reste d'une ancienne / diptyque, que [l'on] / Exposoit sur l'autel / durant la messe; ce / morceau peut avoir / Environ 800 ans il / a beaucoup de rapor aux / diptyques, que l'on voit / dans le Tresor de l'eglise / de Bourges. et alieurs / voy. les Voyages litteraires / de 2 benedictins. Edit 1717 / in 4° tom. I. page 24.25. / N° 15 / Tremet chan. de / St. Urbain 1786 / N° 15." The church of St. Urbain mentioned in this inscription can hardly be any other than the famous one in Troyes, and the fact that the ivory was exposed during the Mass indicates its use as a pax. The earliest extant ivory known to have been used for such a purpose is that with Christ Enthroned in the Colegiata de San Isidoro in Leon, dating from the twelfth century (Goldschmidt, IV, no. 111, pl. XXXVIII). This ivory is mounted on a metal-covered wooden stand, which encloses a relic and permits it to stand upright in order to be kissed (*ibid.*, p. 33, fig. 31). It is quite likely that our ivory was similarly mounted on an upright stand for its use in the Mass, and that its being sharply cut off at the bottom has something to do with this mounting. But whether it, too, served as a reliquary can no longer be ascertained nor can any suggestion be made concerning the date of its conversion into a pax.

The Archangel, inscribed ΓΑΒ[ΡΙΗΛ], is represented in a strictly frontal, hieratic pose, dressed in the imperial loros; he holds in his left hand an orb surmounted by a cross, and in his right—now broken away—a lance or scepter. In the Corpus (Goldschmidt–Weitzmann, II, p. 45) it was recognized that this ivory is most closely related in style and form to two pairs of plaques in the State Library of Bamberg, which today serve as covers for the prayer books of the German Emperor Henry II and his wife Kunigunde, but which were considered originally to have been diptychs (*ibid.*, II, pp. 44–45, nos. 65–66, pls. XXV–XXVI). One pair represents Christ and the Virgin and the other Peter and Paul. They share with our Archangel a rather summary treatment of the facial features and drapery that is competent but somewhat rougher than that of most pieces of the Romanos group

101

to which they belong. The somewhat casual ductus of the letters of the inscription on our panel also has its parallel in the Bamberg plaques.

The text of the Corpus also made clear that, if reconstructed, the Archangel plaque would have the same measurements as the Bamberg pieces (27.9 cm. in height and 11.3 cm. in width), and it was concluded that, like those ivories, it belonged to a diptych, whose other wing, surely representing the Archangel Michael, is lost. This postulation of three diptychs has been challenged by the present author on several grounds ("Die byzantinischen Elfenbeine," see bibliog. *infra*). From the technical point of view, the Bamberg plaques do not have the incisions and holes proper for diptych plaques; their present incisions relate instead to the spines and clasps of a bookcover. It is important to notice that the Archangel plaque has on its frame no incisions indicating either a hinge or a clasp—depending on whether the postulated missing plaque was mounted to its right or left. The smooth frames, without any cuts or holes, point rather to the mounting of the plaques in a wooden core, upon which they would have been secured by overlapping metal bands.

Moreover, from the iconographical point of view, the first Bamberg pair, the frontal Christ and the Virgin supplicating in profile, do not form a self-sufficient unit but are apparently part of a Deesis requiring a third plaque with the figure of John the Baptist, likewise in an attitude of supplication, flanking Christ on the other side. In addition, there is no known instance of two Archangels forming a diptych; in Byzantine art they occur most often either flanking Christ or the Virgin or as part of a Deesis. The unity of style and format of the five plaques suggests rather that they all belong to one and the same object, which we believe to have been the epistyle of an iconostasis. The center of such a beam would have been the Deesis, of which the plaque with John the Baptist is lost, flanked by Gabriel, of which the Dumbarton Oaks fragment is preserved, at the right and Michael at the left. They in turn would be flanked by the second Bamberg pair, Peter on the right and Paul on the left, and then presumably by more or perhaps all of the other Apostles, evenly distributed on each side, as suggested in a first reconstruction drawing ("Die byzantinischen Elfenbeine," fig. 6), which added at the very ends the figures of saints with question marks, because some iconostasis beams do include the saints, furthest removed from the center.

After this reconstruction was made, the author found in the storeroom of the Hermitage in Leningrad another pair of plaques, made into a diptych at a later time, probably in the fifteenth century. These agree so thoroughly with the Archangel and Bamberg plaques in measurements (27.9 cm. high and 11.3 cm. wide) that they must have belonged to the same iconostasis beam (Weitzmann, "Diptix slonovoj kosti," see bibliog. *infra*). Spread over both plaques is an abbreviated Presentation in the Temple, with Simeon on the left and the Virgin with Child on the right. Thus, it follows that this beam included not only the Deesis and the Apostles, but also the cycle of the twelve great feasts, in the sequence of which the Presentation would be third. This discovery has necessitated a new and expanded reconstruction drawing (text fig. g) ("Diptix slonovoj kosti," fig. 4), which assumes that each feast scene required at least two plaques (whether in rare cases a third may have been needed is impossible to determine). At the same time, we reduced the number of Apostles, first, because the three great ivory triptychs of the Romanos group which follow the same expanded Deesis program have an average of six Apostles each (Goldschmidt–Weitzmann, II, nos. 31–33, pls. X–XIII), and second, because an iconostasis beam of the thirteenth

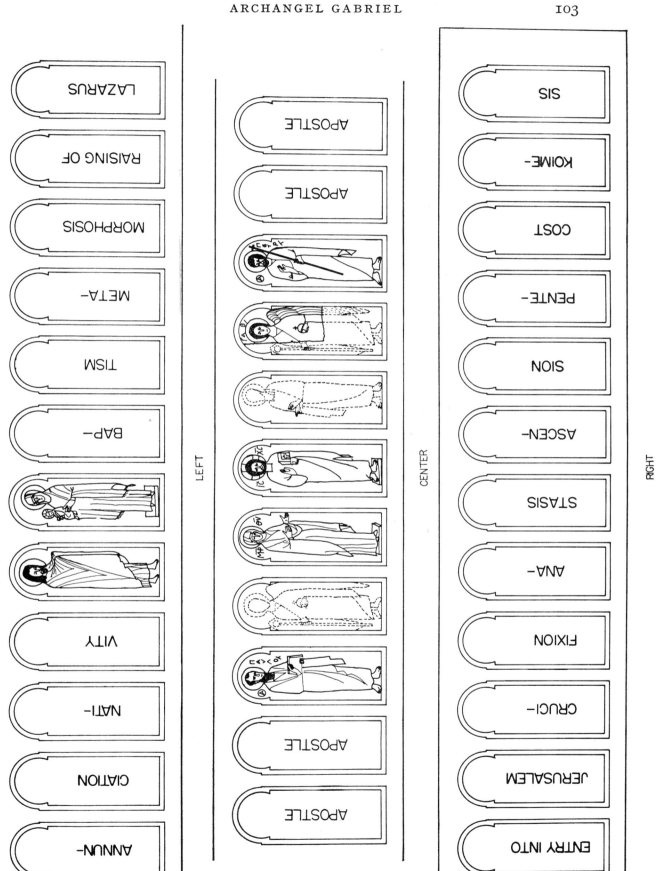

LEFT

CENTER

RIGHT

Fig. g

century in the Athos monastery of Vatopedi shows the Deesis flanked only by the four
Evangelists instead of the full set of Apostles. This clearly indicates that their number
varied among iconostasis beams. On this beam the Evangelists were in turn flanked by
five feast pictures at each side, of which, however, the two at the extreme right are lost
(M. Chatzidakis, "Εἰκόνες ἐπιστυλίου ἀπὸ τὸ Ἅγιον Ὄρος," Δελτίον τῆς Χριστιανικῆς
Ἀρχαιολογικῆς Ἑταιρείας, per. IV, vol. IV, 1964–65, pp. 377ff., pls., 77–86).

In the normal painted iconostasis beam, of which several examples have come to light
on Mt. Sinai (Sotiriou, *Icones*, I, figs. 87–125; II, p. 100f.), the feast pictures fill wide
arches, and it is quite obvious that the narrow format and the distribution of a feast scene
over two panels in the ivories is a result of the restrictions imposed by the material, i.e., the
maximum width of an elephant tusk. Yet it must be noted that two panels, the Anastasis
and the Pentecost, which are among the earliest fragments of painted iconostasis beams,
dating from the twelfth century, are preserved in the Hermitage in Leningrad (V. Lasareff,
"Trois fragments d'epistyles peintes et le templon byzantin," Δελτ. Χριστ. Ἀρχ. Ἑταιρείας,
per. IV, vol. IV, 1964–65, pp. 119ff., pls. 32–33), and that two more, the Baptism and the
Death of the Virgin, in the Athos monastery of Lavra (Chatzidakis, *op. cit.*, pp. 397ff., pls.

Fig. h

88, 91), are of a shape very similar to that of our ivory plaques, i.e., narrow and terminating in recessed arches. For a painted panel there was no intrinsic need for such a narrow format, and it is quite conceivable that the shape was chosen under the impact of a set of ivories like ours. Even the measurements are similar: with a height of 31.5–32 cm., the painted panels exceed the ivories by only a few centimeters.

As was stated before, the number of Apostles in such beams varies. If we somewhat arbitrarily assume six in our case, the total length of the beam would have been about 4.90 m., and with only two the length would have been about 4.34 m. ("Diptix slonovoj kosti," see bibliog. *infra*, p. 148). Either is a normal length; Chatzidakis calculated an original length of 5 m. for the beam in Vatopedi cited above.

What strikes the beholder as unusual is the great number of plaques—no fewer than thirty-five (thirty-one if we assume only two Apostles)—in our reconstruction. Yet there exists a parallel for this kind of epistyle. In a small church in the Abruzzi, S. Maria in Valle Porclaneta (text fig. h), there is above a marble architrave a wooden epistyle with no fewer than thirty-three narrow arches similar in form to the ivory plaques and the four painted panels in Leningrad and Lavra (E. Bertaux, *L'Art dans l'Italie méridionale*, Paris, 1904, p. 554, figs. 251–52; Weitzmann, "Diptix slonovoj kosti," p. 153, fig. 7). Unfortunately the painting is lost, but one might well assume that three larger central arches contained, in the Byzantine manner, a representation of the Deesis. S. Maria in Valle Porclaneta is a Byzantine monastery, and Bertaux with good reason assumed that this iconostasis, unparalleled in Italy, was a copy of the precious one in Montecassino, which Abbot Desiderius had commissioned in Constantinople.

The Dumbarton Oaks fragment thus belongs, along with six complete plaques—four in Bamberg and two in Leningrad—to an iconostasis beam. Although this may not have been the only such beam ever made in ivory (cf. No. 24 *supra*), it may well be assumed that such ambitious projects were very rare, even in Byzantium. We mentioned above the somewhat rough, but nevertheless competent, style of the ivory, and this applies to the Bamberg and Leningrad pieces as well. This style can be explained by two factors: first, by the monumental character of the hieratic figures, which has few parallels among the Byzantine ivories, and second, even more importantly, by the fact that they were placed high up on a beam. It must have seemed advisable for the carvers to use more summary forms for objects meant to be seen from a considerable distance.

Tyler Collection.

H. Peirce and R. Tyler, *Byzantine Art*, London, 1926, p. 38, pl. 47. *Exposition byz.*, Paris, 1931, p. 71, no. 69. G. Salles, G. Duthuit, and F. Volbach, *Art byzantin*, Paris, 1933, p. 45, pl. 24B. Goldschmidt–Weitzmann, II, no. 67, pl. XXVI. Catalogue, *Masterpieces of Byzantine Art*, Edinburgh and London, 1962, no. 62. K. Weitzmann, "Die byzantinischen Elfenbeine eines Bamberger Graduale und ihre ursprüngliche Verwendung," *Festschrift für K. H. Usener*, Marburg, 1967, p. 14 and fig. 5. *Idem*, "Diptix slonovoj kosti iz Èrmitaža, otnosjaščijsja k krugu imperatora Romana," *Vizantijskij Vremennik*, 32, 1971, pp. 146, 155.

41. Plaque
 Cross
 Tenth to twelfth century
 Height 6.8 cm. Width 5.8 cm. Thickness 0.9 cm.
 Acc. no. 72.22 PLATE LXXII

The surface of the plaque is slightly corroded and appears shiny, apparently having been treated with some kind of lacquer. There are no holes and the piece may have been set into a wooden core and held in place by overlapping metal bands or—what seems even more likely—encased in a metal frame with a loop, so that it could be worn on a chain as an encolpion.

The cross, with flaring arms, is bordered by bead-like globules, and at the ends of each arm, clusters of these beads form two little rosettes, while a larger rosette decorates the crossing of the arms. All of this is typical of metal technique, and our cross is obviously an imitation of one in gold or silver. The huge palmette with sinuous leaves below the cross is quite common in Byzantine art, as exemplified in two title pages in the Paris Gregory manuscript gr. 510, written between 880 and 886 (H. Omont, *Miniatures des plus anciens manuscrits grecs de la Bibliothèque Nationale du VI au XIV siècle*, Paris, 1929, pls. XVII–XVIII). This motif is also seen in silver repoussé on the back of a triptych reproduced in G. Schlumberger, *Un empereur byzantin au Xᵉ siècle, Nicéphore Phocas*, Paris, 1890, fig. p. 97. This piece may also be compared with our ivory for the similar use of the bead motif.

The spandrels of our ivory cross are filled with the inscription IC XC NI KA, typical of the Middle Byzantine period and thereafter and written in a heavy, broad-lined uncial, comparable to the inscriptions on the above-mentioned miniatures of the Gregory manuscript.

While the massive form of the cross, the simplicity of the palmette leaf, and the type of script speak for a rather early date within the Middle Byzantine period, the application of the bead motif may speak for a somewhat later phase of the same period, so that it seems advisable to date the piece not more precisely than between the tenth and twelfth centuries.

W. de Grüneisen Collection.
Tyler Collection.

W. de Grüneisen, *Collection de Grüneisen, Catalogue raisonné. Art chrétien primitif du haut et du bas moyen âge*, Paris, 1930, p. 74, no. 395, pl. XXVI. *Exposition byz.*, Paris, 1931, p. 75, no. 91. Goldschmidt–Weitzmann, II, no. 193, pl. LXIII.

42. Furniture Appliqué. Bone or Ivory
 Rinceaux with Animals (fragment)
 Egypt or Syria, seventh to eighth century
 Height 9.2 cm. Width 4.7 cm. Thickness 1.5 cm.
 Acc. no. 56.17 PLATE LXXII

The piece is broken on three sides with only part of the border at the bottom remaining, and even here nothing of the surface carving is left. The plaque is broken away just to the

right of the vertical axis. At the left, however, where two small pieces without decoration seem to have been glued in the wrong places, little is lost. How much is missing from the top is impossible to say. In addition to the two small pieces already mentioned, two more—one with a rosette at the upper left and the other with part of a tendril and a grape at the upper right—are attached apparently in the right places. There are two holes, only one of which is small enough for a peg to fasten the appliqué to a piece of wooden furniture. Two holes in the underside of the frame and traces of a third in the broken section indicate an upright, and probably later, mounting.

The piece is blackened on all sides, probably from exposure to fire, which may also be responsible for its brittleness. Because of its blackness, the piece had previously been classified as wood, and thus escaped my attention. Only recently, during its examination by the Conservation Department of the Fogg Museum, was it established that it is not wood, but is instead either bone or ivory. Without further investigation the technical experts could not be more precise. There is a piece in the Benaki Museum at Athens (E. Kühnel, *Die Islamischen Elfenbeinskulpturen VIII.–XIII. Jahrhundert*, Berlin, 1971, p. 26, no. 5 and pl. II [here complete bibliography]) which is closely related in style and technique. Kühnel, who examined this piece most thoroughly, states that it is definitely bone; since our piece is from the same workshop, and most likely of similar use, it too may well be of bone.

The vine-scroll forms a symmetrical pattern, with the lower tendrils held together by a ring with acanthus leaf and the upper ones intertwined. Of the two larger spirals one terminates in a tri-lobed leaf and the other encloses a long-eared hare turning its head back and nibbling a damaged cluster of grapes. Some tendrils terminate in bunches of grapes whose drilled pattern gives a rosette-like impression. The one true rosette, at the upper left, appears to be stuck upon the tendril.

The related piece in the Benaki Museum is damaged like ours in that most of the right half of the symmetrical rinceau pattern is lost. Yet, as close as the two pieces are stylistically and technically, they cannot be of the same date, for on the Benaki piece the geometrical pattern of the tendrils is defined in a more pronounced manner, suggesting a more advanced stage in the development toward the arabesque; consequently one would expect our piece to be slightly earlier, and, therefore, it could not have belonged to the same object. The earlier date for our piece is also suggested by the freer and more naturalistic rendering of its vine leaves, revealing a relatively closer adherence to the classical tradition. On the other hand our vine-scroll is more stylized than that surrounding the Bacchus figure in an ivory relief of the Aachen pulpit (J. Strzygowski, "Die Elfenbeinreliefs der Kanzel des Domes zu Aachen," *Hellenistische und Koptische Kunst in Alexandria*, Vienna, 1902, p. 60 and figs. 48–49; good reproductions in H. Schnitzler, *Rheinische Schatzkammer*, I, Düsseldorf, 1957, pls. 116 and 119). Here the tendrils are not yet forced into a geometric pattern, the leaves curl more freely, the grapes do not show the characteristic perforations of our plaque, and, in general, drilling is more sparingly used. Thus we should like to date our piece between the Aachen pulpit plaques and the Benaki Museum fragment.

While the attribution of the Benaki Museum piece has wavered between a Coptic and an Islamic origin, Kühnel has dated it decidedly, and in our opinion convincingly, in the eighth century, i. e., the Umayyad period. He links it with the palace façade of Mschatta, from

the middle of the eighth century, on the basis of the similar ornamental motifs as well as a technical affinity, especially the deep under-cutting, which creates striking effects of light and shadow. On the other hand, the Aachen pulpit reliefs are now dated by most scholars in the second half of the sixth century (K. Weitzmann, "The Reverse of the Plaque with Heracles' Lion Fight," *La Cattedra Lignea di S. Pietro in Vaticano*, Atti della Pontificia Accademia, Ser. III, Memorie X, Rome, 1971, p. 251 and fig. 3). Thus we propose for our piece an origin in the early Umayyad period, perhaps still at the end of the seventh, but not later than the first half of the eighth century. Kühnel did not specify whether the Benaki piece was made in Syria or Egypt, and I also should prefer to leave both possibilities open in the case of our piece, although its stronger reflection of the Coptic tradition might be seen as tipping the scale in favor of an Egyptian origin.

Collection of Sir Leigh Ashton.

PLATES

N.B. Unless otherwise indicated, all objects are reproduced 1:1.

PLATE I

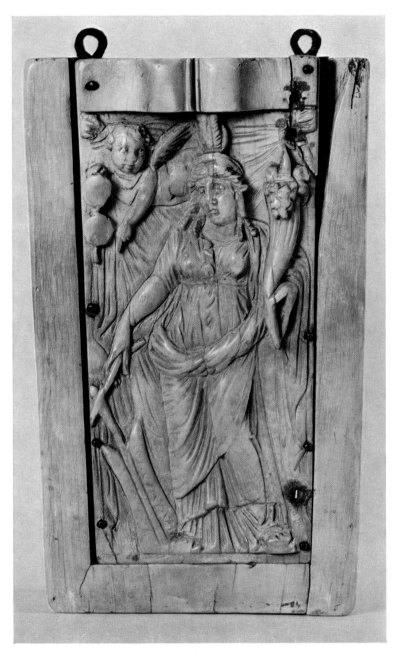

No. 9

PLATE 2

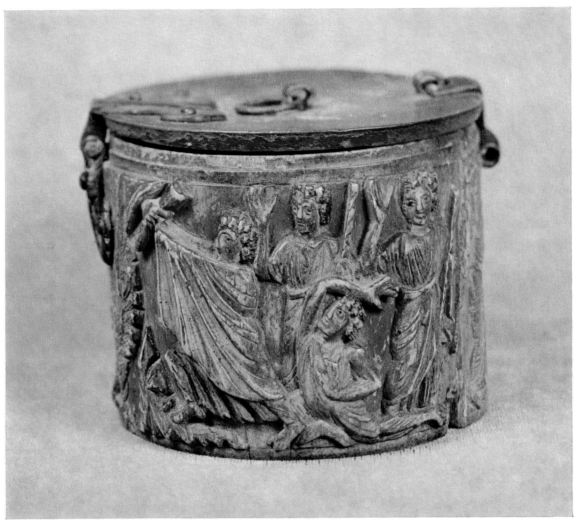

No. 18

PLATE 3

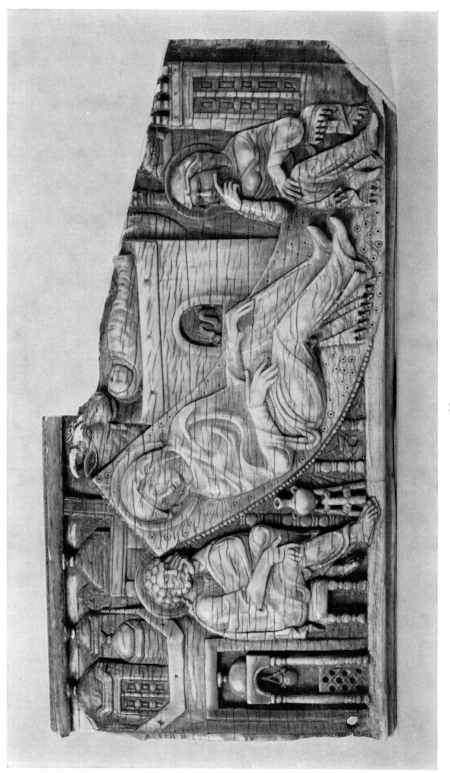

No. 20

PLATE 4

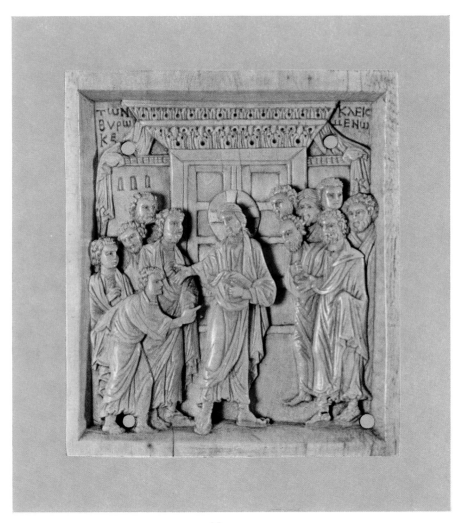

No. 21

PLATE 5

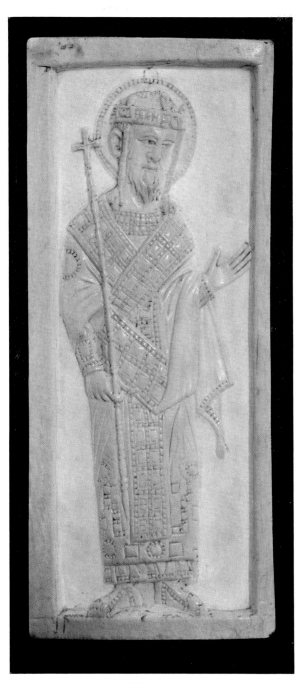

No. 25

PLATE 6

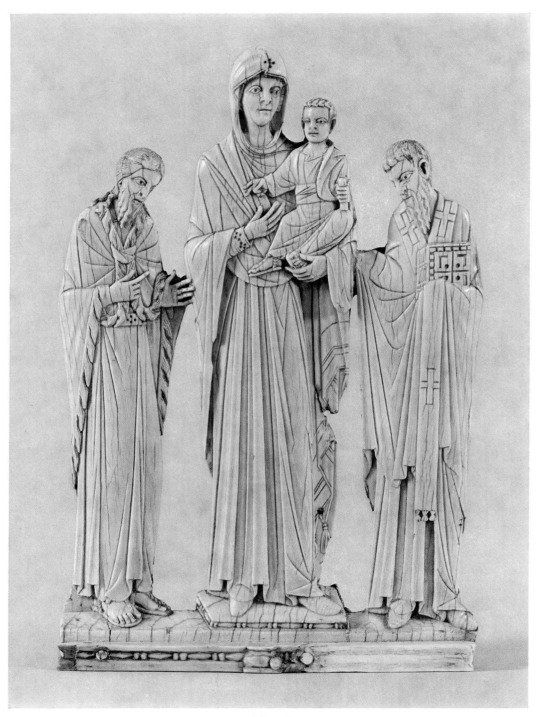

No. 26

PLATE 7

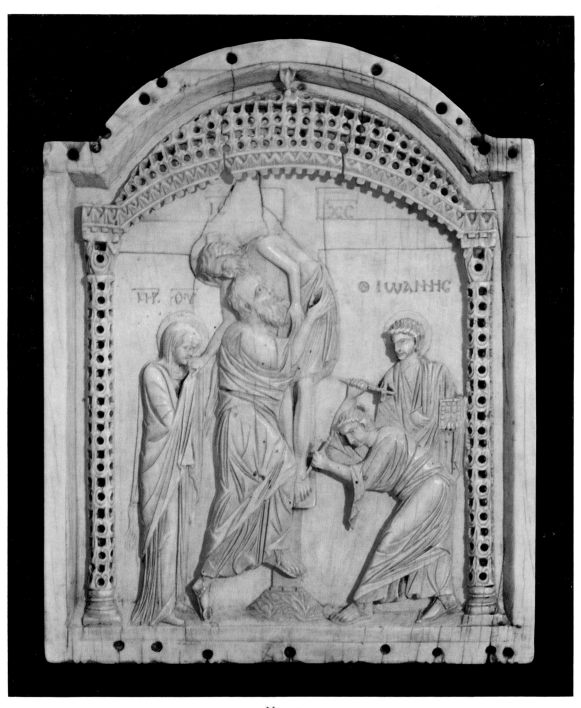

No. 27

PLATE 8

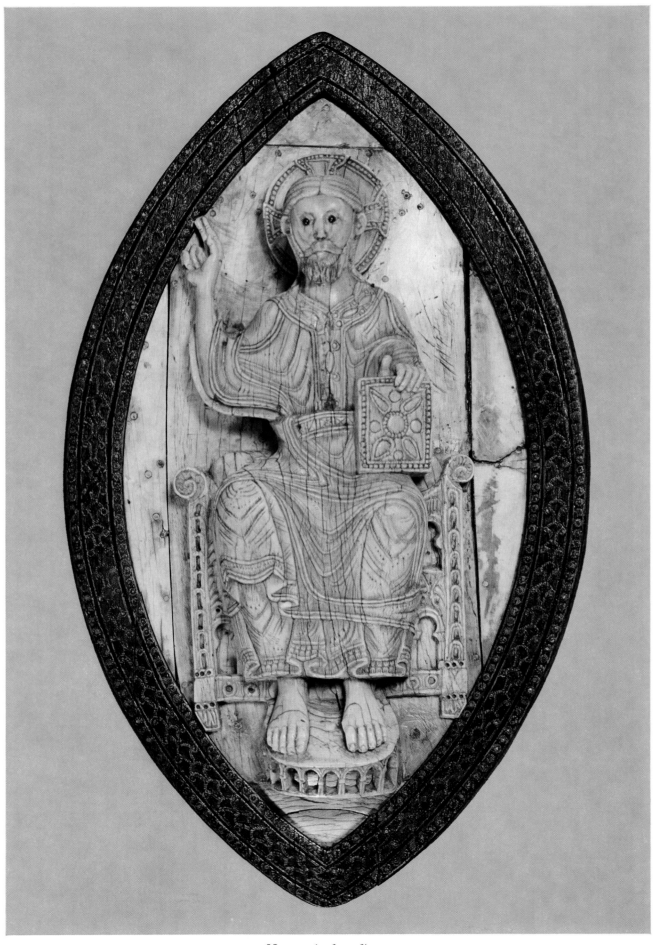

No. 32 (reduced)

PLATE I

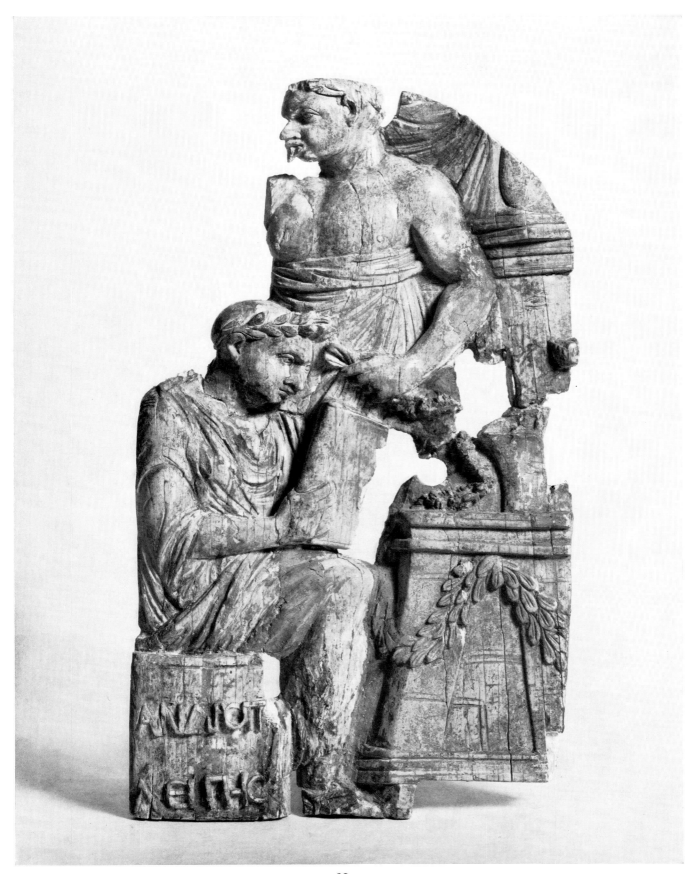

No. 1

PLATE II

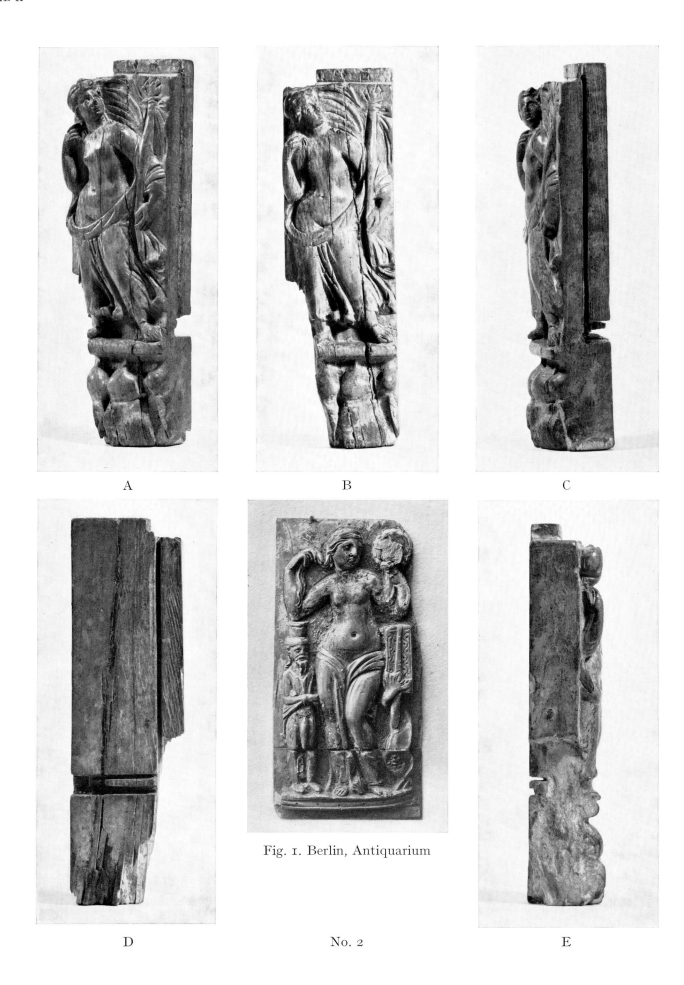

A

B

C

D

Fig. 1. Berlin, Antiquarium

No. 2

E

PLATE III

Fig. 2. Baltimore, Walters Art Gallery

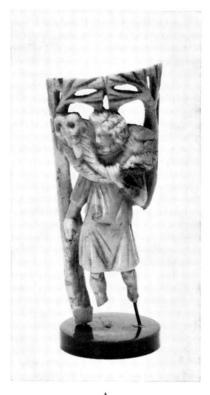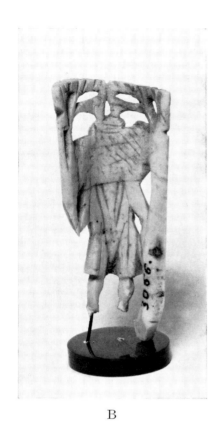

A B

No. 3

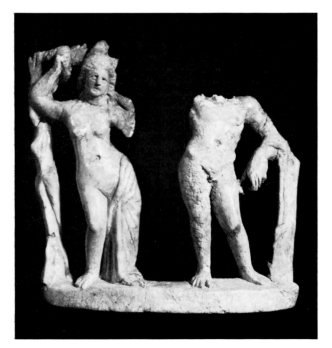

Fig. 3. Lucerne, Kofler Collection

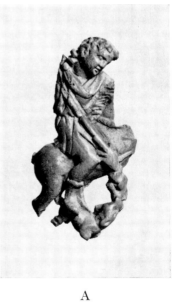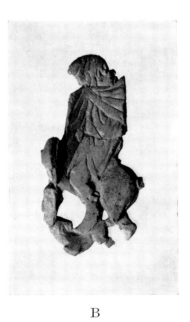

A B

No. 4

PLATE IV

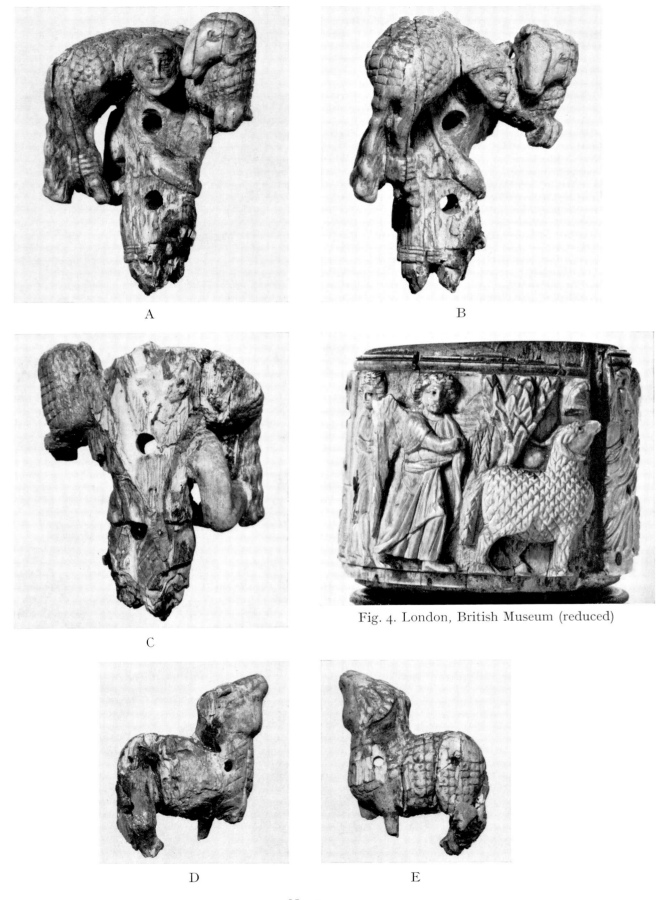

A

B

C

Fig. 4. London, British Museum (reduced)

D

E

No. 5

PLATE V

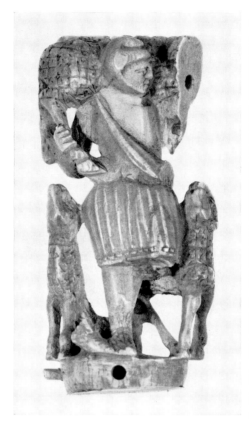
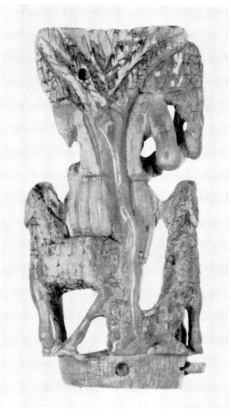

Fig. 5 Fig. 6 Fig. 7

Liverpool, Museum (reduced)

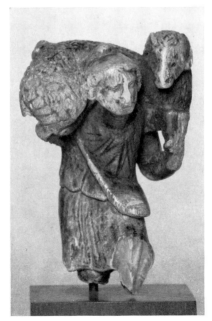
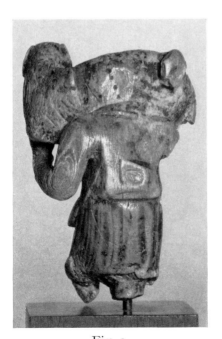
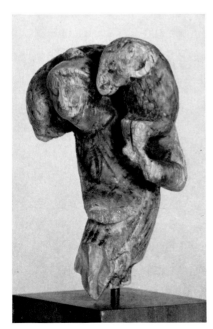

Fig. 8 Fig. 9 Fig. 10

Riggisberg, Abegg Stiftung

PLATE VI

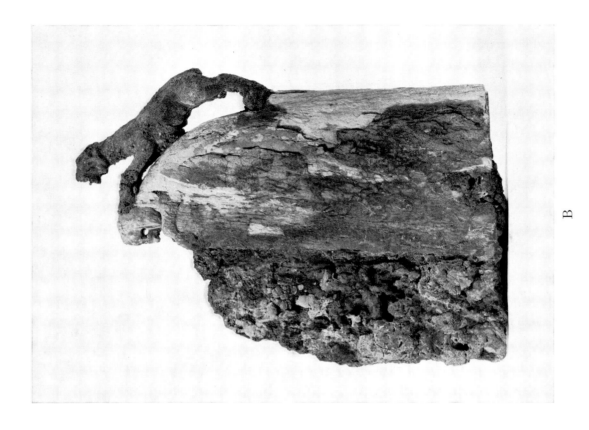

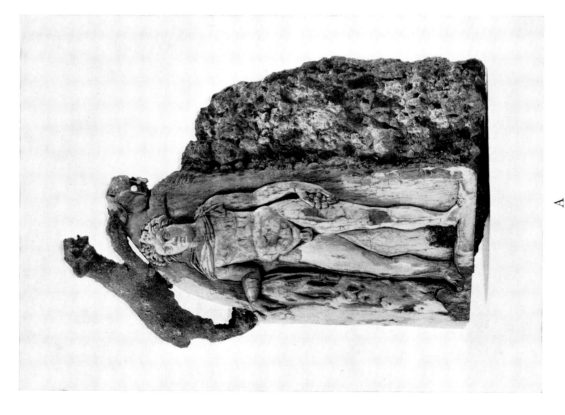

B

No. 7

A

PLATE VII

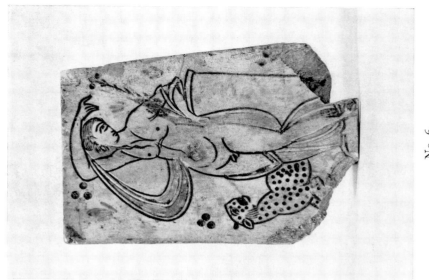

No. 6

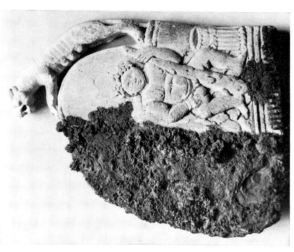

Fig. 12. New York, Metropolitan Museum

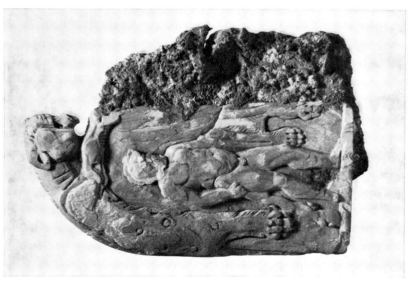

Fig. 11. Baltimore, Walters Art Gallery

PLATE VIII

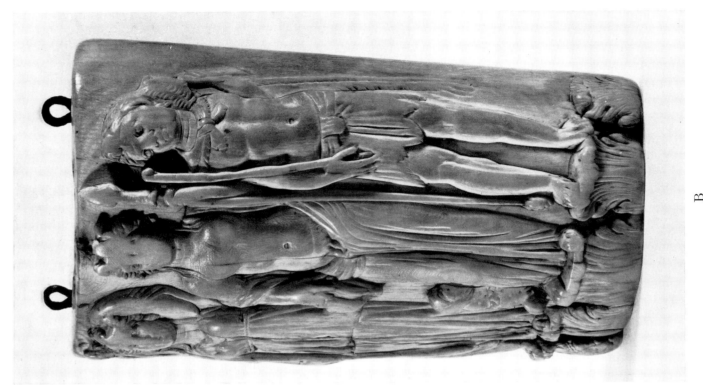

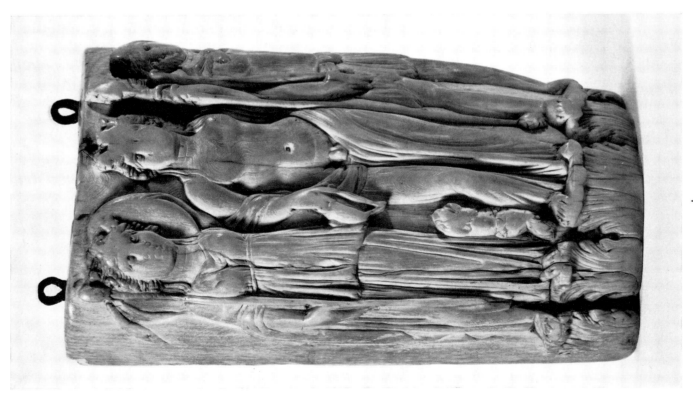

B

A

No. 9

PLATE IX

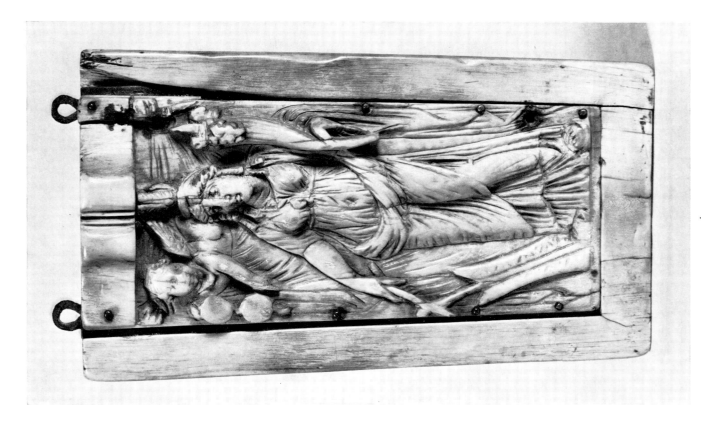

B

A

No. 9

PLATE X

A

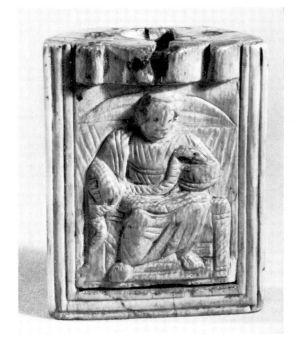

A

B (reduced)

No. 9

B

C

No. 10

PLATE XI

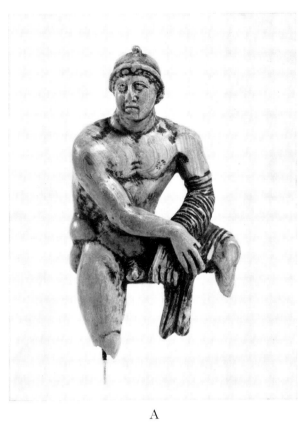

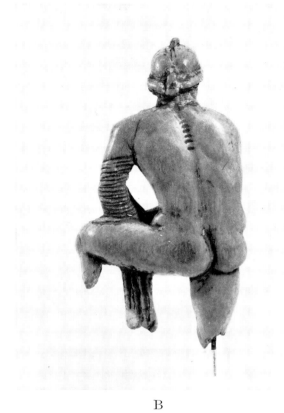

A

B

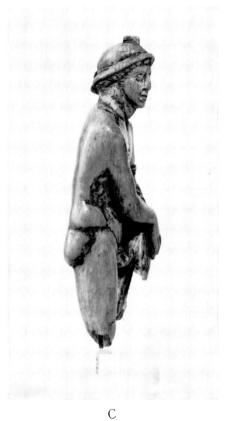

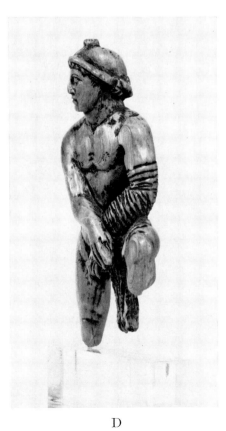

C

D

No. 8

PLATE XII

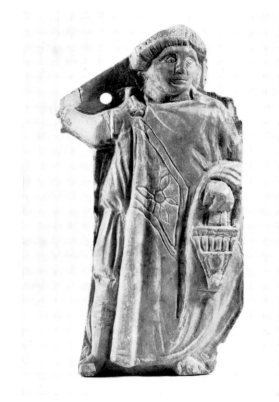

A

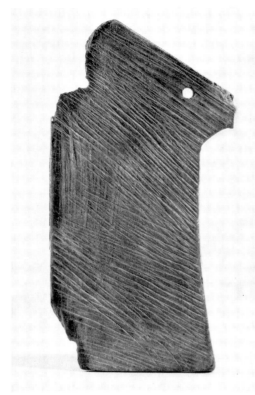

B

C (enlarged)

No. 11

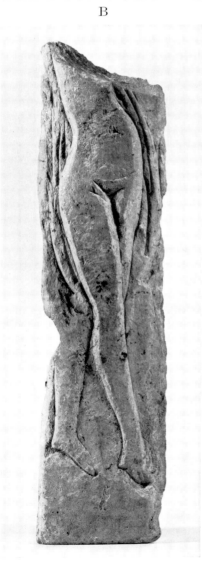

No. 12

PLATE XIII

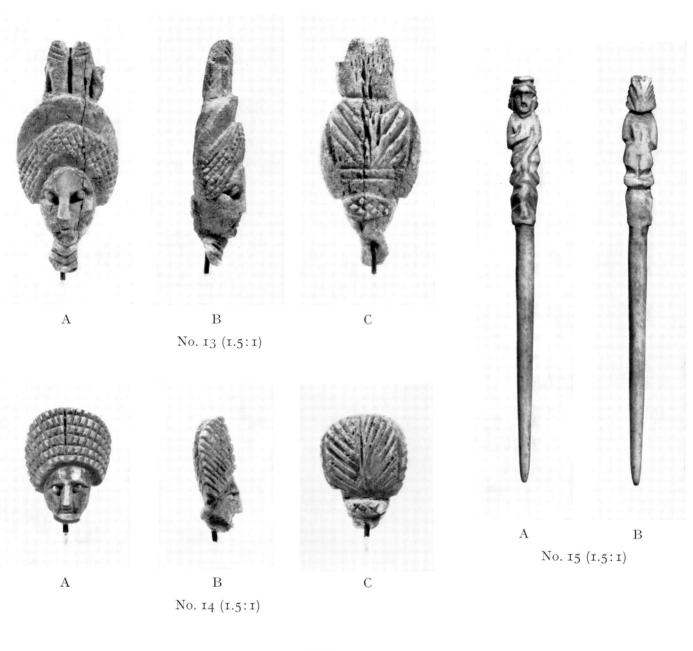

A B C

No. 13 (1.5:1)

A B C

No. 14 (1.5:1)

A B

No. 15 (1.5:1)

No. 16

PLATE XIV

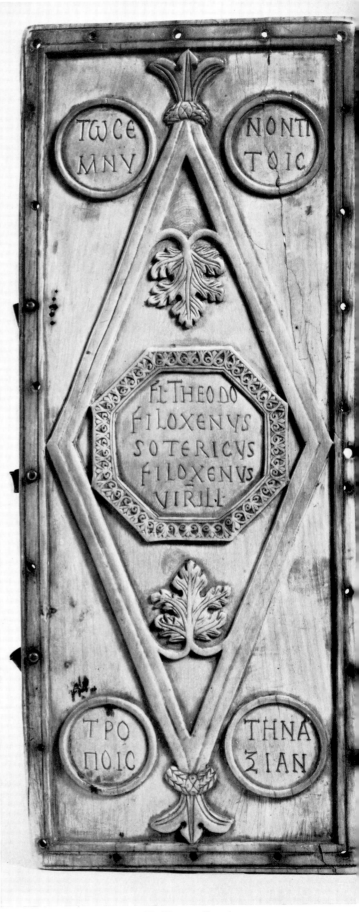

A. Back Leaf

B. Front Leaf

No. 17 (reduced)

PLATE XIX

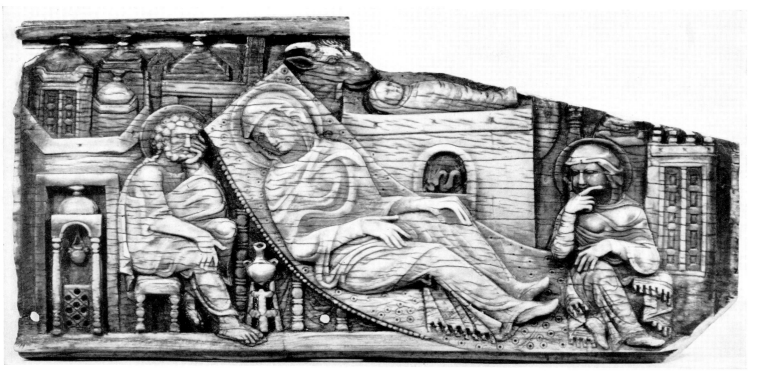

A

B (enlarged)

No. 20

PLATE XX

B

A

No. 20 (enlarged)

PLATE XXI

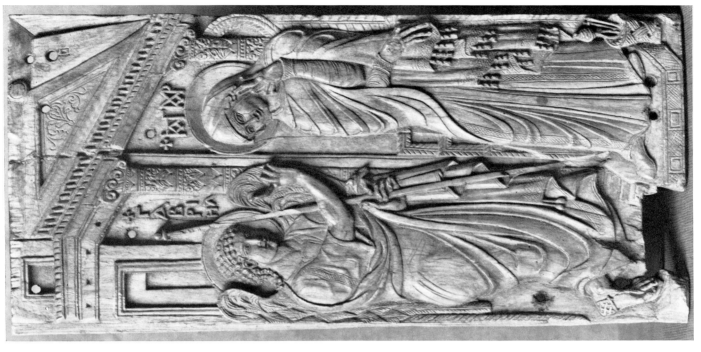

Fig. 16. Milan, Museo del Castello Sforzesco

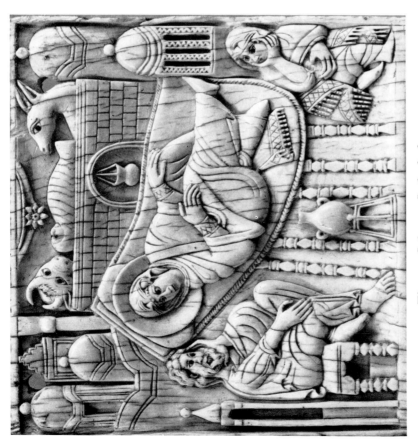

Fig. 15. Salerno, Cathedral

PLATE XXII

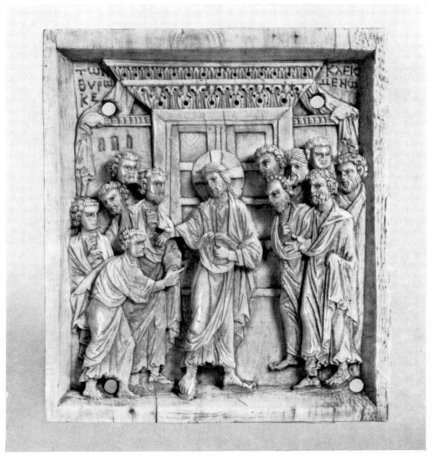

No. 21

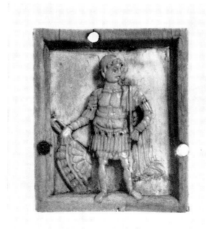

No. 22

PLATE XXIII

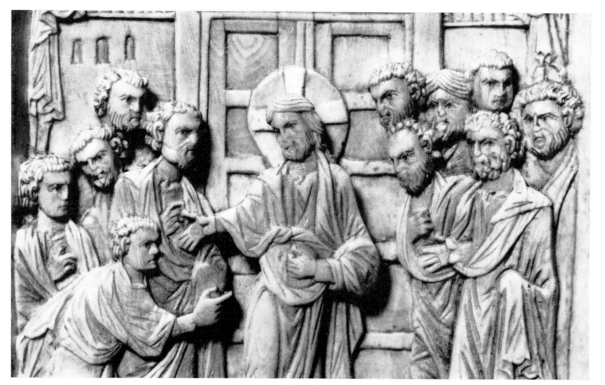

A (2:1)

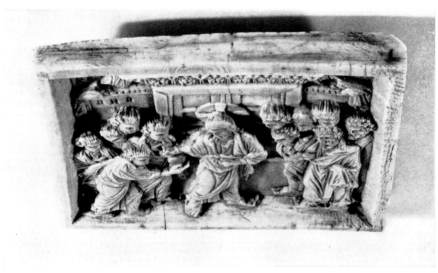

B

No. 21

PLATE XXIV

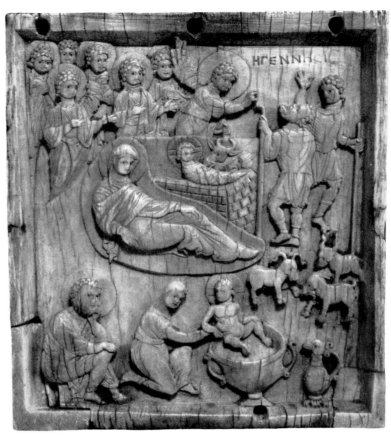

Fig. 17. London, British Museum

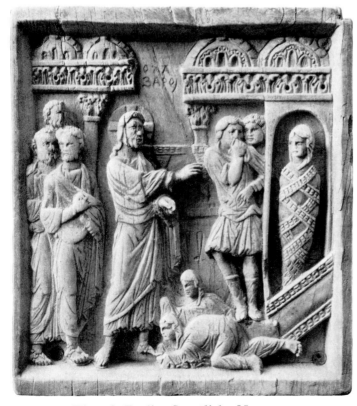

Fig. 18. Berlin, Staatliche Museum

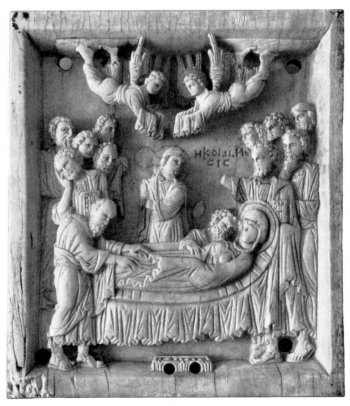

Fig. 19. Houston, Museum of Fine Arts

PLATE XXV

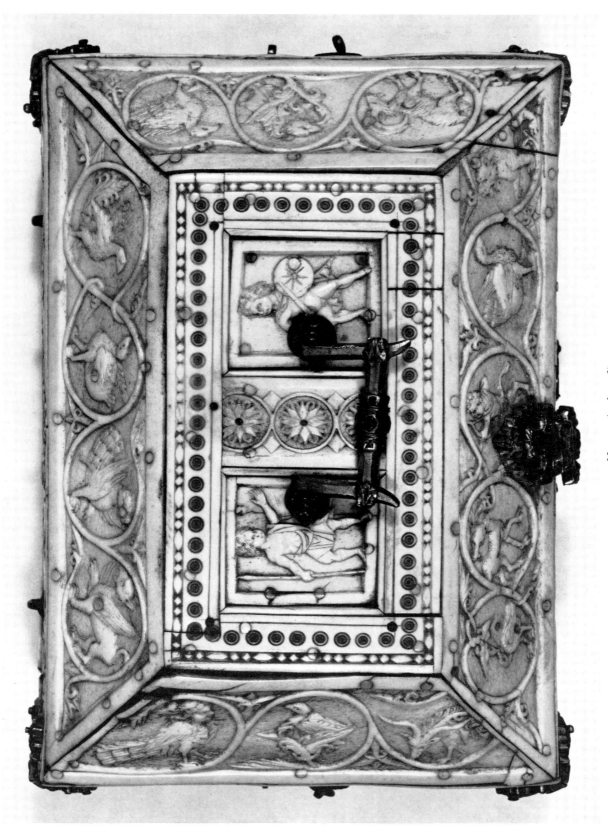

No. 23 (reduced)

PLATE XXVI

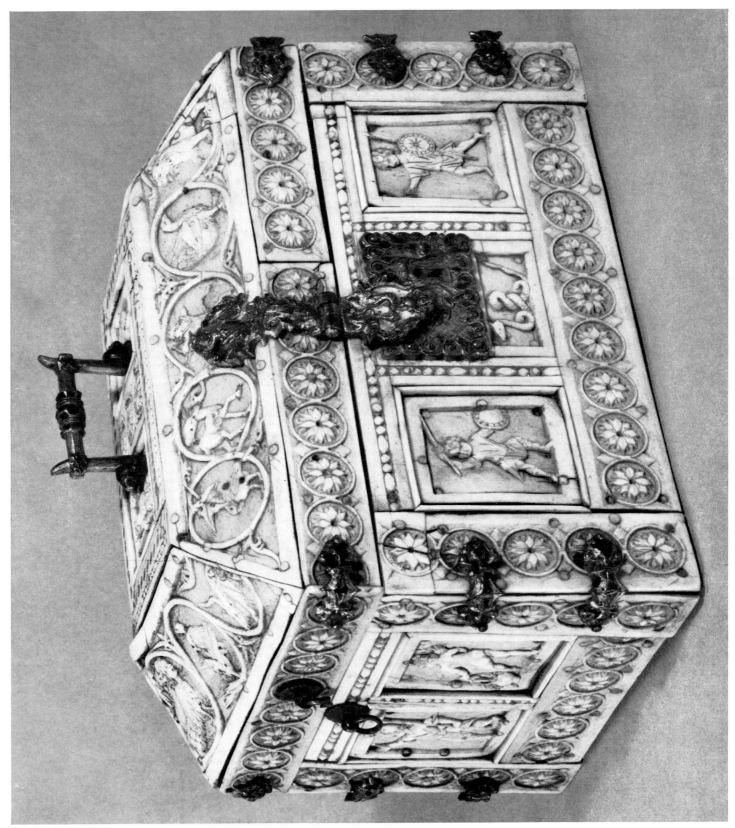

No. 23 (reduced)

PLATE XXVII

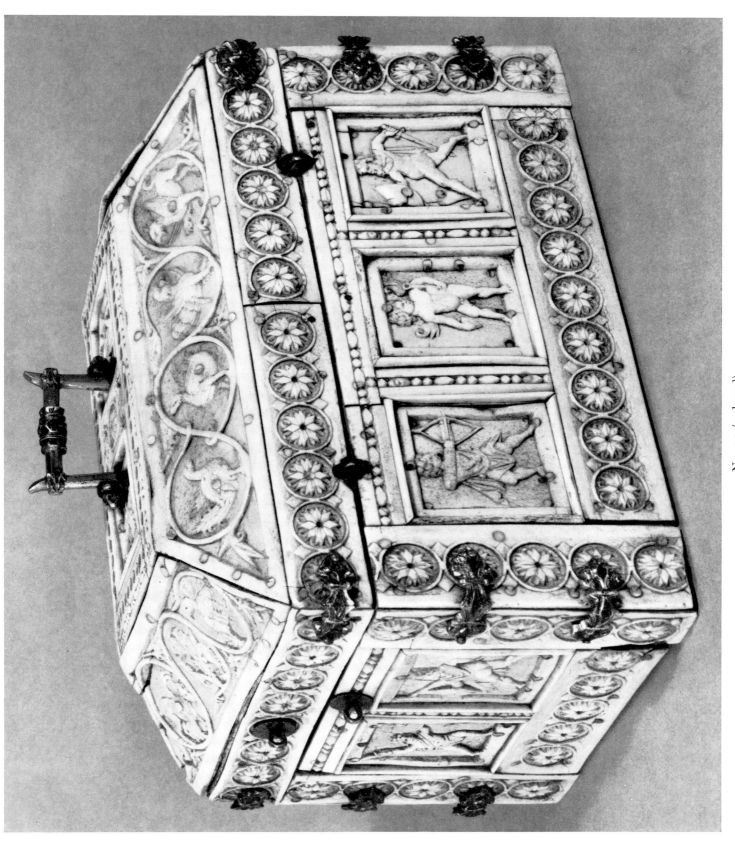

PLATE XXVIII

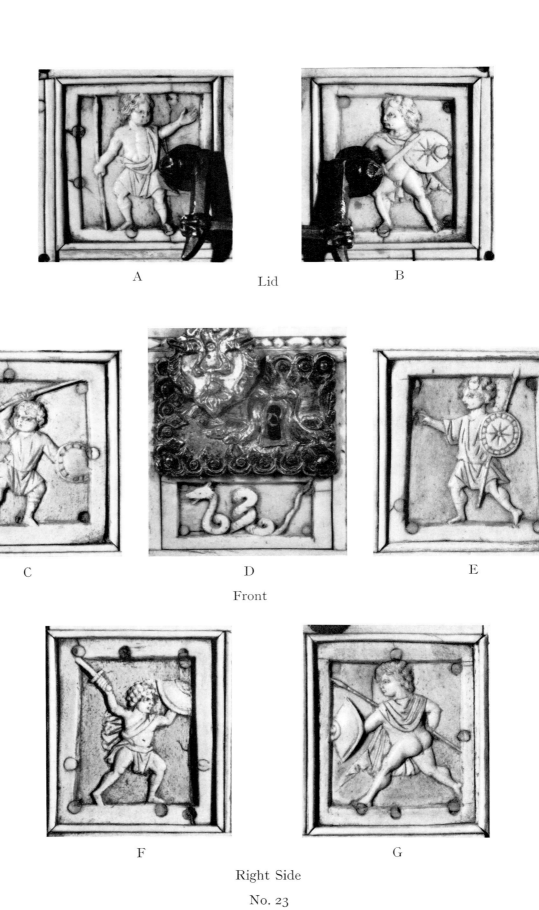

A Lid B

C D E

Front

F G

Right Side

No. 23

PLATE XXIX

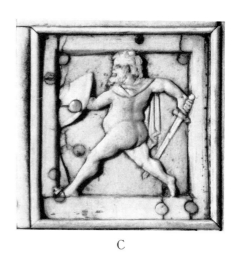

A

B

C

Back

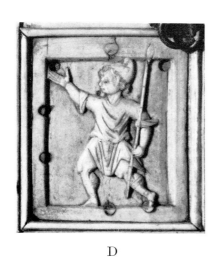

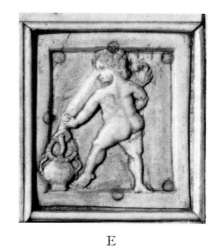

D

E

Left Side

No. 23

PLATE XXX

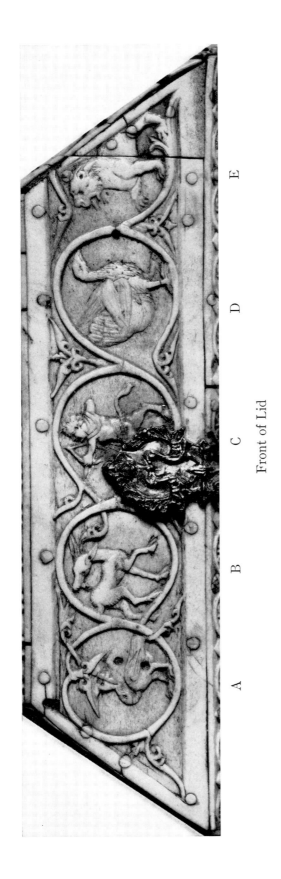

A B C D E

Front of Lid

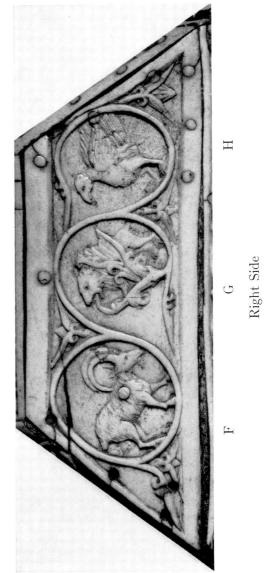

F G H

Right Side

No. 23 (slightly reduced)

PLATE XXXI

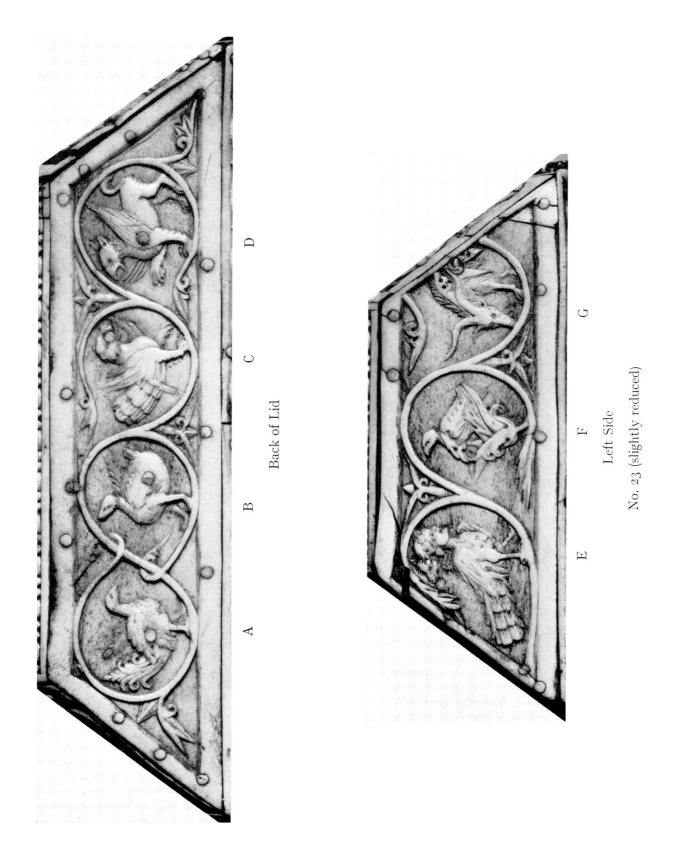

A B C D

Back of Lid

E F G

Left Side

No. 23 (slightly reduced)

PLATE XXXII

No. 24 (reduced)

PLATE XXXIII

Fig. 20. Gotha, Schlossmuseum (reduced)

PLATE XXXIV

A

B (reduced)

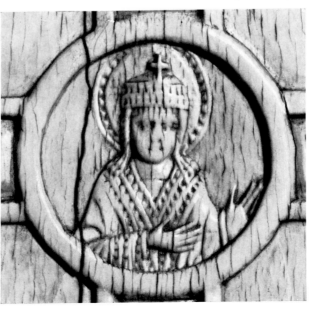

C (enlarged)

No. 24

PLATE XXXV

Fig. 21 Gotha, Schlossmuseum (reduced) Fig. 22

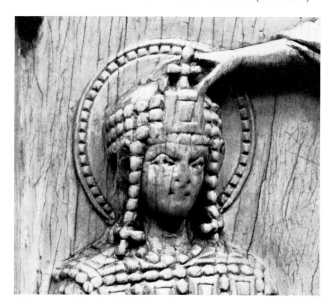

Fig. 23. Paris, Cabinet des Médailles (enlarged)

PLATE XXXVI

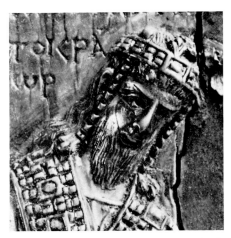

Fig. 24. Moscow, Historical Museum (enlarged)

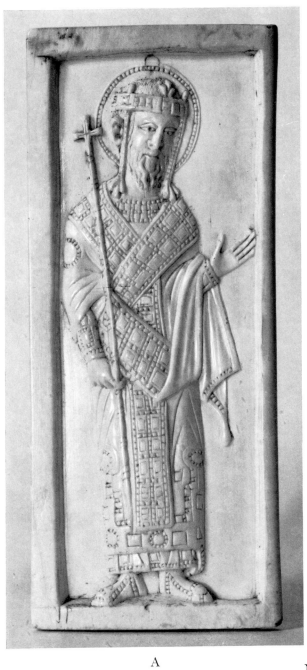

A

No. 25

B

PLATE XXXVII

A

B
No. 26 (2:1)
C

PLATE XXXVIII

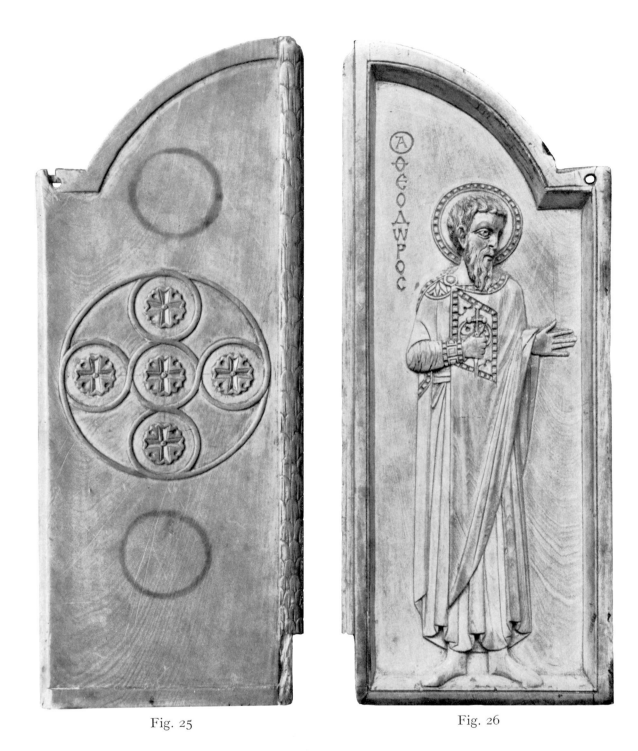

Fig. 25 Fig. 26

Paris, Louvre

PLATE XLIII

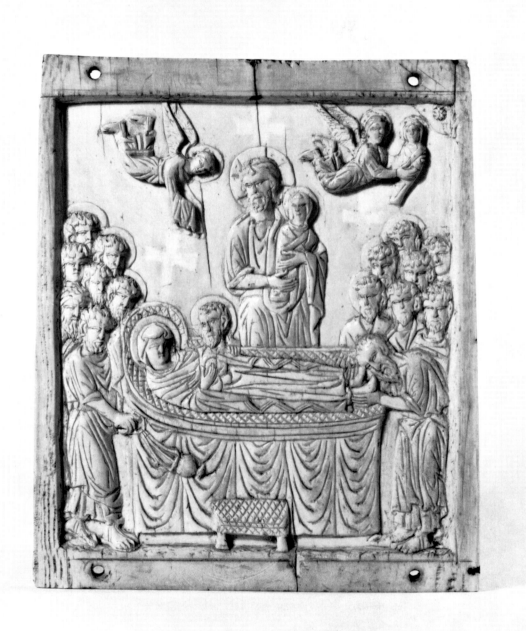

No. 29

PLATE XLIV

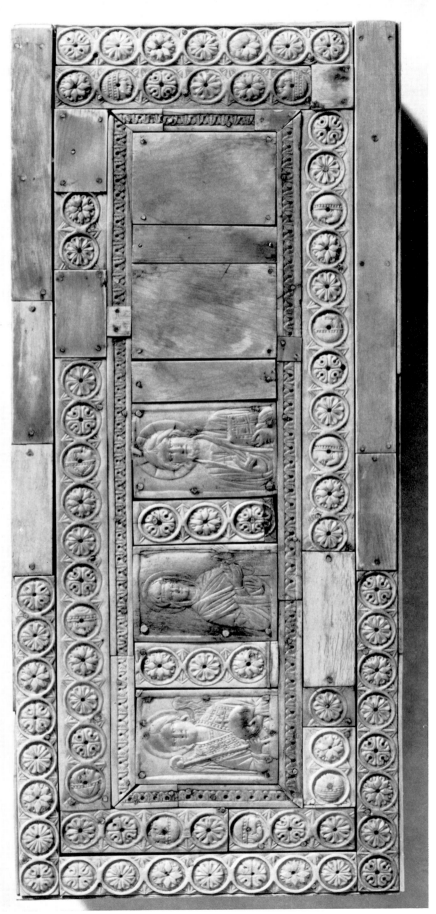

No. 30 (reduced)

PLATE XLV

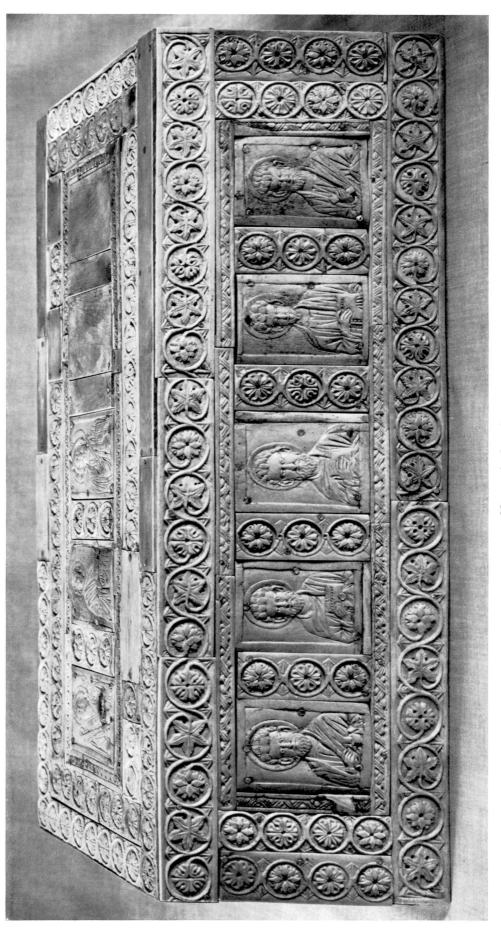

No. 30 (reduced)

PLATE XLVI

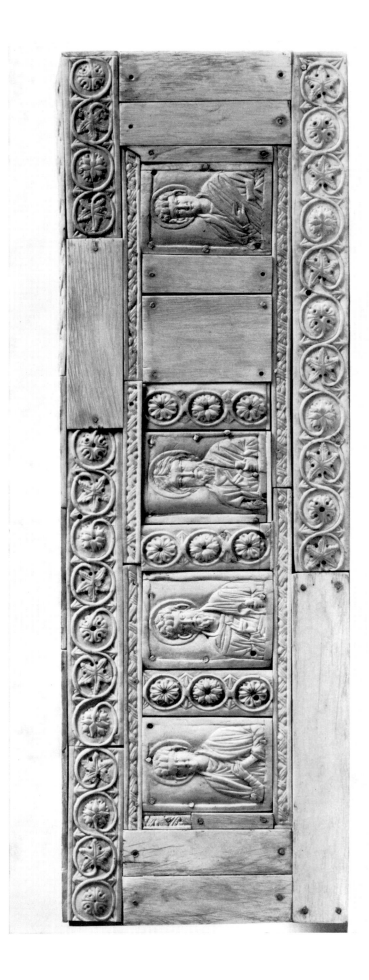

No. 30 (reduced)

PLATE XLVII

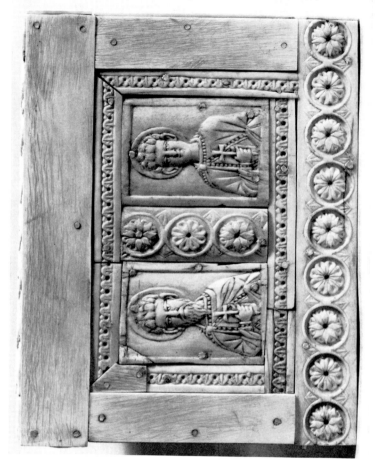

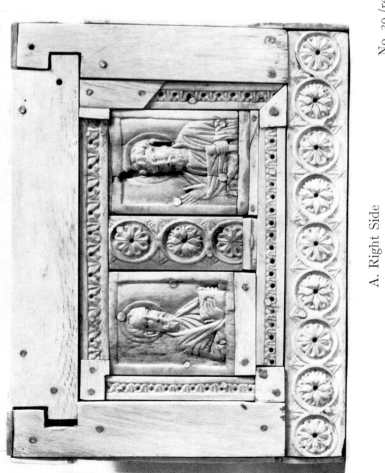

B. Left Side

No. 30 (reduced)

A. Right Side

PLATE XLVIII

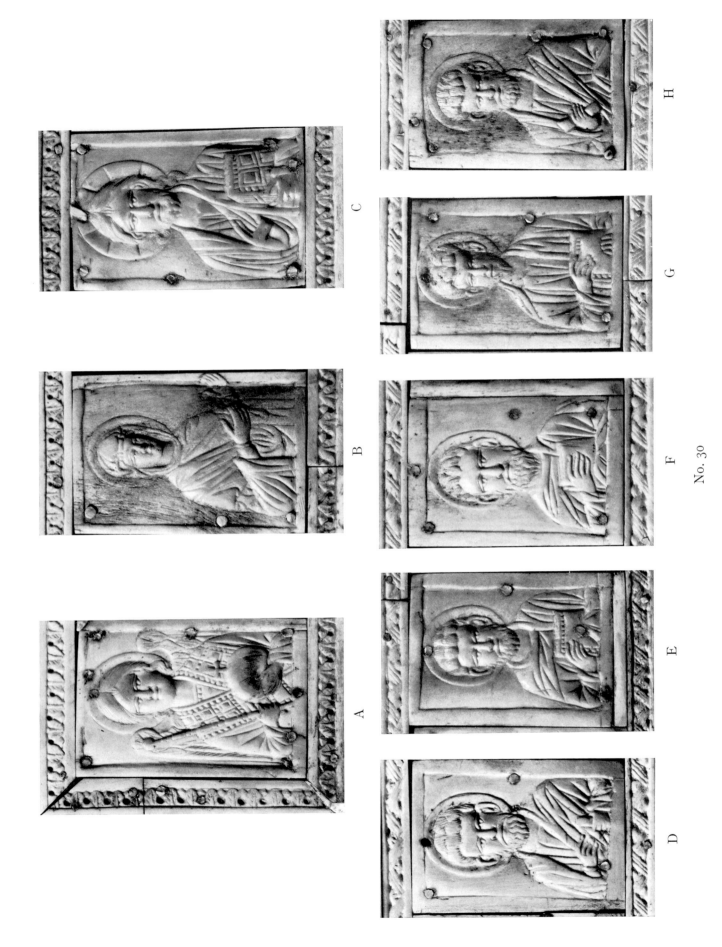

A

B

C

D

E

F

G

H

No. 30

PLATE XLIX

Fig. 27. Olim Rome,
Collection Stroganoff

A

B

C

D

E

F

G

H

No. 30

PLATE L

Fig. 28. Lid

Fig. 30. Left Side

(reduced)

Florence, Museo Nazionale

Fig. 29. Right Side

PLATE LI

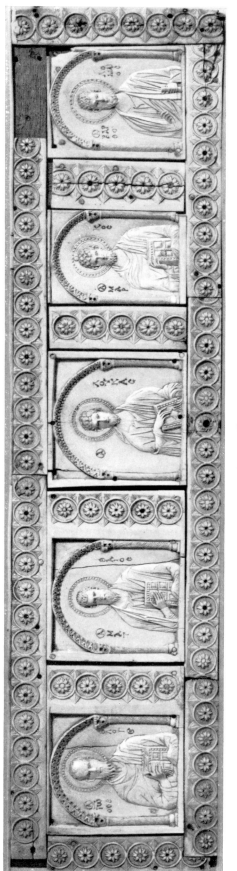

Fig. 31. Rear

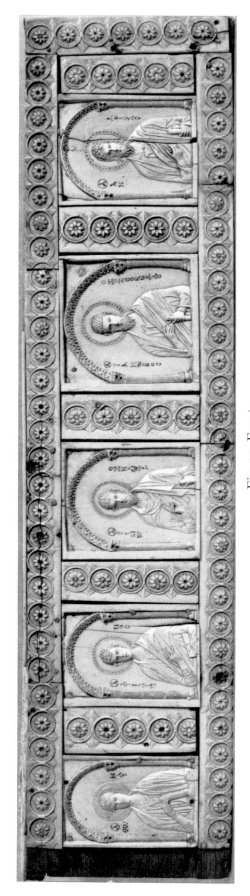

Fig. 32. Front

(reduced)

Florence, Museo Nazionale

PLATE LII

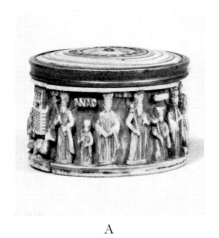

A

B

C (enlarged)

D (enlarged)

No. 31

PLATE LIII

A

B

C

D

E

No. 31 (*ca.* 2:1)

F

PLATE LIV

Fig. 34 (reduced)

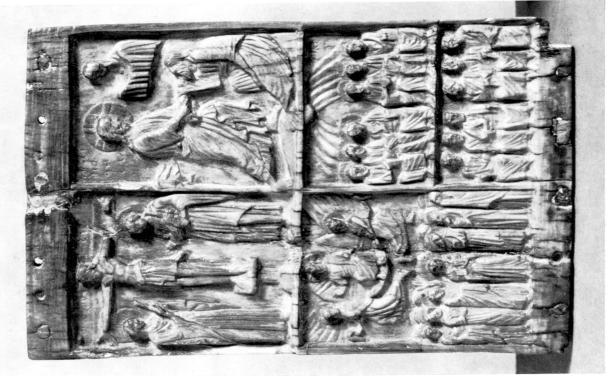

Fig. 33

Baltimore, Walters Art Gallery

PLATE LV

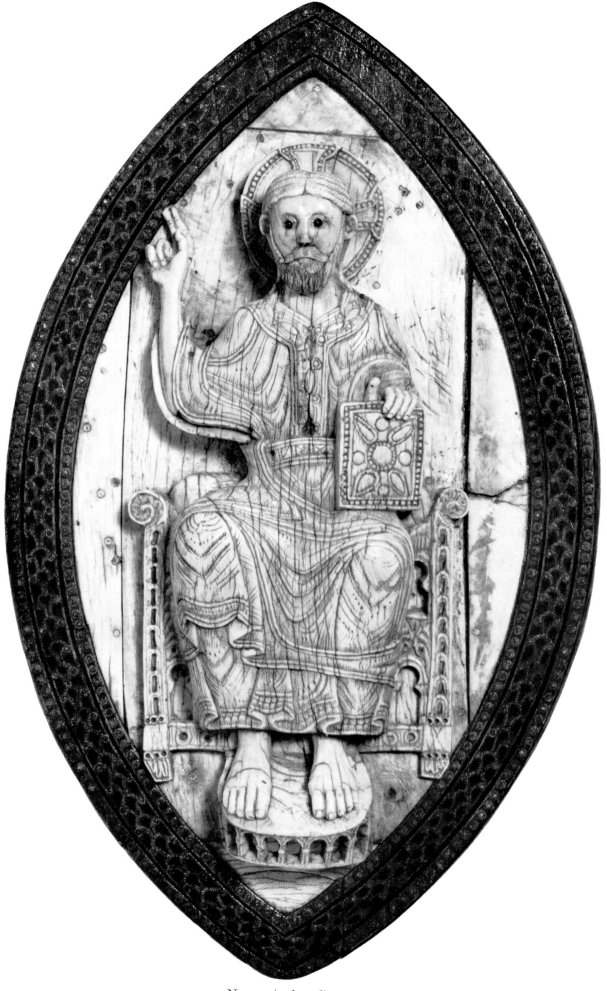

No. 32 (reduced)

PLATE LVI

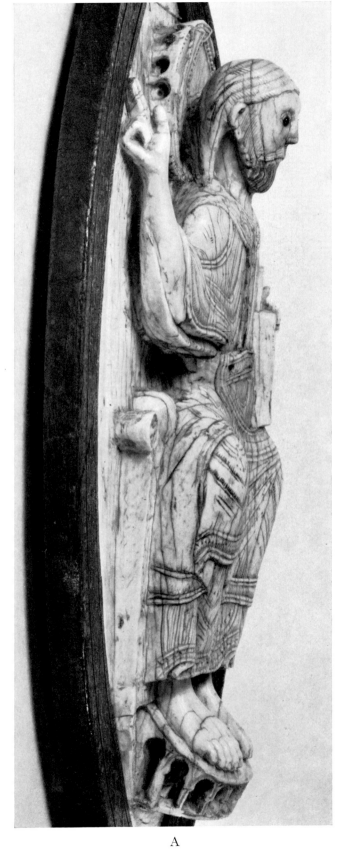 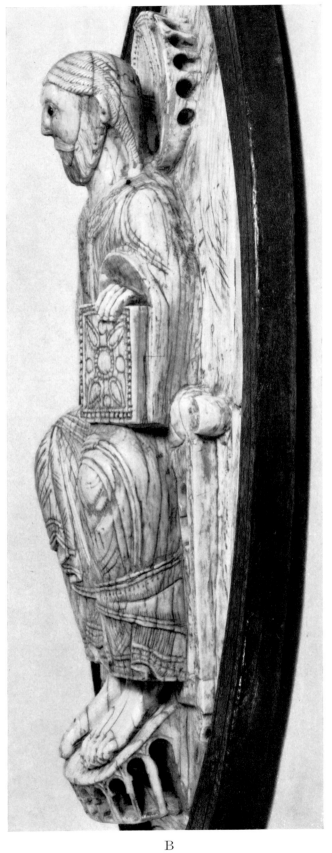

A B

No. 32

PLATE LVII

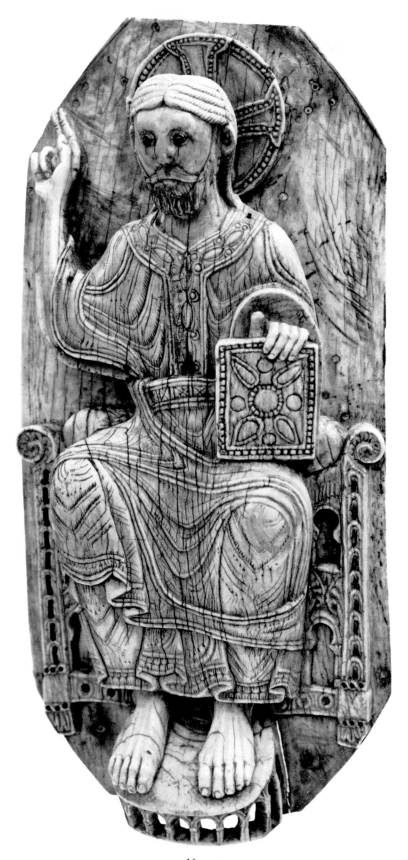

No. 32

PLATE LVIII

A (reduced)

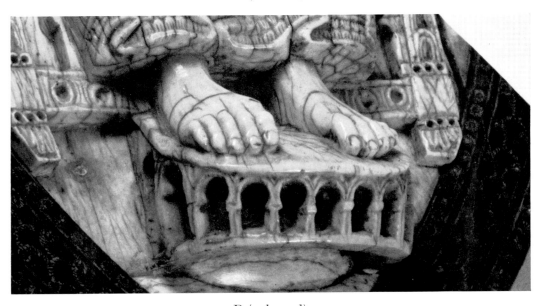

B (enlarged)

No. 32

PLATE LIX

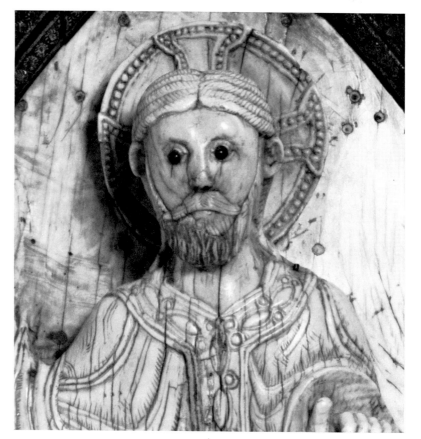

A

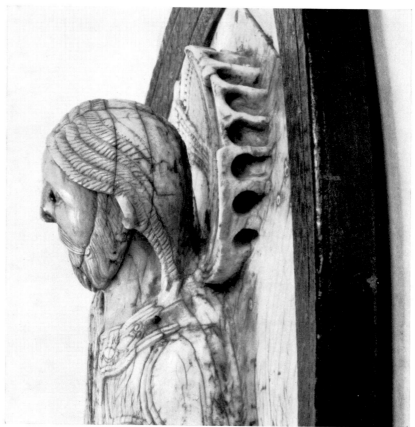

B

No. 32 (enlarged)

PLATE LX

A

B

No. 33

C

PLATE LXI

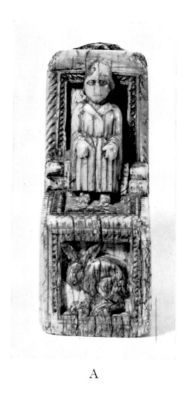

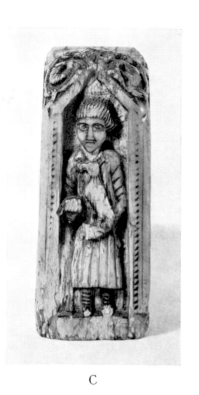

A

No. 33

C

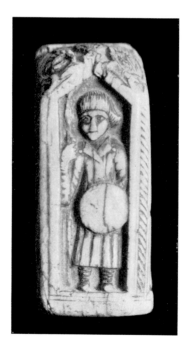

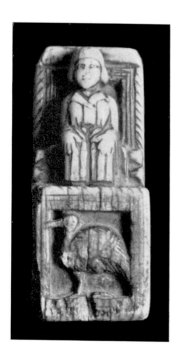

Fig. 35

Fig. 37

Fig. 36

Olim Frankfurt am Main, Collection Fuld

PLATE LXII

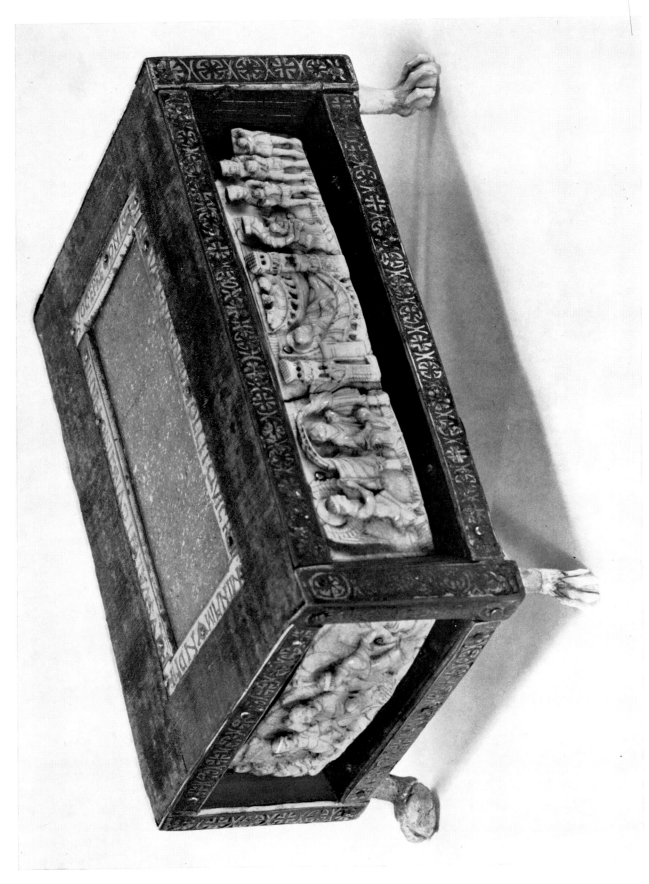

No. 34 (reduced)

PLATE LXVII

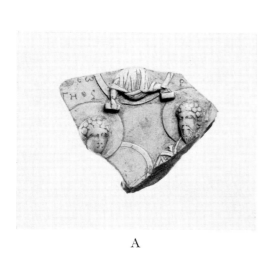

A

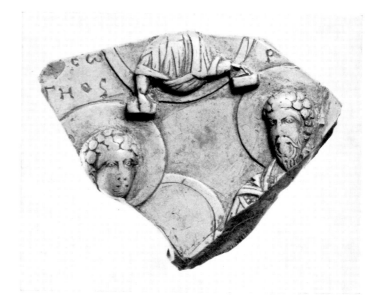

B (enlarged)

No. 35

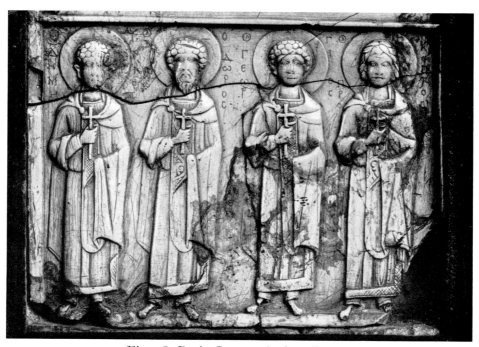

Fig. 38. Paris, Louvre (reduced)

A

B

No. 36

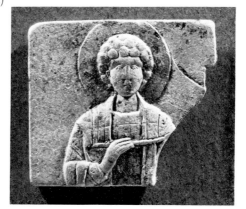

Fig. 39. Baltimore, Walters Art Gallery

PLATE LXVIII

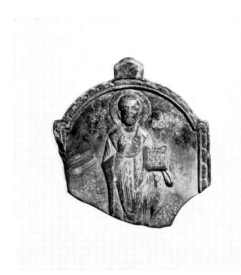

A

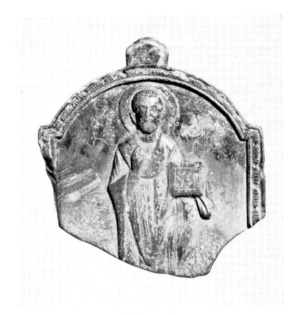

B (1.5:1)

No. 37

No. 38

A

B (2:1)

No. 39

PLATE LXIX

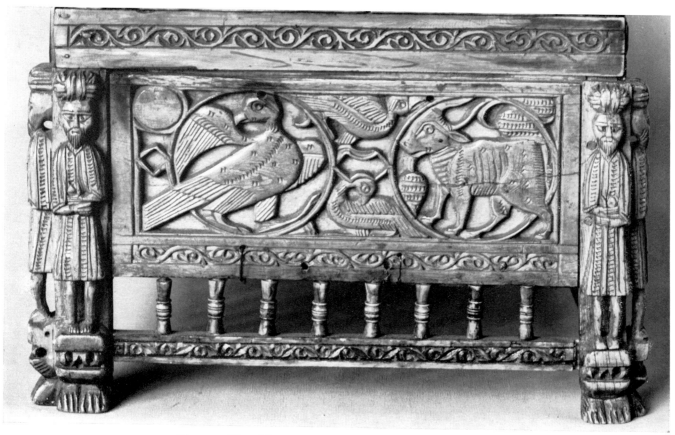

Fig. 40. New York, Metropolitan Museum (cf. No. 2)

Fig. 41. Rossano, Archiepiscopal
Museum (cf. No. 11)

Fig. 42. Patmos, cod. 71
(cf. No. 23)

Fig. 43. Rome, Vatican cod. gr.
1087, fol. 306ʳ (cf. No. 23)

PLATE LXX

Fig. 44. Istanbul, Saraçhane (cf. No. 24)

Fig. 45. Madrid, Nat. Lib. cod. 5.3. N. 2, fol. 145ʳ (cf. No. 31)

Fig. 46. Madrid, Nat. Lib. cod. 5.3. N. 2, fol. 78ᵛ (cf. No. 31)

PLATE LXXI

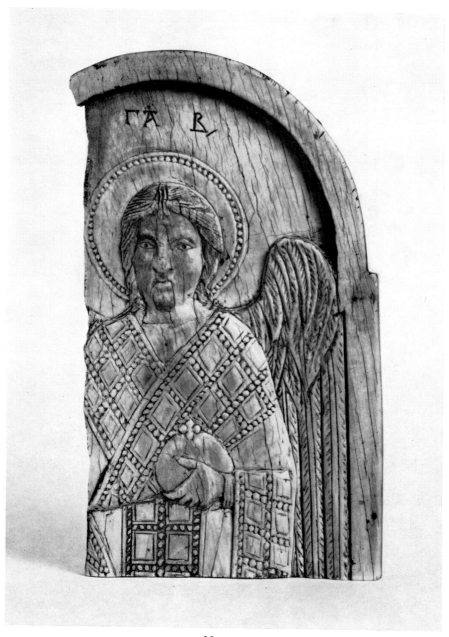

No. 40

PLATE LXXII

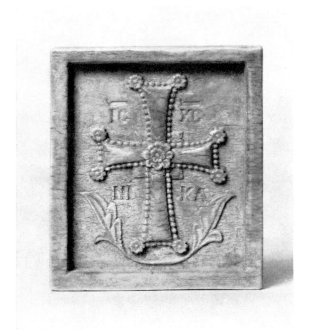

No. 41

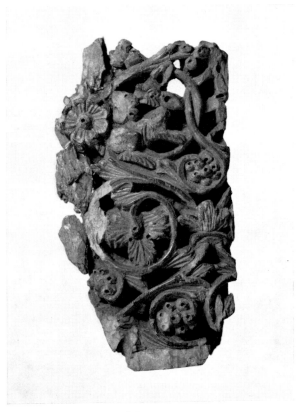

No. 42